EXPLODITY

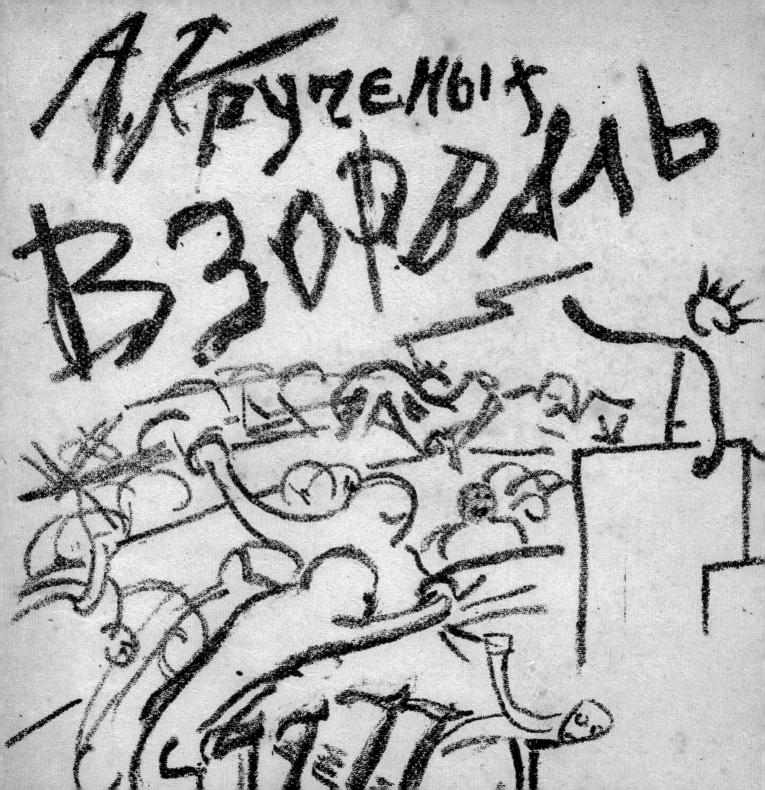

EXPLODITY

Sound, Image, and Word in Russian Futurist Book Art

NANCY PERLOFF

The Getty Research Institute

To my mother

and to the memory of my father

Contents

I came to the Russian avant-garde somewhat fortuitously. My graduate-school training was in musicology, with a specialty in the European avant-garde and in American experimental music. I received a second degree in art history, focusing this time on French and German modernism. My PhD dissertation, published by Oxford University Press in 1991, addressed composer Erik Satie, members of his group, "Les Six," and the café-concert. In 1994, I acquired the David Tudor archive for the Getty Research Institute (GRI). At the time, I knew little about Russian art. But in 1995, not long after the demise of the Soviet Union, the GRI had the chance to acquire a rare archive of El Lissitzky manuscripts. The materials were exceptionally beautiful, and I could read the correspondence—written on his personal letterhead—because it was in German (the native tongue of Lissitzky's wife, Sophie Lissitzky-Küppers). The archive became the core of a GRI exhibition I curated with Éva Forgács, an accompanying conference, and a volume I edited with Brian M. Reed, *Situating El Lissitzky: Vitebsk, Berlin, Moscow* (2003).

By this time, I was enthralled by Russian art of the early twentieth century. But few Anglo-American scholars were able to study the Russian avant-garde, because materials in Russia were notoriously difficult to access and the language posed a significant barrier. Searching further in the GRI's collections, and spurred on by our extensive holdings of books by Lissitzky, I discovered a treasure trove of handmade Russian futurist books that had come to the Getty in the mid-1980s but had scarcely been looked at. I developed an exhibition around them, which I titled *Tango with Cows: Book Art of the Russian Avant-Garde, 1910–1917* (2008–9). In the course of giving exhibition tours, lecturing, and organizing a sound-poetry evening, I was fascinated and gratified to see that visitors and scholars alike took an intense interest in this unfamiliar material. (The exhibition website, recordings of Russian sound poetry, and a video of "Explodity" [our GRI performance evening] are all available at PennSound—http://writing.upenn.edu/pennsound/x/Explodity.php. Thanks to

Charles Bernstein for making this possible.) My recent exhibition, *World War I: War of Images, Images of War* (2014–15), included patriotic prints from the futurist years by Natalia Goncharova and Kazimir Malevich. Although hitherto relatively unknown, they became exhibition "hits."

The next steps for me were apparent. I needed to master the Russian language well enough to read and interpret *zaum* (transrational) poetry. And I needed to travel to Russia to study as many examples of the futurist books as I could uncover. In 2011, when I visited Moscow and Saint Petersburg, libraries and museums had opened their doors, and scholars like me were granted access to the collections.

In many ways, I see the present book as a coming together of my interest in the relation of modernist music and the visual arts with the specific inflection of those arts in the Russia of the 1910s—the years of war and revolution. Another revolution—digital scholarship—has come to my aid. An online component of this print publication features ten recordings of Russian *zaum* poems performed by Vladimir Paperny. Throughout the text, an icon ◀) indicates poems that can be listened to at www.getty.edu/ZaumPoetry. We have designed the resource to facilitate comparison between the sounds of the Russian poems and their visual expression in the handwritten and illustrated pages of the digitized futurist books.

The artist's book has, of course, been popular for the better part of the twentieth century, and exhibitions of artists' books, whether those of French surrealism or the American 1960s, have been legion. But, as I shall argue here, the artists' books made in Russia between 1910 and 1915—the so-called futurist period—are unique in their fusion of the verbal, visual, and sonic: these are books to be listened to as well as seen and read. And thanks to digitization, they can now reach a large audience.

—*Nancy Perloff*

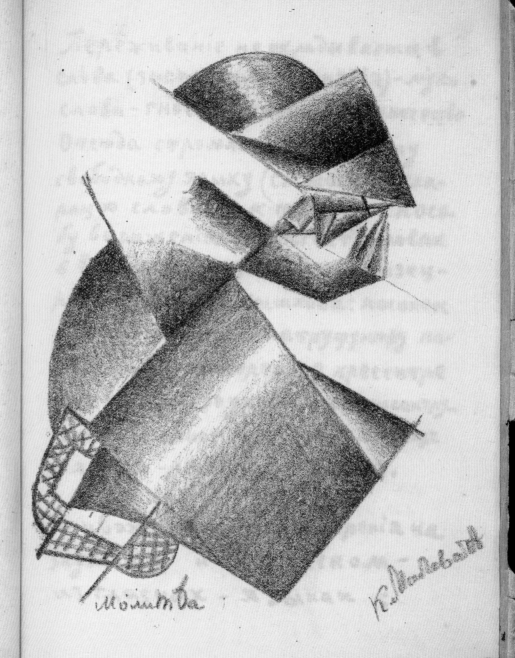

Молитва

К. Малевичъ

We [futurists] have rejected reason because we have birthed another kind, one that might be called trans-sense, *zaum,* in comparison.

—KAZIMIR MALEVICH

Introduction

Nonobjective Painting: Malevich and the West

Russian futurist books are not easy to come by. Produced in small editions ranging in quantity from fifty to several hundred copies and lithographed on rough, scrappy paper with stapled bindings, these diminutive artists' books may not have been intended to survive. Yet some did, and they can be tracked down in disparate collections in both Russia and the West. Spanning the brief period from 1910 to 1915, futurist books had important methods in common. Poets and painters collaborated on a distinctive interplay between "beyonsense," or "transrational," sound poetry (known in Russian as *zaum*) and visual imagery that sometimes hints at narrative but, like the poetry, hovers on the edge of representation. Recurring verbal, visual, and vocal references to the folklike and the primitive, reversibility and mirror forms, the fourth dimension, and apocalypse dominate the artistic expression of these books. Moreover, futurist poets and painters intended their books to be heard as well as read. Predating the cataclysms of World War I and the Russian Revolution, futurist books were considered decadent by the Soviets and were virtually ignored in the West until the 1980s.

In spring 2011, I traveled to Moscow and Saint Petersburg, where the greatest and most extensive collections of Russian futurist books reside in museums and libraries. Having studied the Getty Research Institute's futurist book collection, one of the most significant outside Russia, I was interested in comparing our copies with variant versions at other institutions. In my work on modern European books, I had never encountered the fragility and tactile, handmade beauty

that characterize futurist book art, nor had I witnessed the making of variants. I wanted to know why Russian poets and visual artists introduced modifications, and what that practice revealed about the aesthetic of futurist book art. As I pored over the books in Russia, I discovered that variations were subtle, consisting of a difference in paper quality or texture, a change in the ink color of rubber-stamped poetry, occasional shifts in the order in which poetry and imagery were presented, and alternations between the use of calligraphy and stamping for the transrational poetry. I needed to examine the individual books very closely, indeed page by page, in order to detect these slight variations.

My visit to Russia took place a hundred years after the original production of the Russian futurist books. The world they emerged from was one of tremendous urban growth, but it was also a time in which literacy rates remained low and Russian villages still lacked modern machinery (with the exception of areas such as Ukraine and the south).[1] Modernization in the Russian Empire between the 1890s and 1914 took the form of a doubling of the population; the beginning of a new middle class; the introduction of telephones, motorcars, electric trams, mass media, and advertising; and industrialization, which included a massive program of railroad building. Railroads made it possible for the first time to transport freight and natural resources across the vast distances of the Russian Empire. However, even with an increase in the number of peasants migrating out of the villages, roughly half of Russian land still remained in the hands of a few tens of thousands of noble families.

The reader must bear in mind that Russian futurist book art was the product of a country that differed dramatically from the more developed West. The continued predominance of a peasant population certainly dovetailed with the futurists' interest in handmade books and folklike imagery, as epitomized by the flower collage adorning the cover of the book *Mirskontsa* (1912; Worldbackwards) (see "*Mirskontsa*," fig. 1, p. 87). However, the wild contrasts in the Russian Empire—between, on the one hand, a semiliterate peasantry still tied to the land and beholden to the nobility and, on the other, a burgeoning middle class—set up a very particular context in which the Russian avant-garde worked. Mostly provincials themselves, the Russian futurists witnessed the rapid shift in their country from a rural to an urbanized and industrialized society. Their art thus combined a neoprimitivism rooted in their own past and based on Byzantine art, the icon, and the popular print (*lubok*), with startling innovations in language, sound poetry, and the printed word that were to anticipate the postwar avant-garde of the West.[2]

Although book art is the subject of this study, it is useful to begin by comparing the more familiar medium of painting as it was produced in Russia and the West. We shall see that Russian avant-garde painting before the war conveys the same polarities that characterize the interdisciplinary futurist book. Consider, for example, Kazimir Malevich's *Morning in the Village after a Snowstorm* (fig. 1).[3] A comparison between this work and several landscape paintings by his European contemporaries reveals not only the difference in Malevich's choice of subject matter but also his invention of a new visual language. In this painting, Malevich transforms two peasant women carrying buckets (a theme he painted twice in 1912 and a third time in 1912–13) into colorful, steely trapezoids with conical heads. Their geometric, three-dimensional forms can only partially be distinguished from the surrounding village huts. Chimneys atop pyramid-shaped roofs emit plumes of smoke in the form of interlocking spheres. This language of volumetric planes borrows from cubism, just as the speed of the snow banks swirling in the wind recalls the lines of force and dynamism of Italian futurist paintings.[4]

Malevich's work of the early 1910s is often described as "cubo-futurist." While the experimental techniques of cubism and Italian futurism are clear sources, his choice of subjects—Russian peasant women, a woodcutter, a knife grinder—differs vastly in class, gender, and cultural context from cubist and Italian futurist models.[5] Moreover, Malevich's approach to color and contour takes *Morning in the Village* in radically new directions. For instance, the bright reds and blues on the peasants' roofs are inflected with blacks and grays, as are the snow banks. This dark coloring creates the impression of strong shadows. Whereas the cubists and Italian futurists were not inclined to depict the effects of sunlight or natural light on scenes from nature, Malevich used earth tones on some of the huts and deliberately painted a morning scene (as his title tells us) in which the sun casts strong shadows. Indeed, the visible effects of wind on the icy white snow convey a morning chill.

Curiously, this naturalistic approach, which looks back to paintings such as Claude Monet's *Haystacks* (1890–91), exists concurrently with a mechanization distinctive to Malevich. The enormous tree in the background has a metallic tube for a trunk and stiff, harsh planes for leaves. The peasant figures approaching the tree are monumental and machinelike. Their stiff and heavy torsos, heightened volume and mass, and quixotic asexuality (despite the skirt attire) subvert fin-de-siècle conventions of artistic beauty, especially those of the West.[6] Moreover, Malevich provides no facial features or definitions of limbs, with the result that the two women become interchangeable robotic types. In all of these respects, his women are a far cry from the romanticized

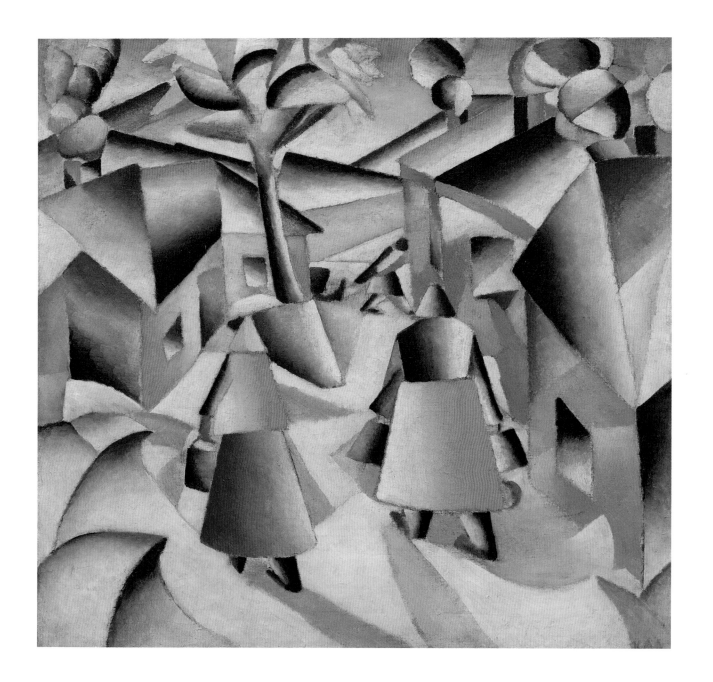

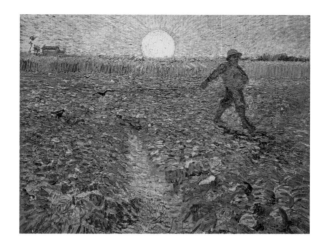

peasants of Vincent van Gogh and the exotic Tahitians of Paul Gauguin. Take into account Van Gogh's placement of his lone, graceful sower in the golden glow of dusk (fig. 2) and Gauguin's attention to the gleaming black hair and mysterious expressions of his Tahitian women (fig. 3).

By contrast, Malevich's peasant women and the figure pulling a sleigh in the background contribute to the painting's oscillation between nonobjectivity and representation, but, ultimately, they become part of an abstract composition. Moreover, Malevich differs from European

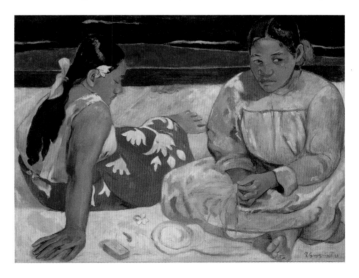

modernists in his application of a childlike, neoprimitive approach to his natural scene through the repetition of forms, such as those that comprise the peasants and the huts, and through a palette consisting of primary reds and blues and some yellows. He combines this approach with a mechanization of peasants and landscape that alludes in part to Italian futurism.

Only a few years earlier, in the summer of 1909, Pablo Picasso visited the town of Horta de Ebro, in his native community of Catalonia, Spain, and painted *Factory at Horta de Ebro* (fig. 4). The contrast with Malevich's *Morning in the Village* reveals the marked difference between each artist's approach to landscape painting, and specifically to scenes of small towns. Consider first, however, the approaches they share in common. Picasso and Malevich depicted a scene that was part of their everyday experience, a scene they witnessed frequently. The structures (and, in Malevich's case, human figures) are broken down into three-dimensional cubic forms to transform this reality. The triangles, trapezoids, and rectangles that produce these forms are highlighted, and windows are shown as dark, blank cavities.

Striking differences can be attributed, however, to Malevich's inclusion of human figures, which, despite their robotic appearance, personalize the scene through their proximity to the village huts. His peasants also reinforce the ordinary subject matter that Malevich chose for his painting. By contrast, with the exception of the phallic factory chimney, Picasso's steely landscape has an impersonal look. Its identifying features do not differ all that much from those of the reservoir at Horta de Ebro, which he also painted in 1909.

In the treatment of light, Malevich explores the effects of the morning sun on newly fallen snow, whereas Picasso provides no clues as to the time of day and omits shadows. His palette is darker and more monochromatic, focused upon grays, blue-grays, mottled browns, and green (for the leaves of the palm trees). While green tones do exist in the mountains around Horta, palm trees do not.[7] Picasso fabricated them, perhaps to give his landscape a more southern look or to infuse an element of fantasy. Malevich did not share the same interest in inventing aspects of a scene. His painting, even in its abstraction, seems to be closer to a vision of what he actually saw.

Especially in the center of his painting, Picasso uses blue-gray to experiment with surfaces hollowed outward and inward. Although this fluid shifting between convex and concave, coupled with the absence of human figures, heightens the abstract nature of Picasso's landscape, *Factory at Horta de Ebro* does not take up the advanced abstraction that pervades *Morning in the Village* (see fig. 3). The clear figure-ground relationship between the factory, palm trees, and sky contrasts with Malevich's dispersal of planar forms across his picture surface. Village huts occupy the

Fig. 4.
Pablo Picasso (Spanish, 1881–1973). *Factory at Horta de Ebro*, 1909, oil on canvas, 53 x 64 cm. Saint Petersburg, The State Hermitage Museum.

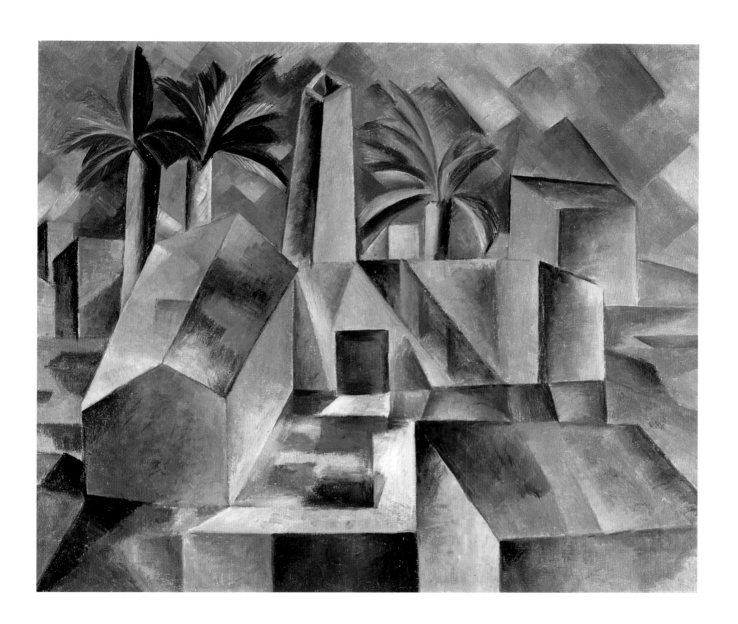

foreground and background, recede into a distant vanishing point, and seem to spill beyond the picture frame. Malevich's painting is about nature (the snow, the sunlight) and the mechanized and manmade; it is at once about a specific moment and a timeless scene of peasant life. This timelessness and the integration of the peasant women into the abstract composition give the painting an otherworldly, spiritual quality. One might ask where the women are heading. Is a hut beckoning them or will they walk past the huts to the tree? The mysteriousness of *Morning in the Village* precludes any realism that would suggest answers to these questions.

Ironically, then, although many think of Picasso as the great innovator of the period and the creator of a new formal vocabulary, Malevich presents the more dramatic rupture with the past. In conveying ordinary folklife by means of the most advanced techniques of abstraction, he achieved what he was later to call the "zero of form"; in other words, the destruction of the "ring of the horizon" and the escape from the "circle of objects."[8] His shifting planes and new concepts of weight, mass, and dynamism of form and color not only incorporate the methods of Russian cubo-futurism but also anticipate his proto-suprematist set and costume designs for the futurist opera *Pobeda nad solntsem* (1913; *Victory over the Sun*).[9] For the "World's First Futurist Opera," which premiered on 3 December 1913 at the Luna Park Theater in Saint Petersburg, Malevich designed a set containing a black square that heralded the end of the horizon ring and the beginning of nonobjectivity, as formally announced in his painting *Black Square*

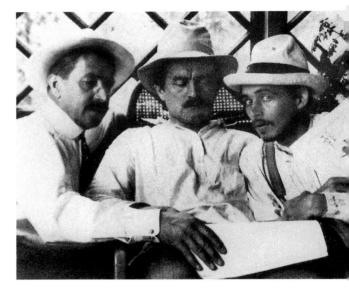

(1915). Each of the opera's collaborating artists—Malevich and his close friends, the poet and playwright Alexei Kruchenykh and the composer and art theoretician Mikhail Matiushin—took up the challenge of what Matiushin called the *razlom;* that is, the act of breaking apart and the breach that is the product of this act (fig. 5).[10] Working in a style similar to that used to depict his monumental peasant figure on the cover of the book *Troe* (1913; The three) (fig. 6), Malevich designed his costumes of colored geometrical planes that convey a sense of mass, volume, and three-dimensionality. According to Kruchenykh's memoir, "The actors recalled machines in motion. The costumes designed by Malevich were built cubistically: from wire and cardboard. This altered human anatomy: the performers moved as if fastened with clamps, and directed by the rhythm of the artist and the director."[11]

Fig. 5.
Mikhail Matiushin, Kazimir Malevich,
and Alexei Kruchenykh, 1913.
Saint Petersburg, State Russian
Museum.

Fig. 6.
Kazimir Malevich (Russian, 1878–1935).
Cover of Elena Guro, Velimir Khleb-
nikov, and Alexei Kruchenykh, *Troe*
(The three) (Saint Petersburg, 1913).
Los Angeles, Getty Research Institute,
88-B29825.

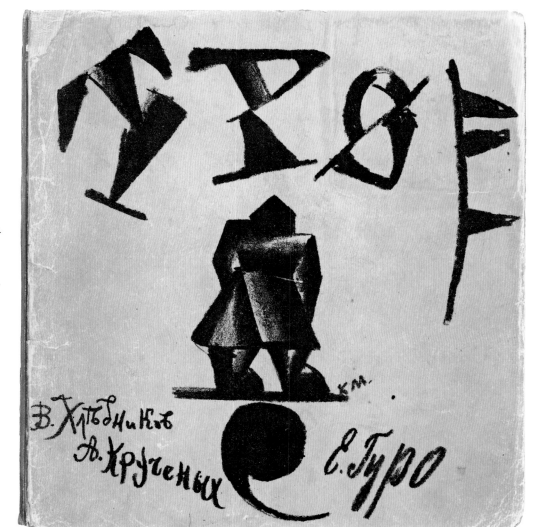

Kruchenykh's *zaum* libretto contains neologisms, nonsensical words, and linguistic structures that undermine the rules of grammar and logic. In parallel fashion, Matiushin discarded a traditional, diatonic musical language and experimented instead with dissonance, quarter tones, and even sound-color correspondence in his musical score. The costumes, libretto, and score thus expedite the *razlom* that is enacted in the opera's minimalist plot as the overthrow of the sun by two futurist Strongmen. Act 1 centers around the capture of the sun, while act 2 focuses on the establishment of a future world, or "Tenth Land." According to Malevich and Matiushin's explanation in an interview on 1 December 1913, the Strongmen capture the sun by transforming the world into chaos, smashing established values into fragments, creating new values out of those fragments, and discovering unexpected and unseen connections.[12] The resistance to the mimetic tradition of Western art and the denotative conventions in literature mark the daring enterprise of the Russian futurists.

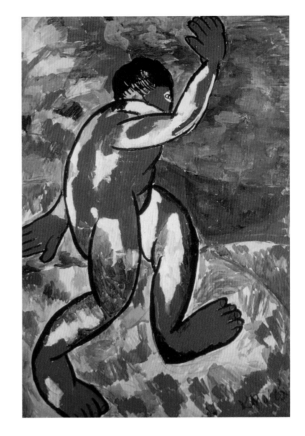

Malevich's costume designs for the all-male cast of *Pobeda nad solntsem* were more overtly masculine than his androgynous peasant figure on the cover of *Troe*—of whom we may see a front or a back—or his peasant women in *Morning in the Village*. The treatment of gender represents another central difference between Malevich and Picasso. In his early masterpiece *Les demoiselles d'Avignon* (1907; The ladies of Avignon), for instance, we see Picasso's invention of a proto-cubist language, which, when combined with Iberian masks and the disproportions of Iberian art, caused a breakthrough in Western painting.[13] In contrast to Malevich, Picasso exploits the satiric and grotesque aspects of his brothel scene and uses a sexually charged visual vocabulary to highlight the phallic forms of fruit in the foreground and the staring nude women in the middle ground, one with her legs wide apart, toward whom the fruit points. Malevich painted few nudes, and the rare times he did, he made almost no reference to sexuality. The movements of his *Bather,* for instance, conceal breasts and genitalia so that the sex remains uncertain (fig. 7). The figure is potentially very large, extending beyond the upper and lower edges of the canvas and displaying oversize hands and feet, which resemble the webbed feet of animals and give it a neoprimitive stance. It strides alone vigorously and in

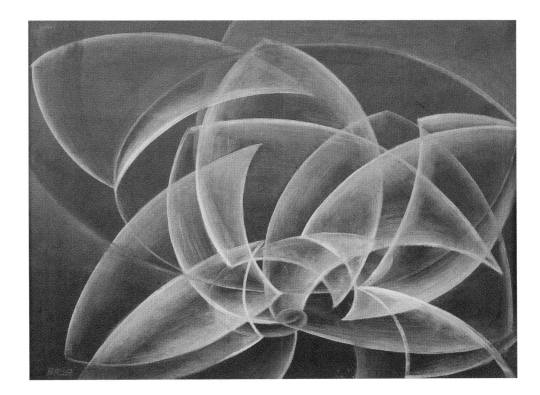

stylized fashion through an abstract landscape colored in a palette reminiscent of Paul Cézanne. The monumental, otherworldly, even imaginary dimension of this work and much of Malevich's art sets him apart not only from Picasso but also from Van Gogh and Gauguin.

About two years after Malevich painted *Morning in the Village,* the Italian futurist Giacomo Balla produced abstract studies of forms in motion, which he called *Vortice* (Vortexes). In the painting *Vortex, Space, Form* (1914) (fig. 8), Balla departs from the referentiality of his earlier *Street Lamp* (1910–11), in which a luminescent electric lightbulb outshines the sliver of a moon. In *Vortex,* Balla limits his palette to shades of orange and metallic gray-blue and evokes speed through spinning and overlapping blades that radiate from an orange vortex. Light illuminates the blades closest to the vortex but does not cast shadows as it would if emanating from a natural source. Rather, Balla thrusts the viewer inside, or just outside, of his fulcrum and avoids a figure-ground relationship.

The accent on metallic sheen and mechanical motion certainly connects Balla's painting to Malevich's *Morning in the Village* and later suprematist paintings, as does its nonobjectivity. However, two fundamental attributes—the primitive and the naturalistic—are missing. Indeed, modernist tensions such as the naturalistic versus the mechanized, the childlike versus the abstract, and the earthly versus the otherworldly, which are so profound and palpable in Malevich's work, seem to play no role in Balla's work. Malevich was well aware of the gulf separating Italian from Russian futurism. Having praised the "new painterly attitude" that characterized the impressionists, Cézannists, cubists, and futurists, Malevich writes of Italian futurism: "Futurism as a worldview was expressed in dynamism and its philosophy regarded the entire world and all human behavior only dynamically. We considered [Italian] Futurism an urban art that lived among the big industrial cities. Futurism was unthinkable in a remote village. The natural environment for a Futurist was metallic, dynamic soil."[14] He continues, "The content of Futurism was the steel-electro-motor world. The appearance of a guitar, moon, or redhead was unimaginable; it was smokestacks and spring bridges like devil's leaps over the steely surface of the water. None of that was expressed in Russian Futurism." He also contrasts the Russian futurists' love of nature ("the objectless truth lies in nature itself") with the Italians' entire focus on "dynamic force."[15]

Modernisms East and West

How, then, is the contrast I have been charting between the "Eastern" Malevich, on the one hand, and the "Western" Picasso, Balla, Gauguin, and Van Gogh, on the other, conveyed and echoed in writings by these artists? Let's begin again with Malevich, whose Polish family moved among different Ukrainian villages when he was growing up. In his "Chapters from an Artist's Autobiography," Malevich describes his response to Russian icons, which he saw on his first trip to Moscow in 1904, when he was twenty-five:

> I sensed something familiar and marvelous in them. I saw the Russian people with all their emotional creativity. That's when I recalled my childhood: the horses, flowers, and roosters of primitive ornamentation and wood carving. I discerned a connection between peasant art and icons: icon painting is a form of the highest culture of peasant art. I discovered the spiritual side of "peasant time," I came to understand the peasantry through the icon, understood that their faces are not those of saints but of simple people.[16]

The sentiments of this passage reveal the significance for Malevich of growing up on a sugar-beet plantation outside Kiev, imitating peasant life by rubbing garlic on a crust of bread and running around barefoot, and emulating the peasants' painting. He associates peasants not only with icon painting but also with the beauty of nature on the plantations where they worked, recalling that "the beet plantations extended infinitely, blending into the far horizon, settling into low valleys or rising into hills, embracing villages and hamlets in its green fields....So it was amid these villages, which were located in beautiful nature spots and formed a lovely landscape element, that my childhood passed."[17] Before his visit to Moscow, Malevich had made no distinction between pictures painted by peasants and art taught at art schools. Even after his visit, he "remained on the side of peasant art and started painting in a primitive spirit."[18]

Around the same time, the Russian futurist painter Natalia Goncharova and her partner, Mikhail Larionov—both of whom were born in the provinces of the Russian Empire, Goncharova outside of Moscow and Larionov near Odessa, Ukraine—collected broadsheets, popular prints known in Russia as *lubki* (from *lubok*), and ancient stone statuettes called *kamennye baby,* in order to promote and contextualize their own art as non-Western and "national."[19] Because the two major Russian collectors Ivan Morozov and Sergei Shchukin went directly to Paris to acquire French paintings and collected no modern Russian work, Goncharova and Larionov assumed responsibility for making their work known by aligning it with prehistoric artifacts. In her 1913 essay "The Hindu and Persian Broadsheet," Goncharova contrasts the "greater civilization" of the West with the "greater cultural depth of the spirit and proximity to nature" of the East, a description with which Malevich might have concurred.[20] For Goncharova, as for Malevich, the primitive statuettes had been discovered right in her backyard—that is, on the central steppes of the Russian Empire.[21]

The worlds of Goncharova, Larionov, and Malevich present a telling contrast with those of the Western avant-garde. The French artist Paul Gauguin, for example, who worked as a stockbroker and businessman in Paris before abandoning his business career in 1886 and his European home in 1891, did not turn to a domestic, primitive tradition as a model. Instead, as is well known, he chose Tahiti, in French Polynesia, so as to get as far away from French civilization as possible. In an 1895 letter to August Strindberg, he remarks on the "clash between your civilization and my barbarism....A civilization from which you are suffering; a barbarism which spells rejuvenation for me."[22]

Malevich and his circle did not pursue a parallel course by cloaking Russia in a negative light, as a tainted country to leave behind. Moreover, Malevich saw no contradiction between

his attraction to peasant life and his desire to work in the city of Moscow. Gauguin, by contrast, described the "eternally summer sky" and "marvelously fertile soil" of Tahiti—and the fact that Tahitians "never worked"—as exotic features of a new and different primitive past that distanced him from the corruption of present-day European urban culture.[23] Although his Tahitian paintings are in fact steeped in the French colonialism and decadence of his time, Gauguin argued that by living in Tahiti, he could escape French civilization and recover a primal past that had been lost. His paintings of Tahitian women reveal his particular paternalistic perspective on the primitive other (see fig. 3).[24]

The Dutch artist Vincent van Gogh, who spent his early adulthood working for a firm of art dealers, shared Gauguin's desire to create paintings that "give the impression of a way of life quite different from that of us civilized people."[25] Distasteful of a corrupt Europe, Van Gogh found his model closer to home, in images of the French peasant, whom he romanticized. Of his masterpiece *The Potato Eaters* (1885), he observed that "those people, eating their potatoes in the lamplight, have dug the earth with those very hands they put in the dish, and so it speaks of *manual labor,* and how they have honestly earned their food." Like Gauguin, and Cézanne before him, Van Gogh chose to leave Paris and set up a studio and refuge in the South of France, where true colorists could work. He criticized Parisians for their lack of a "palate for crude things" and inquired rhetorically, "Why did the greatest colorist of all, Eugène Delacroix, think it essential to go South and right to Africa?" Van Gogh shared with Gauguin the search for a primitive other, far away from the city and enticing in its exoticism. Several decades later, Pablo Picasso would paint his *Les demoiselles d'Avignon,* parts of which he modeled on Iberian masks. The critique by French artists of their own culture and their fascination with the primitive other continued to dominate their imagination.

Searching the past for nationalist models thus took very different forms in Russian and French modern art. For Malevich, Russian icons overturned his "desire for nature and for sciences—anatomy, perspective.... The icon painters conveyed content in anti-anatomical truth, outside the perspective of space and line. Color and form were created on a purely emotional perception of the theme."[26] In drawing a line between icon painting and peasant art, Malevich emphasized their "emotional art" as well as their spirituality. The primitivist Gauguin, whose paintings and Tahitian essays were known and available to the Russian public, leaned more toward the secular.[27] His reference to the "bare and primordial" languages of Oceania puts forth a claim that he could recapture an ancient and simple worldview in Tahitian culture.[28] We might call this a past, but we must recognize that it was fabricated and bore little relation to his own country's

medieval art or the Dark Ages. Whereas the French escaped to the countryside and to islands in the South Pacific, Malevich and his futurist colleagues left rural culture for the big cities of Moscow and Saint Petersburg. There, they continued to experiment with the traditional genres of the *lubok* and the icon, even as, ironically, theirs was to be a modernism more revolutionary than that of the postimpressionists.

The Italian futurists—and the founder of their movement, the poet Filippo Tommaso Marinetti—developed an aesthetic very different from the Russians and the French, as we have already seen in Balla's *Vortice*. Marinetti believed that deep changes in technology and science and in concepts of time and space demanded a rejection of the past and those institutions that valued it, including museums, libraries, and academies. Glorifying war as "the world's only hygiene" and advocating speed, urbanism, and violence as the new basis for the arts, Marinetti invented the futurist literary genre of the *parole-in-libertà* (words-in-freedom). Here, he abandoned grammatical relationships between words; abolished adjectives, adverbs, and conjunctions; and explored a free typography that evokes sound, color, and motion. Marinetti's wartime *parole* "In the Evening, Lying in Her Bed, She Rereads the Letter from Her Artilleryman at the Front" (1917) is, despite the realism of its title, a predominantly abstract visual poem (fig. 9). Inspired by the speed of technology, and especially the whirling propeller of the airplane, Marinetti invented utterly novel typography that "treats words [and abstract visual shapes] like torpedoes and hurls them forth at all speeds: at the velocity of stars, clouds, aeroplanes, trains, waves, explosives, molecules, atoms."[29] Onomatopoeic words—the explosive "SCRABrrRrraaNNG" and "GRAAAAC TRAC," the distant "tumb-tumb-tumb-tumb" of the artillery shells—participate in a cacophony of simultaneous sounds amidst a patriotic call for "War to the Germanophiles!"

Yet as futuristic and abstract as Marinetti's words-in-freedom and Balla's *Vortice* are, they lack the polarities so deeply felt in Malevich between the naturalistic and mechanized, primitive and abstract worlds. Moreover, while the highlighting of the verbal-visual-vocal in Italian manifestos and *parole* certainly provided an initial model for the Russian futurists, referentiality ("explosion," "simultaneity") and the expression of a "steel-electro-motor world" in the Italian work offer a marked difference from the non-narrative interplay of word-image-sound in Russian futurist book art, as I will explain. Moreover, the spiritual, otherworldly "fourth dimension" (the hint of a realm beyond the work of art) in the work of Malevich and his associates does not insert itself in the art of the Italian futurists. Rather, they remained fully engaged in the culture and technology of their modern world.

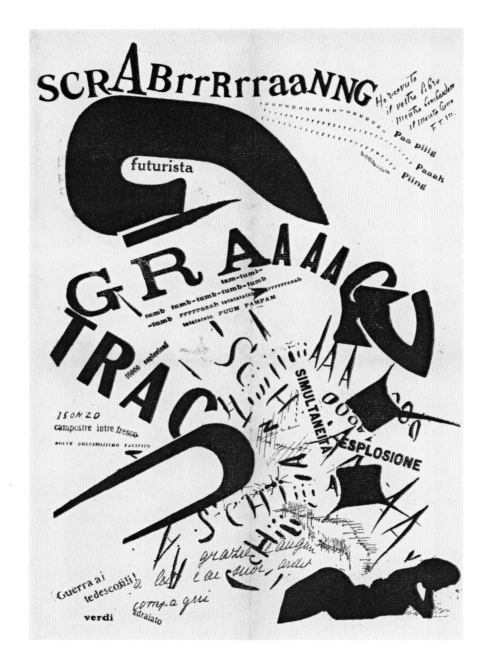

Fig. 9.
Filippo Tommaso Marinetti
(Italian, 1876–1944).
"In the Evening, Lying in Her Bed,
She Rereads the Letter from
Her Artilleryman at the Front."
From Les mots en liberté futuristes
(Milan: Edizioni futuriste di "Poesia,"
1919), 105–6.
Los Angeles, Getty Research Institute,
87-B6595.

Fig. 10.
Roman Jakobson, age 23, 1920.
Cambridge, Massachusetts Institute
of Technology, Institute Archives and
Special Collections, Roman Jakobson
Papers, MC. 0072, box 135.

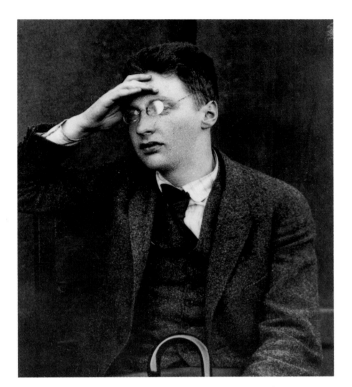

Malevich, Jakobson, and the Stray Dog Cabaret

How did Malevich understand so early on that abstraction, or at least extreme stylization, was to be the hallmark of his avant-garde cenacle? How did this set of "backward" provincials become the real radicals of the prewar years in Europe? In his "Memoir: A Futurian of Science," published in *My Futurist Years*, the formalist critic Roman Jakobson writes in detail about his encounters and conversations with artistic contemporaries in Moscow and Saint Petersburg, Malevich among them.[30] In these early days of his career, Jakobson was drawn equally to poetry and to the visual arts (fig. 10). He describes attending futurist evenings that were crowded public gatherings in the large hall of the Polytechnical Museum in Moscow. "This was a time when readers gravitated almost exclusively towards poetry," he writes, "…towards the new word," as opposed to the stories and novels of Alexei Remizov or Maxim Gorky.[31]

Jakobson recalls meeting Vladimir Mayakovsky for the first time in 1911, when he was still much closer to artistic circles and especially interested in the impressionist and postimpressionist painters (Cézanne, Gauguin, and Van Gogh), whose work he saw at the Tretiakov Gallery. He considered it important to state his proximity to the visual arts, although as a student of language, he understood poetry best.[32] Acquaintances such as Mayakovsky, David Burliuk, Velimir Khlebnikov, and Alexei Kruchenykh began their training in the visual arts and were immersed in collaborations among poets and painters when Jakobson entered this world. Of Mayakovsky, the literary theorist Viktor Shklovsky writes, "His father was a forester in a far province. His two sisters worked in a factory. And he painted paintings. He liked the Impressionists."[33]

Jakobson joined private gatherings of poets and actors at the Stray Dog cabaret in Saint Petersburg, a venue that first opened its doors on New Year's Eve 1912. The founder and proprietor, Boris Pronin, who had studied at Konstantin Stanislavsky's Moscow Art Theater school, housed his cabaret in the wine cellar of the former Dashkov mansion and conceived of it as a cultural spawning ground. Pronin commissioned his artist-friend Sergei Sudeikin to paint the walls and ceiling with fantastical birds and flowers inspired by Charles Baudelaire's *Les fleurs du*

mal (1857; The flowers of evil), and he brought in as cofounder the composer Mikhail Kuzmin. The programs at the Stray Dog, which did not begin before midnight, featured musical performances, poetry readings, debates, and staged performances. Although the clientele consisted principally of poets, the Stray Dog served as a meeting place for artistic bohemia, namely the postsymbolist crowd of acmeists and futurists.[34] According to Shklovsky, "By nighttime [the Stray Dog] would fill up with actors, writers, and other regulars. All the non-artists were called 'pharmacists.' The philistines were treated with contempt."[35] Jakobson describes the cabaret as "quite crowded. The walls and the people pressed all around."[36] The futurist poet Vasily Kamensky writes, "The Stray Dog was the favorite corner—tavern—theater—monster of Poets, Artists, Composers, Actors."[37]

Leading Russian poets made their first appearances at the Stray Dog. Anna Akhmatova "read poetry in a calm voice"; Osip Mandelstam "howled"; and Khlebnikov, who read his poem "Kuznechik" (1908–1909; The grasshopper), "had the softest voice of all. He would almost only move his lips."[38] These observations by Shklovsky are followed by hints about significant changes in the role of painting and the visual at the Stray Dog: "But people moved in painting. Paintings hung crookedly on the walls. The figure in [Marc] Chagall's painting had climbed out onto the roof.… Everything was so bizarre in the paintings of Goncharova and Larionov that it seemed the room was supposed to be filled with noise. Painting was falling to pieces. The surfaces of paintings stood out in goose bumps. The world was cold."

It was Jakobson who, with Malevich, explored and theorized the relationship between the verbal, vocal, and visual. From the vantage of 1977, when Bengt Jangfeldt tape-recorded his conversations with Jakobson, the critic remembers the years 1912–13 and 1913–14 as a pivotal time of "interdisciplinary cooperation."[39] Using language more similar to that of the period, he describes the "extremely close tie between poetry and the visual arts." As an author of transrational verse (under the pseudonym Aliagrov), Jakobson moves freely in his memoir between poetry and linguistics, painting and the visual arts. He came to admire Malevich when he learned about the artist's gradual departure from representational to abstract painting. The two first met in 1913 in Moscow, when the young Jakobson was deeply engaged in theories of verbal and visual abstraction. He attended futurist performances in Moscow, listened to poetry readings at the Stray Dog cabaret in Saint Petersburg, and articulated his impressions about language and phonology in a spate of declarations and manifestos.

In "Chapters from an Artist's Autobiography," Malevich establishes an analogy between nonobjective painting and the futurist theory of the "word as such." According to this poetic theory, which I discuss at greater length in this volume's chapter titled "Sounding the Accidental ('Death to Symbolism')," the word takes on a new role as a self-referential, material, phonic, and abstract form. Malevich writes that sometime after the Revolution of 1905, when he had returned to Kursk,[40] he determined that "painting in general consists of two parts. One part is pure, the act of pure painterly form as such, the other part consists of subject matter, what is called content.... Reality for me became not that phenomenon that must be conveyed with precision, but a purely painterly phenomenon.... I was utterly against making painting a means, it had to be an end in itself."[41]

For Malevich and Jakobson, this "pure painterly form" corresponded to the "emancipated verbal sound" in poetry.[42] Malevich published letters in *The Yearbook of the Pushkin House* based on his earliest conversations with Jakobson, in which he praised the young poets Khlebnikov and Kruchenykh. In a letter of June 1916 to his close friend Matiushin, Malevich alludes to the revolution of transrational poetry, arguing that "the new poets waged a battle with thought, which enslaved the free letter, and tried to bring the letter closer to the idea of sound (not music); from this came mad or *zaum* poetry."[43]

Intriguingly, such comments indicate that the "new painterly realism" at the core of Malevich's conception of suprematism found its verbal and vocal analogy in *zaum* (the neologism built from the preposition *za* [beyond] and the noun *um* [the mind]), and, specifically, in a rejection of the "sense and logic of the old reason," in favor of the "sense and logic of the already newly emerged reason, the 'trans-sense' (*zaumnyi*) reason."[44] Malevich, in concurrence with Jakobson, singles out and praises Kruchenykh for treating the letter as a sound and for extending the length of the sound by accumulating letters that do not necessarily cohere to form words. He takes issue with the futurists' use of words, declaring, "If a word is made up of a few letters, it ceases to be a word.... Then there are no words, there are the sounds."[45] Malevich aligns himself with Kruchenykh and criticizes the other futurist poets, whose "word as such" fail, in his opinion, to encompass a poetry of letters and sounds.

In a remarkable letter to Matiushin that carves out a history of sound and recommends that poets arrive at "note-letters" expressing "sound masses" rather than words, Malevich argues from a painter's perspective that must have inspired the young and impressionable Jakobson. Recommending that the new poets "take a stand on the side of sound (not music)," Malevich writes:

First there were no letters, there was only sound. This or that thing was indicated by sound. Later, sound was separated into individual sounds and these divisions were depicted by signs. After that, it was possible to express for others one's thoughts and descriptions.

The new poet is a kind of return to sound (but not paganism). From sound came the word— now from the word has come sound. This return is not a going backwards, here the poet abandoned all words and their assignation. But from it he took sound as a poetic element.

And the letter is no longer a sign for expressing things, but a note of sound (though not musical)…

Having arrived at the idea of sound—we got note-letters, which express sound masses, and it is in the composition of these sound masses (what used to be words) that a new road will be found.…Thus we come to the third condition, that is, the distribution of letter and sound masses in space, which resembles painterly Suprematism.[46]

A summary by Jakobson of this verbal-vocal-visual line of thought underscores their shared aesthetic and the importance each placed on sound:

The theme was that the verbal sound could have more in common with nonrepresenta-tional painting than with music. This topic vividly interested me both then and much later: the question of the relation of word and sound, the extent to which the sound retains its kinship with the word, and the extent to which the word breaks down for us into sounds— and further, the question of the relation between poetic sounds and the notation for those sounds, that is, letters.[47]

Here, Jakobson anticipates the futurist principle that because sound and meaning cannot be separated, the phonic dimension of speech deserves much closer inspection than it usually receives. He incorporates the visual component through his reference to nonobjective painting, thus encapsulating the word-image-sound interplay and the collaboration of poets and paint-ers that characterized Russian futurist book art. Among Russian avant-garde painters, Malevich was perhaps closest to Jakobson in those early years. Jakobson's friendships with Khlebnikov,

Kruchenykh, and Vladimir Mayakovsky indicate that he bridged the worlds of poetry and painting and may have inspired others to do the same.

As a linguist, moreover, Jakobson played another significant, but less noted, role. He spoke fluent French and could therefore serve as an interpreter for some of his futurist friends. Whereas an acmeist poet such as Anna Akhmatova spoke multiple languages and even produced translations of Armenian, French, Italian, and Korean poetry, several futurist poets and painters did not speak a word of any foreign language.[48] The poet Benedikt Livshits refers to this deficiency in his account of the train ride he and the futurist painter David Burliuk took in 1911 to Chernianka, near the Black Sea: "We began to talk about poetry. Burliuk was totally unfamiliar with French poetry. He had vaguely heard of Baudelaire, [Paul] Verlaine and maybe [Stéphane] Mallarmé."[49] Livshits proceeds to read his favorite pieces from Arthur Rimbaud, acknowledging that few people at the time read Rimbaud in the original French: "Of the Russian poets only [Innokenty] Annensky, [Valerii] Briusov and myself had translated him."

According to Jakobson's recollections, when he met with Malevich in the summer of 1913, the painter disclosed the creation of his new nonobjective paintings and proposed traveling to Paris with his linguist friend to organize exhibitions in collaboration with lectures by Jakobson. "Partly he made this proposition," observes Jakobson, "because he didn't speak French."[50] While Nikolai Kulbin, Elena Guro, Natalia Goncharova, and Olga Rozanova spoke fluent French, Mayakovsky spoke only Russian and therefore struggled during his overseas trips to France, Germany, and the United States: "He was irritated beyond measure by his lack of language skills. He, a poetic genius, a pyrotechnic display of witticisms, word games, and brilliant rhymes in his mother tongue, was sentenced to total dumbness abroad!"[51]

Why the difference in language fluency between some of the futurists and their Russian contemporaries, Akhmatova, Nikolai Gumilev, and Mandelstam? The likely reason was social class. The acmeists—like the previous generation of Russian artists and writers, including Fyodor Dostoevsky, Alexander Pushkin, and Leo Tolstoy—descended from the nobility or the wealthy merchant class of the big cities, where knowledge of French was de rigueur, as we know from Ivan Turgenev's and Tolstoy's novels. The Russian futurists, by contrast, came from the middle or lower classes and from the provinces. Hoping to educate potential rural audiences, David Burliuk and Mayakovsky teamed up for a recitation and lecture tour of Russian provincial towns that lasted from mid-December 1913 to the end of March 1914.[52]

Jakobson took great pride in the Russian futurist manifesto *Poshchechina obshchestven-nomu vkusu* (1912; A slap in the face of public taste), which dismissed the nineteenth-century past with the words "Toss Pushkin, Dostoevsky, Tolstoy, and so on, and so on, from the steamship of modernity."[53] Such an imperative would not have been uttered by the French avant-garde, who had a long, continuous tradition of art and literature and therefore looked back to the painter Jacques-Louis David, neoclassicism, the French Revolution, and the Enlightenment; the classic nineteenth-century artists Eugène Delacroix and Jean-Auguste-Dominique Ingres; and the writers Rimbaud and Baudelaire. In a letter to his brother Theo in about August 1888, Van Gogh writes: "I should not be surprised if the impressionists soon find fault with my way of working, for it has been fertilized by Delacroix's ideas rather than by theirs. Because instead of trying to reproduce exactly what I see before my eyes, I use color more arbitrarily, in order to express myself forcibly."[54]

In rejecting Dostoevsky, Pushkin, and Tolstoy and embracing archaic Russian forms, the Russian futurists skipped over several previous centuries for which they lacked a continuous tradition in order to retrieve the folk and religious motifs of their own country.

Transcending *Byt*

Jakobson's essay "On a Generation That Squandered Its Poets" (1931) is a critique of Mayakovsky and the futurist generation, and it calls attention to the differences between Russian and Western values. The Russian word *byt*—defined by Jakobson as "the stabilizing force of an immutable present, overlaid, as this present is, by a stagnating slime, which stifles life in its tight, hard mold"—has no comparable word in any western European languages.[55] It was *byt* that prompted the futurists to develop counteracting forces, also distinctively Russian, such as a belief in the resurrection of the dead, victory over death, and immortality. Mayakovsky and Khlebnikov accurately foretold the date of the Russian Revolution. In parallel terms, the life story of Mayakovsky, who serves as the principal character in his volumes of verse, "has been set forth ahead of time right down to the details of the denouement," which is his suicide. Never before, observes Jakobson, has the writer's fate been laid bare with such pitiless candor in his own words. Jakobson's critique of Mayakovsky makes a case for why the futurist project, while revolutionary, was so short-lived: "We strained toward the future too impetuously and avidly to leave any past behind us. The connection of one period with another was broken. We lived too much for the future, thought about

it, believed in it; the news of the day—sufficient unto itself—no longer existed for us. We lost a sense of the present."

Yet I would argue that the values used to counteract *byt* encompassed the past as well as the future, perhaps not for Mayakovsky, but for his futurist colleagues. As we will see in the next chapter, futurist poets ascribed a nonlinear aesthetic to their book art. This move challenged the forward march of time by making room instead for reversibility (a stepping backward in time) and, with it, nonsignification. Certainly, the allure of the primitive, the folk, the *lubok* becomes clearer when we understand that a book like *Mirskontsa* had associations with Russian icons, children's rubber-stamping, and mirror techniques applied to word and image.

The unique circumstances of the Russian futurists also stem from the social conditions of their country. Literacy rates in Russia were astonishingly low at the time Malevich painted *Morning in the Village*. In 1914, only 40 percent of the population was literate. By contrast, in France, Germany, and northern Europe, literacy was nearly universal by the 1890s. In Russia, moreover, it was the village, still largely unmodernized, that made the country primitive by European standards; indeed, it was a "sea of backward agriculture dotted with larger or smaller islands of modern industry and society."[56] The fact that Russian futurists were born in these ancient villages before moving to the modern cities contributed to the strange collocation of primitive motifs and advanced abstraction that distinguished their painting and especially their book art. My first chapter addresses the lives of the poets and painters who came from the provinces to collaborate on *Mirskontsa*, one of the extraordinary episodes in futurist bookmaking.

As I move into this historical chapter, then follow it with an analysis of the futurist aesthetic and close readings of both the aesthetic and the verbal-vocal-visual in several key futurist books, it is important to keep in mind that the Russian avant-garde you will learn about differed markedly from Western models. Certainly, the Russian futurists shared with the Italians an interest in abstraction and in future languages. Yet the push and pull between past and future, the radical disruption of linearity, the elevation of sound as signifier, the entrance of the fourth dimension—all constitute Russian inventions startling in their departure from Western sources and prescient of a postwar avant-garde to come.

Notes

For the epigraph in this chapter, see the letter from Kazimir Malevich to Mikhail Matiushin, June 1913, Kuntsevo, in Irina A. Vakar and Tatiana N. Mikhienko, eds., *Kazimir Malevich: Letters, Documents, Memoirs, Criticism*, trans. Antonina W. Bouis, 2 vols. (London: Tate, 2015), 1:51.

This Getty volume follows the modified Library of Congress transliteration system, which is used by major libraries in the United States and the United Kingdom.

1. The historical information in this paragraph is drawn from Paul Bush-kovitch, *A Concise History of Russia* (New York: Cambridge University Press, 2012), 209, 212, 214, 217–19, 221.

2. For definitions of *neoprimitivism*, see manifestos by Alexander Shevchenko and Natalia Goncharova, which argue that the East is the source of all culture and that Russian artists should aspire toward nationality (i.e., their own country's artistic forms) and the forms of the East. Alexander Shevchenko, "Neoprimitivism: Its Theory, Its Potentials, Its Achievements" (1913) and Natalia Goncharova, "Preface to Catalogue of One-Man Exhibition" (1913), in John E. Bowlt, ed., *Russian Art of the Avant-Garde: Theory and Criticism* (New York: Thames & Hudson, 1988), 44–60.

3. This painting, as well as *Woman with Buckets* (1912–13) and *Knife Grinder* (1912–13), were exhibited at the *Target* exhibition, which opened on 24 March 1913 in Moscow. See Vakar and Mikhienko, *Kazimir Malevich*, 1:47.

4. See, for example, Giacomo Balla's *Swifts: Paths of Movement + Dynamic Sequences* (1913) and Umberto Boccioni's *Dynamism of a Cyclist* (1913).

5. Eugene Ostashevsky, ed., and introduction, *Victory over the Sun: The First Futurist Opera by Aleksei Kruchenykh*, trans. Larissa Shmailo (W. Somerville, MA: Červaná Barva, 2014), n.p.

6. Eugene Ostashevsky, "Introduction," in idem, *Victory over the Sun*, n.p.

7. Pierre Daix, *Picasso: The Cubist Years, 1907–1916; A Catalogue Raisonné of the Paintings and Related Works*, compiled by Pierre Daix and Joan Rosselet (London: Thames & Hudson, 1979), 66.

8. Kazimir Malevich's manifesto, *From Cubism and Futurism to Suprematism: The New Painterly Realism* (1915), is reprinted in Bowlt, *Russian Art*, 118.

9. Eugene Ostashevsky quotes the composer and art theoretician Mikhail Matiushin's description of the tendencies of contemporary art brought together in *Pobeda nad solntsem*. See Ostashevsky, "Introduction," n.p.

10. Ostashevsky, "Introduction," n.p. For excellent biographical information on Kruchenykh and Matiushin, including their relationships to Malevich, see Vakar and Mikhienko, *Kazimir Malevich*, 1:47, 77.

11. *Troe* was an almanac of writings by the poets Elena Guro, Khlebnikov, and Kruchenykh, and published in Guro's memory at the same June 1913 retreat in which Malevich, Matiushin, and Kruchenykh conceived of *Pobeda nad solntsem*. For Kruchenykh's recollections, see Alexei Kruchenykh, *Our Arrival: From the History of Russian Futurism* (Moscow: RA, 1995), 67. For a finer translation, which I quote, see Ostashevsky, "Introduction," n.p.

12. Christina Lodder, "Kazimir Malevich and the Designs for *Victory over the Sun*," in *The World's First Futurist Opera: Victory over the Sun*, ed. Rosamund Bartlett and Sarah Dadswell (Exeter, UK: University of Exeter Press, 2012), 178.

13. Daix, *Picasso*, 14.

14. Malevich, Kazimir Malevich, "Chapters from an Artist's Autobiography," in *Kazimir Malevich: Letters, Documents, Memoirs, Criticism*, 2 vols., ed. Irina A. Vakar and Tatiana N. Mikhienko, trans. Antonina W. Bouis (London: Tate, 2015), 1:36–38.

15. Malevich, "Chapters," 1:38.

16. Malevich, "Chapters," 1:27. This new translation supersedes that of Alan Upchurch in "Malevich: Chapters from an Autobiography," *October* 34 (Fall 1985): 37–38.

17. For this quotation and the following one, see Malevich, "Chapters," 1:17.

18. In another passage from his "Chapters," Malevich describes how the sunshine called the peasants quietly to work and later "called them to sleep, hiding its rays behind the earth's globe.…I also liked the moon, I always thought it was arguing with the sun, making the night very beautiful, better than lamps and candles did." For this and other quotations, see Malevich, "Chapters," 1:17, 18, 20, 28.

19. Malevich describes his membership in an artistic group of "Eastern" orientation comprising Goncharova and Larionov as its core. Together they traced icon painting back to Byzantium and to the spirit of antiquity. See Malevich, "Chapters," 1:33–34.

20. Jane Ashton Sharp, *Russian Modernism between East and West: Natal'ia Goncharova and the Moscow Avant-Garde* (New York: Cambridge University Press, 2006), 159, 273. Translations from the Russian are by Sharp.

21. The *kamennye baby* span the period from the Scythian era (seventh through third centuries BCE) to the thirteenth and fourteenth centuries CE. See Sharp, *Russian Modernism*, 159.

22. Paul Gauguin, *Letters to His Wife and Friends*, ed. Maurice Malingue, trans. Henry J. Stenning (Cleveland: World, 1949), no. 154, to August Strindberg.

23. Paul Gauguin, letter to J. F. Wilumsen, Pont-Aven, autumn 1890, in Herschel B. Chipp, *Theories of Modern Art: A Source Book by Artists and Critics* (Berkeley: University of California Press, 1968), 79.

24. For more information on the intricate motivations behind Gauguin's Tahitian sojourn, see Nancy Perloff, "Gauguin's French Baggage: Decadence and Colonialism in Tahiti," in *Prehistories of the Future: The Primitivist Project and the Culture of Modernism*, ed. Elazar Barkan and Ronald Bush (Stanford, CA: Stanford University Press, 1995), 226–37.

25. For this quote and the following quotes by Van Gogh in this paragraph, see Chipp, *Theories of Modern Art*, 29 ("The Potato Eaters"), 34 ("Expressive Color"), 37 ("Color of the South").

26. Malevich, "Chapters," 1:28.

27. Ilia Dorontchenkov, ed., *Russian and Soviet Views of Modern Western Art: 1890s to Mid-1930s*, trans. Charles Rougle (Berkeley: University of California Press, 2009), 6n14.

28. Gauguin, *Letters to His Wife*, no. 154.

29. This statement by Marinetti is quoted in Steve McCaffery, "From Phonic to Sonic: The Emergence of the Audiopoem," in *Sound States: Innovative Poetics and Acoustical Technologies*, ed. Adelaide Morris (Chapel Hill: University of North Carolina Press, 1997), 150.

30. "Memoir" was based on tape-recorded conversations between Jakobson and Bengt Jangfeldt in 1977. Jangfeldt transcribed and edited these conversations and published them along with letters and essays by Jakobson in 1992 in Russian under the title *Jakobson-Budetlianin*. An expanded English edition appeared in 1997: Roman Jakobson, *My Futurist Years*, ed. Bengt Jangfeldt, trans. Stephen Rudy (New York: Marsilio, 1997). Quotes in this paragraph from Jakobson, *My Futurist Years*, 4–5, 5–6.

31. Jakobson, *My Futurist Years*, 4–5.

32. Jakobson, *My Futurist Years*, 5.

33. Viktor Shklovsky, *A Hunt for Optimism*, trans. Shushan Avagyan (Champaign, IL: Dalkey Archive, 2012), 102.

34. Jakobson, *My Futurist Years*, 18–19; and Catherine Ciepiela and Honor Moore, eds., *The Stray Dog Cabaret: A Book of Russian Poems*, trans. Paul Schmidt (New York: New York Review, 2007), viii–xii.

35. Shklovsky, *A Hunt for Optimism*, 98.

36. Jakobson, *My Futurist Years*, 19.

37. From Vasily Kamensky, *Ego—Imia biografiia velikogo futurista* (Moscow, 1918), 137. Cited in Nina Gurianova, *Exploring Color: Olga Rozanova and the Early Russian Avant-Garde, 1910–1918*, trans. Charles Rougle (Amsterdam: G+B Arts International, 2000), 154. Olga Rozanova also "hung out" at the Stray Dog and described one "apache evening" in which she stayed from 12:30 to 7:30 a.m. See letter from O. Rozanova, 9 December 1913, cited from a handwritten copy made by N. I. Khardzhiev, Foundation Cultural Centre Khardzhiev-Chaga, Amsterdam. See Gurianova, *Exploring Color*, 150.

38. Quotes in this paragraph taken from Shklovsky, *A Hunt for Optimism*, 99.

39. For quotations in this paragraph, see Jakobson, *My Futurist Years*, 26–27, 24.

40. Kursk is the city in central Russia where Malevich first moved in 1896 and fell in with a community of artists. It is where he started his painting activity. See "From the Provinces: Anticipations of *Mirskontsa*," this volume; and Malevich, "Chapters," 1:24–25, 44.

41. Malevich, "Chapters," 1:31.

42. Jakobson, *My Futurist Years*, 23.

43. See letter 65 from Malevich to Matiushin, before 23 June 1916, in Vakar and Mikhienko, *Kazimir Malevich*, 1:88.

44. These statements are taken from letters from Malevich to Matiushin, June 1913 and 3 July 1913, in Vakar and Mikhienko, *Kazimir Malevich*, 1:52. "Zaumnyi" appears in italics in the letter as it does in my quote.

45. Letter from Malevich to Kruchenykh, 5 July 1916, in Vakar and Mikhienko, *Kazimir Malevich*, 1:93.

46. Letter from Malevich to Matiushin, before 23 June 1916, in Vakar and Mikhienko, *Kazimir Malevich*, 1:89.

47. Jakobson, *My Futurist Years*, 24.

48. Goncharova was an exception.

49. Benedikt Livshits, *The One and a Half-Eyed Archer*, trans. John E. Bowlt (Newtonville, MA: Oriental Research Partners, 1977), 41.

50. Jakobson, *My Futurist Years*, 28, 37.

51. Bengt Jangfeldt, *Mayakovsky: A Biography*, trans. Harry D. Watson (Chicago: University of Chicago Press, 2015), 305.

52. On social origins and the futurist tour, see Jangfeldt, *Mayakovsky*, 15–18.

53. For translation, see Boris Dralyuk and David Burliuk, *A Slap in the Face: Four Russian Futurist Manifestos*, trans. Boris Dralyuk (Los Angeles: Insert Blanc, 2013), 13.

54. Chipp, *Theories of Modern Art*, 34. The artistic tradition of the German avant-garde, consisting of Caspar David Friedrich and Philipp Otto Runge in the nineteenth century, was not as long and continuous as that of the French, while their literary tradition reached its peak with the eighteenth-century writer of lyric and epic poetry Johann von Goethe, followed in the nineteenth century by Heinrich Heine, Johann Herder, E. T. A. Hoffmann, and Heinrich von Kleist.

55. For the quotations in this paragraph, see Jakobson, *My Futurist Years*, 214, 230, 244.

56. Bushkovitch, *A Concise History*, 225, 221–22.

From the Provinces:
Anticipations of *Mirskontsa*

The mysterious polarity between "primitive" imagery and advanced abstraction that characterizes Malevich's paintings also pervades the futurist books, which are my subject here. But the latter pose very different challenges, being poet and painter collaborations that use the book medium to invent a genuinely new interplay of word, image, and sound. Beginning with the futurist miscellany *Sadok sudei* (A trap for judges) of 1910 and extending to the collection *Zaumnaia gniga* (Transrational boog) of 1915, Russian futurists participated in a fever of book production. Their activity was intense and concentrated, especially between 1912 and 1914. Sometimes poets and painters produced books within the same month, as in August 1912, when the hand-lithographed *Starinnaia liubov'* (Old-fashioned love) was followed by *Igra v adu* (A game in hell). The same year saw the publication, in November, of *Mirskontsa* (Worldbackwards) and, in December, of *Poshchechina obshchestvennomu vkusu* (A slap in the face of public taste).

In the even more prolific year of 1913, futurists collaborated on *Poluzhivoi* (Half-alive), *Pustynniki: Poema* (Hermits: A poem), *Pomada* (Pomade), *Vzorval'* (Explodity), *Troe* (The three), and *Slovo kak takovoe* (The word as such), to name only the best known. The year 1914 saw publications of *Utinoe gnezdyshko…durnykh slov* (A duck's nest…of bad words), the second edition of *Igra v adu* (A game in hell), and *Te li le,* among others. Mostly hand-lithographed but occasionally typeset when the miscellany was large, the avant-garde books were produced by a mix of the same contributors, namely the poets Elena Guro, Velimir Khlebnikov, Alexei Kruchenykh, and Vladimir Mayakovsky, and the visual artists David Burliuk, Natalia Goncharova, Mikhail Larionov, and Kazimir Malevich.

While the preceding is intended to spotlight the enormous productivity of futurist poets and painters during a short but intense period of time, I have not written this book as a survey of futurist publications; we have a number of such surveys already.[1] They tend to isolate individual

pages or poems from a range of futurist books, rather than study a sequence of pages in one or two books from the perspective of not only the imagery but also the verbal and the vocal dimensions. In this chapter, I establish the history behind the making of a single example that is both representative and dazzlingly rich—*Mirskontsa* (Worldbackwards), a hand-lithographed collaboration between the poets Velimir Khlebnikov and Alexei Kruchenykh and the painters Natalia Goncharova and Mikhail Larionov. *Mirskontsa* brings together sound poetry, visual imagery, and verbal gestures, the latter consisting of neologisms, puns, and the language of *zaum*.

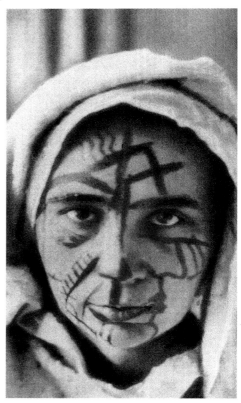

Given its experimental nature and the fame of at least three of its collaborators—Goncharova, Khlebnikov, and Larionov—we might ask why this avant-garde book collaboration has been so little studied. Certainly, the hand-lithographed books of the Russian futurists constitute a private and therefore lesser-known discourse than, for example, the large public debates that poets and painters organized to accompany exhibitions. *Mirskontsa* is exceptional among these futurist publications, moreover, in its very small print run of 220 copies. In addition, the sheer fact of being Russian has meant less scrutiny from Western critics and historians than is given to European modernist art. But most significantly, *Mirskontsa* represents neither poetry nor painting nor graphic art; rather, it is a hybrid form called the artist's book, defined in this case by its use of sound poetry, collage, hand lithography, and the deliberate production of variant copies.

Current scholarship on the Russian avant-garde devotes ample attention to classic modernist poets such as Anna Akhmatova and Boris Pasternak and even to the revolutionary poet Vladimir Mayakovsky. Similarly, there is extensive literature on the paintings of Kazimir Malevich and, to a lesser but still significant degree, those of Goncharova and Larionov. By contrast, the contributions of Khlebnikov and Kruchenykh, and of Malevich, Goncharova, and Larionov to the artist's book are scarcely recognized, especially by English-language writers. And there does not seem to be a critical method for analyzing this hybrid genre. This chapter provides an account of the early creative lives of the collaborators on *Mirskontsa* and their shared interest in the principle of reversibility. Contrasting the Russian artist's book with another collaborative form, the public debate, begins to articulate what made futurist book art so distinctive.

In their day, the subtlety of expression of futurist books may have prompted journalists and poets to turn their attention to more explosive and accessible forms of futurist collaboration, principally the public debate, which served as an interesting foil to the futurist book. The debate was a forum organized by Mikhail Larionov between 1912 and 1914 to accompany his series of exhibitions: *The Jack of Diamonds, The Donkey's Tail, The Target,* and *No. 4.* At the *Target* debate (March 1913), to take one example, artists and poets provoked the audience with lectures on "Rayism," "Nationalism against Subservience to the West," "Against the European Theater," and "Music and Rhythm and the Theater of the Future."[2] The lively public reaction to these lectures and the accompanying reviews in the press made the polemics of the debates a natural draw for large audiences. Goncharova and Larionov furthered their reputations as the heroes and villains of the newspaper columns by participating in other public forums in Moscow, such as painting their faces and reciting futurist poetry on Kuznetsky Most (the main street of the city), engaging in fist fights at the opening of the Pink Lantern cabaret bar, participating in outrageous decorations for the Press Ball, and planning to open a futurist theater in which the audience would sit on wire netting directly beneath the ceiling (fig. 1).[3]

Whereas the debates offered an opportunity for visual artists to engage with audiences, futurist books engaged artists with poets. The books may have been little known to the Russian public and had a reputation for unusual content and design. One wonders what to make, for instance, of an anecdote that Roman Jakobson recounts to Kruchenykh in a letter of February 1914: "In Moscow no one knows of the existence of your new books. I pointed this out to the clerk at Obrazovanie [a large bookstore in Moscow], asked him to put them in the window. He answers: 'Thank God no one knows!'"[4] "What's one to do?" Jakobson asks Kruchenykh rhetorically and moves on to inquire about Khlebnikov.

Poets and painters collaborating on *Mirskontsa* had not known one another for very long when they embarked on this book project. They were in their late twenties at the time. Mostly born and raised in far-flung villages and provinces on the outer edge of the Russian Empire, they grew up at the turn of the twentieth century, during a period in which the slow but steady rise of rural education was beginning to have an impact on peasant society, and an enormous increase in migration was taking place from the villages to the factories of Saint Petersburg and Moscow.[5] Rural and provincial youth participated in this large migration to the metropolis, where they came to improve their education.[6] Due to the vast scale of the Russian Empire, many of the poets and painters traveled long distances from their birthplaces. Social class and formal

Fig. 1.
Natalia Goncharova with face painting, 1913.

education varied, but with the exception of Goncharova, whose family came from the nobility, futurist poets and painters were born to the middle or provincial class or to peasant families, and they received little formal education before they arrived in the capitals. The collaborators on *Mirskontsa* initially came to the cities to pursue different fields of study, including the natural sciences, medicine, and history. Although their talents coalesced around the arts, they were more united by a common rebellion against the norm—that is, against representational painting and the formalities of symbolist poetry.[7]

How did such a range of artists come together to create a book like *Mirskontsa*? Most studies of Russian futurist art focus on group ethos and aesthetics. But the artists were first and foremost unique individuals for whom Russia's history—but especially its geography—played a major role. Indeed, as we shall see, the word *Russian* does not adequately capture the ethnic variations behind the group label.

Fig. 2.
Velimir Khlebnikov, n.d.

Fig. 3.
Map of the Russian Empire, ca. 1910.

Khlebnikov's *Zaum*

The life of Velimir Khlebnikov is noteworthy for its brevity, extreme poverty, and intense productivity (fig. 2). Born Viktor Khlebnikov in 1885 in the Republic of Kalmykia, on the northern tip of the Caspian Sea (fig. 3), the poet grew up amid Mongolian Buddhists who were supervised by his father, Vladimir, a highly educated and prominent naturalist and ornithologist working in a provincial capacity as a regional administrator. Theirs was the only house in a settlement of nomadic tents surrounded by camels on the steppe. Life in this eastern outpost below the Ural Mountains carved an early identity for Khlebnikov as both western (Russian) and eastern (Siberian). His family moved frequently and over long distances, settling when he was only six in the extreme western province of Volynia, where they lived in an abandoned estate; they then returned eastward about four years later (1895) to live in the Mordovian village of Pomaevo, in the Simbirsk Province located on the northern edge of the central steppes and the upper Volga River (see fig. 3). In Pomaevo, Khlebnikov learned about Mordovian myth and folklore and began writing poetry. In 1898, his family moved again, this time north of Simbirsk, to establish itself more permanently in the city of Kazan. There, Khlebnikov studied drawing with an art student from the Kazan Art School before

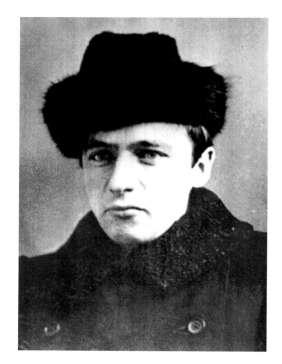

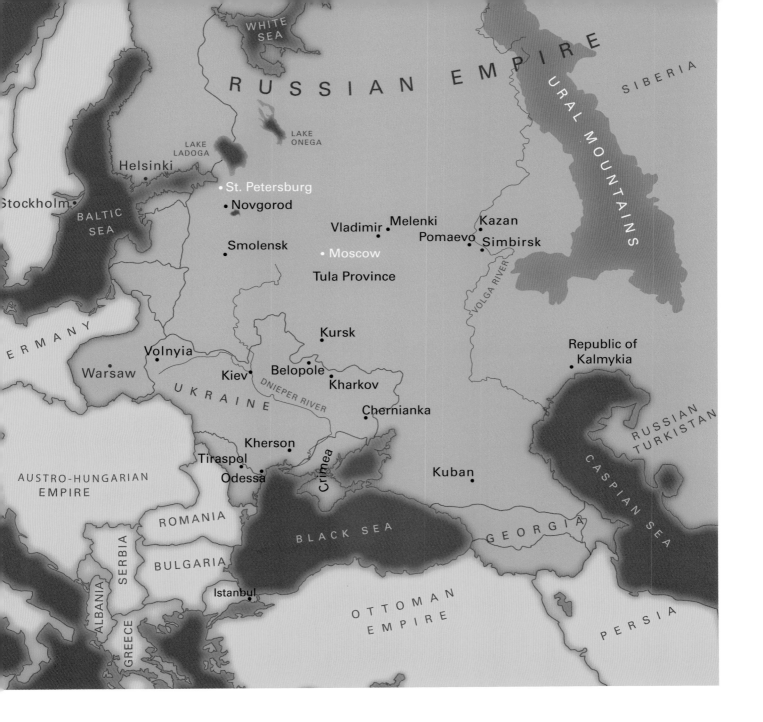

enrolling in mathematics at the prestigious University of Kazan. Drawing offered a natural outlet for his observational skills, and he advanced from sketches to oils and canvas.[8]

Influenced and inspired by their father's work in the natural sciences, Khlebnikov and his brother Alexander embarked in spring 1905 on an expedition to the Pavdinsk Preserve in the northern Urals to record bird songs and gather specimens for their father's collection. An essay they coauthored and published in 1911, "Ornithological Observations in the Pavdinsk Preserve" (based on a report they presented to the Natural Science Society, which sponsored their trip), contains detailed and evocative descriptions of birdcalls that anticipate the transrational language of *zaum*. Particular species captured Khlebnikov's imagination and prompted him to ascribe emotions and motivations to their calls. For instance, he interprets the loud cries of the male black woodpecker, "p-ee-ee-t, p-ee-ee-t," and "teeraan" or "teeran-aan," and the soft response of the female, "p-ee-ee-n," as an exchange of birdcalls designed to protect the nest. Of the nutcracker, he writes:

> The nutcracker often sits for a while with closed eyes after feeding, ruffling its feathers and evidently reveling in the sounds of its voice, as if recounting something of its impressions of the day in its own strange language: "pee-oo, pee-oo, pee-oo," it moans painfully and piteously; "pee-ee, pee-ee, pee-ee," it pipes in a delicate voice, like the cry of the hazel grouse; then insistently and intelligently, "knya, knya, knya"; then switches to muttering, "kya, kya, kya"; then trembling with intensity, almost as if it were angry, and ruffling its feathers, it makes a rude hoarse hiss.[9]

In this way, Khlebnikov explores the nonsensical but suggestive sounds of the different birds. His earliest surviving poem, "Ptichka v kletke" (Bird in a cage), offers a sympathetic observation of a trapped bird. The image of nature trapped and tamed remained a potent one throughout Khlebnikov's work.[10] It may have inspired his enigmatic title for the futurist almanac (as Russians call their literary miscellanies) *Sadok sudei* (1910; A trap for judges), in which each Russian word takes on additional meanings through its unlikely pairing with the other. *Sadok* means "trap" or a "cage" for breeding animals, while *sud'ia* means "judge." Their surprising combination, which results in a sonic play of repeated consonants (*s* and *d* in each word) and changing vowels, as well as a common stress on the second syllables, produces multiple, ambiguous meanings. On one level, the judges are the critics and the literary press whom the avant-garde spurns and traps;

on another level, the "trap" is a coop or hatchery for poets, who will become the new legislators of poetry of the future.[11] The positive and negative connotations of "trap"—both to breed and to keep in captivity—reflect, perhaps, Khlebnikov's own uneasy relationship with animals, as well as his inventive use of ambiguity to extend the humor.

The years 1908–9 marked a turning point for Khlebnikov. Living in Kazan, he wrote his first serious poetry, often turning to birds for imagery, and in March he sent fourteen poems to Viacheslav Ivanov, one of the leaders of the symbolist movement in Russia and the symbolist circles in Saint Petersburg. Shortly after, Khlebnikov had the opportunity to meet Ivanov in Crimea, where Ivanov rested after being jailed for antigovernment political activities (see fig. 3).[12] Six months later, by September 1908, Khlebnikov had left Kazan and moved to Saint Petersburg, where he began to publish his literary work. Although he enrolled in the University of Saint Petersburg in natural sciences—probably to please his father, who held an advanced degree from the university—from this time forward, literature became the focus of his interests. One can speculate that Saint Petersburg, unlike Kazan, had its appeal as a center of symbolism (Ivanov held weekly meetings for poets and artists there) and of literature and publishing more broadly. Through the university, Khlebnikov became a student in S. A. Vengerov's famous Alexander Pushkin seminar, and, by his second year, he had shifted to a major in Russian and Slavic literatures.[13]

As part of this shift, and inspired by his enthusiasm for the Pan-Slavic movement of 1908, Khlebnikov changed his name from Viktor to the south Slavic Velimir. Informing his family, he wrote, "I'm sending you my card, with Viktor scratched out and Velimir written in."[14] He invented the name, just as he would invent neologisms in his poetry and prose, by utilizing Slavic word roots with multiple etymologies in order to create puns and new, often multilayered "meanings." The adjective *veliki*—an etymological source for Khlebnikov's "veli"—means "great," so that together with *mir* (world), the name could suggest "great world." "Veli" can also be traced to the verb *velet'* (to order) and to the noun *velenie* (a command). Paired with *mir,* we have "to order" or, loosely translated, "to command the world." In these two readings, Khlebnikov establishes his prophetic role in time and his early fascination with the word *mir,* which can also mean "universe," hence implying space as well as time.

During his first year in Saint Petersburg, Khlebnikov made a valiant attempt to participate in the meetings of Ivanov's reorganized Academy of Verse, also known as the Academy of Poets, the Poetic Academy, and the Society of Lovers of the Artistic Word. The symbolists initially accepted him, recognizing the coincidence between his interest in the roots of words and their own motto,

from Saint Paul: "In the beginning was the Word." However, his submission of a prose poem, "O Garden! Garden!" (in Russian, "O sad! Sad!"), an homage to Walt Whitman, was rejected by the new symbolist journal *Apollo,* which covered the latest currents in Russian and Western art and literature and included as collaborators the Saint Petersburg painters of the former World of Art group.[15] By early 1910, Khlebnikov had left Ivanov's circle.[16]

Shrewdly, and in a fortuitous turn for his path as a futurist poet and collaborator on *Mirskontsa,* Khlebnikov had also sought out the writer, artist, and aviator Vasily Kamensky, who was only a year older and serving as editor of an almanac titled *Spring* (fig. 4). At their first meeting, which took place in late October or early November 1908, a month after Khlebnikov's arrival in Saint Petersburg, Kamensky enthusiastically agreed to publish his colleague's first piece of literary prose, "A Sinner's Seduction." This gesture marked the beginning of a friendship that shaped Khlebnikov's artistic contacts, as well as his theoretical development, for several years. Early in 1909, Kamensky introduced Khlebnikov to the composer and theoretician Mikhail Matiushin and his wife, the poet and painter Elena Guro (fig. 5). At their apartment, Khlebnikov met David

Fig. 4.
Vasily Kamensky during a tour of the Russian provinces, winter 1913–14. Stockholm, Bengt Jangfeldt archive.

Fig. 5.
Elena Guro and Mikhail Matiushin, Saint Petersburg, ca. 1911.

Fig. 6.
David Burliuk during a tour of the Russian provinces, winter 1913–14. Stockholm, Bengt Jangfeldt archive.

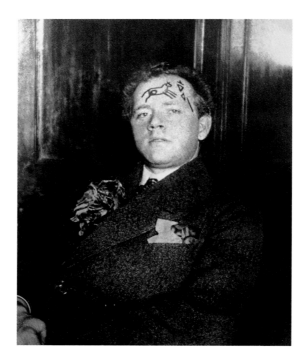

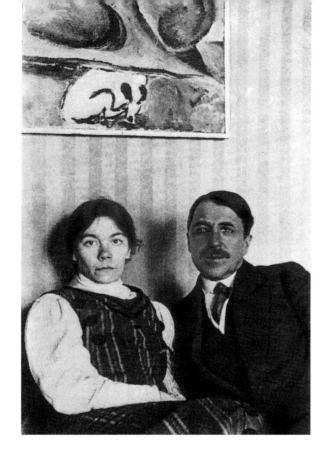

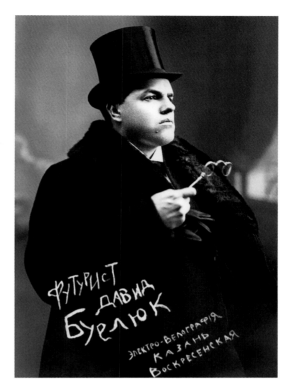

Burliuk, also a poet and painter (fig. 6). And it was there that he probably first encountered the physician, painter, and promoter of the new art Nikolai Kulbin. In March, Kulbin organized the second *Triangle* exhibition, which featured brothers David and Vladimir Burliuk, Guro, Kamensky, and Matiushin, as well as a section devoted to drawings and autographs by writers including Khlebnikov.

In spite of this early recognition, Khlebnikov had difficulty supporting himself from the start. When a post as a tutor proved unsuccessful, he was fortunate to have David Burliuk arrange for him to move to the Fontanka Canal with Kamensky and his new wife. Burliuk describes Khlebnikov's circumstances when he came to rescue his new poet friend: "He packed up his 'things' in a hurry—he didn't have much. A small suitcase, and a sack that Vitya [Velimir] dragged out from under the bed....It was a pillow case, stuffed with crumpled pieces of paper, pages torn out of notebooks, whole sheets or even just torn-off corners of pages....'My manuscripts,' Vitya

muttered."[17] Early on and throughout his career, Khlebnikov lived a hand-to-mouth, vagabond existence, relying on his group of friends for financial as well as moral support. A letter written to his mother from Saint Petersburg on 28 November 1908 reads, "I lead a 'bohemian' life. Petersburg can be like a good stiff breeze; it has a chilling effect. My Slavic feelings are frozen as well."[18]

South to the Black Sea

Two letters that Khlebnikov sent to Kamensky in 1909 not only document their friendship but also convey an interest in the concept of time, especially the conflation of past and present, that anticipated both the aesthetic of *mirskontsa* and the important role of the phonic in the artist's book of that name. In a letter of 10 January 1909, Khlebnikov writes in a tone half serious and half jesting of his plans for a big novel whose prototype—a painting called *Bathing* by the minor Russian painter Alexander Savinov—represents "freedom from time, from space.... The life of our own time fused with the era of Vladimir the Shining Sun ... as it might be imagined by the composers of *byliny*.... And all linked by a unity of time, piled into a single current at one and the same time."[19] Khlebnikov's interest in invoking ancient times as a model for modernism is typical of his neoprimitive stance. A second letter, dated 8 August 1909, indicates that he was theorizing about issues of time and speech creation. He writes that he was working on a "complicated piece, *Time Transversal,* where the logical rules of time and space are broken as many times as a drunkard in an hour raises a glass to his mouth. No chapter will have any connection whatsoever to the next ... included is the right to use newly created words, a kind of writing based on words from a single root, use of epithets, universal phenomena, painting with sound."[20] The break with logic in time and space, together with the freedom to create new words from single roots and to base word choice on sound, invokes the principle of "world from the end"—the writing of transrational poetry as a form of sound poetry.

In June 1911, Khlebnikov was officially expelled from the University of Saint Petersburg for nonpayment. He does not seem to have returned, thereby leaving his training in Russian and Slavic literatures unfinished. According to the young lawyer and aspiring poet Benedikt Livshits, in the summer of 1911, at the invitation of the Burliuk brothers, Khlebnikov traveled south with Mikhail Larionov to Chernianka, the administrative and economic center of an estate managed by the Burliuks' father—who was of peasant stock—near the northern coast of the Black Sea (see fig. 3).[21] Paying his own visit to Chernianka six months later in December 1911, Livshits recounts that Khlebnikov left behind manuscripts of his poetry, which "made language *come alive*. The

breath of the primordial word wafted into my face."[22] Livshits marvels at Khlebnikov's uncovering of the Slavic roots of words, which "awakened the word's dormant meanings," and he distinguishes this method from a creation of roots, which would have had to take place outside the confines of Russian, and, indeed, any language. "The experience of the West was multiplied by the wisdom of the East," Livshits observes, attributing this bringing together of East and West (ancient and modern, word and image) to the movement in Russian poetry and painting, which came to be called *futurism*.[23] Khlebnikov did not use this term, preferring the neologism *budetlianstvo,* based on the Slavic verb *budet'* for "will be" and translated as "will-be-ness."

David, Vladimir, and their brother Nikolai Burliuk joined Livshits in forming the artistic group Hylaea, which was the ancient Greek name for the area in southern Russia near the Black Sea coast.[24] Livshits was so amazed by Khlebnikov's philological experiments that the poet automatically became a member. Kruchenykh and Mayakovsky joined the association soon after. David Burliuk may have been responsible, moreover, for formally introducing Khlebnikov to Kruchenykh and Mayakovsky, both of whom had originally come to Moscow as young painters but later shifted their creative aspirations to poetry.

"Breaking the Logical Rules of Time and Space"

Alexei Kruchenykh was born on 9 February 1886 into a poor peasant family in the Kherson Province (fig. 7). In his memoirs, he recalls that "until I was eight, I grew up as a normal peasant urchin, wild, uncontrollable."[25] In 1894, he left his province for the city of Kherson, a port located in southern Ukraine on the Black Sea (see fig. 3). After receiving an "elementary education," he entered the Odessa Art College in 1902 and graduated four years later with a secondary-school teaching certificate in art. Kruchenykh writes that he worked as a village schoolmaster in Smolensk Province and as a teacher at a girls' gymnasium in Kuban Province. Because the cities of Kuban, Odessa, and Smolensk are far apart geographically, it is not clear when Kruchenykh held these positions in relation to his move to Moscow in 1907.

In 1906, in Odessa and Kherson, Kruchenykh drew lithographic portraits of revolutionary leaders and continued to produce these caricatures for satirical journals when he arrived in Moscow. Between 1908 and 1910, he worked for humorous magazines creating caricatures of professors, and in 1908 he published in his native city of Kherson a series of caricatures of writers and artists titled *All Moscow in Caricature*.[26] Kruchenykh's publications thus took him back to Kherson, where he worked with the Burliuk brothers in 1907–9. By winter 1910–11, he had returned to

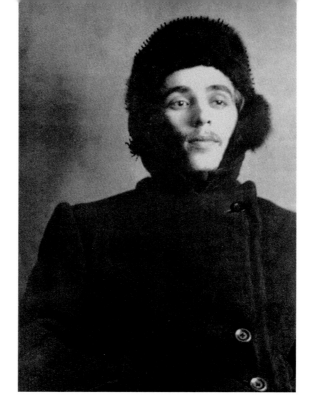

Moscow. In his memoirs, he recalls that at about the time of his first meeting with Khlebnikov and Mayakovsky in spring 1912, he had decided to shift from painting to poetry: "It was in these years that, foreseeing the imminent destruction of painting and its replacement by something else that subsequently became photomontage, I snapped my brushes in good time and threw away my palette to the greater glory and destruction of futurism—the valedictory literary school, which at that time was just igniting its final (and brightest) worldwide flame."[27]

When Kruchenykh and Khlebnikov first met, each had studied drawing and painting before turning to poetry. Of the two, Khlebnikov pursued more formal academic studies. Working in caricature, Kruchenykh equipped himself with a sophisticated eye and an ear for humor. Indeed, in further explaining his preference for poetry over painting, he writes: "Just to SEE the world wasn't enough for me. I had a sharp ear. Dumb pictures, the backbiting milieu of artists, was depriving me of half the world, making it one-sided. My world had to have sound, 'the great silents' had to speak…. There is not…a more natural, perfected, and multifaceted medium than the word. One can live without painting or music, but without the word, man does not exist!"[28]

This emphasis on the sounds of words was, then, a common interest for the two poets. It became an impetus for collaboration. In addition, Kruchenykh shared with Khlebnikov a preoccupation with the concept of *mirskontsa* as a literary method and a key principle of futurist aesthetics.[29] Sometime in 1912—and before the publication of the artist's book *Mirskontsa*—both poets produced literary works that explored a world of time-and-space reversals. Khlebnikov wrote a play titled *Mirskontsa,* which he later published in the collection *Riav! Perchatki* (1908–14; Roar! Gauntlets). Kruchenykh composed a poem with the *zaum* title "Starye shchiptsy zakata" (Old tongs of sunset), which was published in the futurist collection *Poshchechina obshchestvennomu vkusu* (A slap in the face of public taste) in 1912.

In Khlebnikov's play, the story of a husband and wife, Olia and Polia, takes place in reverse chronological order. In the opening scene, Olia describes to Polia how, at age seventy, he was laid to rest in a coffin and driven away in a carriage for his funeral. As time moves forward from the end, we find Olia resurrected from the dead and fleeing in a cab from his own funeral. Reunited with the heroine, Polia, the two characters rummage through an old closet, looking at business attire and wedding clothes that they wore in their youth. As scene 2 opens, they discover that they no longer have gray hair. Their adult children, Petey and Nina, appear. Petey kills a crow, and Nina announces that someone has asked for her hand in marriage. In the three subsequent compressed scenes, Olia and Polia converse with their young children; Olia dons an army uniform; and he and Polia appear as school children carrying book bags. In the final scene, they are wheeled away in their baby carriages.[30]

Vladimir Poliakov credits Kruchenykh with the first published use of the words "mir s kontsa" and Khlebnikov with the invention of the neologism.[31] Quite likely in response to his poet-friend's play, and shortly before the publication of the book *Mirskontsa,* Kruchenykh wrote his poem "Starye shchiptsy zakata," his sole contribution to the collection *Poshchechina obshchest-vennomu vkusu.*[32] Kruchenykh's poem reverses time and space by scrambling the order of events in an erotic tale of an officer and his redheaded coquette. Like that of the play, *Mirskontsa,* "Starye shchiptsy zakata" is about a man and a woman, but, in this instance, they are a young officer and his red-haired girlfriend, the latter of whom coincidentally has the name Polia. Kruchenykh groups his stanzas in sequences (fig. 8). The *zaum*-like imagery of the first two stanzas is followed by a succession of three stanzas (3–5) containing the narrative we would expect to find at the end of the poem: a knife "topples" the officer, and the coquette falls on the table, blushing, rather than dying. Stanzas six and seven present the story that would logically come at the beginning: stanza 6

Fig. 8.
Alexei Kruchenykh, "Starye shchiptsy zakata" (1912; Old tongs of sunset), poetic structure.
Translation by Antanina Sergieff.

1 old tongs of sunset
 patches

2 speckled eyes
 gaze
 gaze
 at the east

3 a boastful knife
 threw glares
 and toppled an officer
 upon the table
 as to the floor
 he died

4 No. eight is surprised
 a sleepy stone
 started rolling his eyes
 and swinging his arms
 and like a lash
 a napkin
 twisted before us

5 a blue confection
 a powdered coquette
 fell on the table just right
 lifted her leg
 blushed a bit
 what a show
 let me through

6 the officer sits at the field
 with red-haired Polia
 and a haughty samovar
 lets out steam
 and whistles
 fishes splash
 the officer has
 eyes like olives
 predatory manners, little lips like raspberries
 gray little eyes
 the red-headed Polia has
 a brooch in the evening
 it was nice in the field

7 then everything changed
 he became big and also red-headed
 as if he'd obtained an answer
 leaned against metal
 became closer to it
 disowned Polia
 didn't want the red-head anymore
 and it was nothing that she bent
 lower and lower
 and his mother found everything out
 and swore at red-headed Polia
 and praised her dear brute
 red-headed Polia knew all this
 to the letter and wept.

8 note by the author—
 the world
 backwards attracts
 in its artistic appearance it
 is expressed like this: instead of 1-2-3
 events are arranged 3-2-1 or
 3-1-2 that is exactly how it is in my
 poem

The stanzas rearranged in chronological order:

1 old tongs of sunset
patches

2 speckled eyes
gaze
gaze
at the east

6 the officer sits at the field
with red-haired Polia
and a haughty samovar
lets out steam
and whistles
fishes splash
the officer has
eyes like olives
predatory manners, little lips like raspberries
gray little eyes
the red-headed Polia has
a brooch in the evening
it was nice in the field

7 then everything changed
he became big and also red-headed
as if he'd obtained an answer
leaned against metal
became closer to it
disowned Polia
didn't want the red-head anymore
and it was nothing that she bent
lower and lower
and his mother found everything out
and swore at red-headed Polia
and praised her dear brute
red-headed Polia knew all this
to the letter and wept.

3 a boastful knife
threw glares
and toppled an officer
upon the table
as to the floor
he died

4 No. eight is surprised
a sleepy stone
started rolling his eyes
and swinging his arms
and like a lash
a napkin
twisted before us

5 a blue confection
a powdered coquette
fell on the table just right
lifted her leg
blushed a bit
what a show
let me through

8 note by the author—
the world
backwards attracts
in its artistic appearance it
is expressed like this: instead of 1-2-3
events are arranged 3-2-1 or
3-1-2 that is exactly how it is in my
poem

provides a vivid introduction to the two characters (the officer has "eyes like olives" and "little lips like raspberries," and Polia wears a brooch), and stanza 7 assumes an ominous tone as the officer changes his mind and disowns Polia. Yet his death, which might logically happen next, has already transpired in stanza 3.

Although, as figure 8 demonstrates, it is possible to rearrange the stanzas in a chronological order, Kruchenykh leaves so much unknown that his poem retains a structural uncertainty—for instance, who is "No. eight" in the fourth stanza? And who kills the officer? In the eighth and final stanza, the poet steps out of his narrative and comments on the reversals, observing that there are multiple ways to organize his poem. In addition to the more literal translation of this stanza, a free translation by Nikolai Firtich reads as follows:

primechanie sochinetelia—	note by the writer—
vlechet mir	carrying the world
s kontsa	backwards
v khudozhestvennoi vneshnosti on	in the work of art
vyrazhaetsia i tak: vmesto 1-2-3	could be expressed as follows: instead of 1-2-3
sobytiia raspolagaiutsia 3-2-1 ili	events are unfolding as 3-2-1
3-1-2 tak' i est' v moem	or 3-1-2 this is the way it is in my
stikhotvorenii	poem.

Firtich's translation has the advantage of connecting the "poem" with the "world" that it carries backwards but the disadvantage that "world from the end" (mir / s kontsa), even as three separate words rather than a neologism, is more ambiguous and multilayered than the English translation, "worldbackwards," implies. *Mirskontsa* suggests both the end of the world, which may take place at any moment in the future (as in the apocalypse), and the beginning of the world, which starts with the prehistoric world and is associated with the resurrection.[33] In the play, the world commences with the resurrection, and, in the poem, it begins with the death of characters who are then resurrected; therefore, the idea of resurrection becomes integral to the *mirskontsa* principle. Kruchenykh's opening poem in the artist's book *Mirskontsa* observes, with comical regret, that he is unable to control his own fate: "How difficult it is to resurrect the dead . . . / But it is more difficult to resurrect myself!" The declarations of the two futurist strongmen in Khlebnikov's prologue to the opera *Pobeda nad solntsem* (1913; *Victory over the Sun*)—"All's well

that begins well!" / "And ends?" / "There will be no end!"—express a similar mystery surrounding past, present, and future and a similar claim for a victory over time.[34]

A preoccupation with *mirskontsa* persists in the surviving fragment of a letter from Khlebnikov to Kruchenykh in 1913, thus postdating the book's publication. Here Khlebnikov emphasizes the humorous and absurd implications of the principle, arguing that only by waiting until the ends of our destinies, when things "return unto dust," will we know how our lives have unfolded:

> I don't know if you share the opinion, but for a Futurian *The World in Reverse* is like an idea suggested by life for someone with a sense of humor, since first of all the frequently comic aspects of the fates can never be understood unless you look at them from the way they end, and secondly, people so far have looked at them only from the way they begin. And so, take an absurd view of the difference between your desired ideal and things as they are, look at all things in terms of their return unto dust, and everything will be fine, I think.[35]

The intriguing convergence of the poets' thinking on *mirskontsa* is complemented by Roman Jakobson's memoirs, which show uncanny common ground. Recalling the years 1912–13 and 1913–14, Jakobson writes, "The thematic of time and space, so mysterious and headspinning, opened up. For us there was no borderline between Khlebnikov the poet and Khlebnikov the mathematical mystic."[36] In a letter to Kruchenykh from February 1914, Jakobson highlights the principle and places it in a scientific context: "You know, none of the poets have said 'world-backwards' before, only [Russian symbolist poet Andrei] Bely and [Filippo Tommaso] Marinetti perhaps sensed it a little, but nonetheless this grandiose thesis is fully scientific (even though you spoke only about poetry, which is opposite to mathematics) and vividly presented in the principle of relativity."[37]

Clearly, *mirskontsa* was much more than the title of a book. Explicating the principle in contemporary terms, the Russian literary scholar S. R. Krasitskii wrote in 2001: "The concept of 'worldbackwards' became one of the key principles of futurist aesthetics.... It represents a violation of standard chronology, rejection of the linear movement of time from past to future, rejection of the commonly assumed connections and causal relations, intensification of alogism, unpredictability, departure from the boundaries of traditional positivist assumptions, which led to a sui generis futurist gnosticism."[38]

Between the Slavic and the Western

Shortly after they met in spring 1912 in Moscow, Kruchenykh and Khlebnikov joined forces for their first collaboration, the book *Igra v adu* (A game in hell). Kruchenykh visited Khlebnikov in his "untidy and student-like bare room" and brought with him a fragment of a new poem. Kruchenykh recalls their collaborative process as follows:

> I pulled two pages of drafts out of my calico notebook, about 40 to 50 lines of my first poem, "A Game in Hell." I showed it to him humbly. Suddenly, to my surprise, Velimir sat down and began to add his own lines above, below, and around mine. That was a characteristic feature of Khlebnikov, he caught fire creatively from the smallest spark. He showed me some pages covered with his minute handwriting. We read it together, argued, and corrected it again. And so we became coauthors unexpectedly and involuntarily.[39]

Kruchenykh invited Goncharova to provide a cover and fifteen lithographs for the book, and he hand lithographed the poetry. The relationship of word and image in this three-way collaboration expressed itself in general terms as a literary parody of Pushkin's verse and a visual parody of traditional representations of devils in Russian Orthodox icons and in Russian *lubki*. During the next five years, Kruchenykh and Khlebnikov would collaborate on five more futurist books.[40]

In early 1913, Khlebnikov moved back to Saint Petersburg, where Kruchenykh and other cubo-futurist poets, including David Burliuk, Guro, and Kamensky, joined him. Drafted into the army in April 1916, Khlebnikov enlisted in a regiment on the Volga River, where he spent most of his time in training camps. Spared active service in World War I by the February Revolution of 1917, Khlebnikov initially embraced the idea of social change and joined the new Soviet of Workers and Peasants. Yet civil war escalated throughout the former Russian Empire, beginning after the November Revolution of 1917, when the Bolshevik army (called the Red Guard), under the leadership of Vladimir Lenin, attacked the Winter Palace in Saint Petersburg (then Petrograd) and forced out the provisional government. The new Soviet government had the support of the workers, but the White Army and the allied powers opposed it.

Between 1918 and 1921, as civil war raged between the Reds and the Whites, Khlebnikov survived by working as a journalist for a Bolshevik newspaper and later as a civilian publicist with the army and the navy on the southern front. He had been ill with typhus, was terribly poor, and had little to eat, but he was satisfied to have formulated his "Laws of Time," the fundamental

Fig. 9.
Kazimir Malevich in Kursk, ca. 1900.

algorithms that he believed governed natural and historical events (the cubo-futurists named him the "King of Time").[41] Khlebnikov made one trip to Persia as a lecturer and journalist for the Red Army, and he described it with rapture in a letter to his sister Vera on 14 April 1921. Returning to Russia in the fall of 1921 and to Moscow in December, he traveled on broken railways to a debilitated city suffering the ravages of civil war and saw children starving to death. Khlebnikov now lived a homeless existence in and out of Moscow and depended on the help of friends. Increasingly ill from gangrene, he died of typhus in 1922 at the age of thirty-six in a village near Novgorod. His friend Kruchenykh would outlive him by over four decades.

The bohemian existence of the poets Khlebnikov and Kruchenykh offers a notable contrast to the careers of the painters Goncharova and Larionov, but it aligns somewhat with that of the young Malevich, whose family moved frequently to different villages and provinces in Ukraine (fig. 9). Although he did not work directly with poets on individual page spreads—as did

Goncharova, Kulbin, Larionov, and Olga Rozanova—Malevich produced book covers and full-page illustrations that served an independent role and contributed a special character to a given book, whether spirituality and mysticism, alogism, primitivism, or what was called the fourth dimension. This crucial and distinctive role will be addressed in a later discussion of Malevich's imagery for the book *Vzorval'* (Explodity).

Malevich was born in 1879 to Polish parents who settled outside of Kiev in Ukraine. His father worked in sugar-beet factories, which, according to Malevich's memories, "were usually built deep in the countryside, far from big and small cities. The sugar beet plantations were large.... Peasants, from the youngest to the oldest, worked on the plantations almost all summer and fall [weeding and harvesting the beets]."[42] Malevich remembers how, from the beginning, he distinguished between the peasants, whom he loved and envied for their total freedom in nature, and the factory workers, who "stood nailed by time to an apparatus or machine: twelve hours in the steam, in the stink of gases, in the dirt." The Malevich family moved often. From 1883 to 1889, when Malevich was four until he was ten, they lived in the village of Maevka, Iampol District, in the Podolsk Province of Ukraine. In 1891, they moved to the town of Belopole, in Kharkov Province (see fig. 3).[43] Highly attracted to peasant life and colorful peasant murals and wood carvings, Malevich remembers resolving never to live and work in a factory and never to go to school. Peasants made everything for themselves, even paint, he recalled with delight, and they had no need of school.

Malevich used his annual visits with his father to the sugar-beet factory fair in Kiev as occasions to study the peasant art he saw in storefronts around town. When he was twelve and living in Belopole, he learned one day from a friend who also loved to draw that "the most famous artists in Saint Petersburg have been called here to paint icons in the cathedral."[44] Malevich and his friend were beside themselves with excitement, never before having seen a "live" artist. "We wanted to sneak into the church and watch these famous artists work," he recalled. Once he and his friend heard the three artists had arrived, they went out onto the main street and peered into people's faces. They searched high and low for the artists, until one day they came upon a house in Belopole in which they could see paintings ("rags") on the walls and the artists walking around. Determined to observe the artists at work, Malevich and his friend waited at the house the next day to catch a glimpse of them leaving: "An hour later, the gate opened and the artists appeared before our eyes. They had paint boxes strapped to their backs, umbrellas, and other inexplicable things. They were in shirtsleeves. Bluish trousers and shoes. The artists walked out

of town, and we followed. A windmill stood in the field. The rye was up and in the distance there were oak trees."

Malevich and his friend watched as the artists started to paint: "We observed everything in the most thorough way, not a single detail escaped us. We wanted to see what they did and how they did it. We crawled very carefully, on our bellies, holding our breath. We managed to get quite close. We saw colored tubes from which they squeezed the paint, which was very interesting.…There was no limit to our excitement. We lay there for two hours [not daring to be seen]." The incident made a lasting impact on the young Malevich: "Paint tubes, palette, brushes, umbrellas, and folding chairs gave me no peace ever since Belopole."[45]

Passionately wanting to study art, Malevich received his first formal schooling in 1895 at the Kiev Art School, but he was forced to move to the city of Kursk one year later. In Kursk, where he organized a Society of Art Lovers, he met talented artists from Moscow and longed to move there. He was not able to until 1904, when he entered the Moscow School of Painting, Sculpture, and Architecture. He studied there until 1910, but he did not overlap with Goncharova and Larionov, who attended the school several years earlier. A theme running throughout Malevich's memoirs is a love of nature, which he shared with his father. Incorporating this passion into his theory of art, he observes: "Everything in nature has this objectless source, but man wants to objectify it.…That is why two truths emerge now, the objective world and the objectless world. But since the objectless truth lies in nature itself, then obviously it must win."[46]

This focus on the nonobjective was certainly espoused by the collaborators on *Mirskontsa,* as seen in the careers of Khlebnikov, Kruchenykh, and Malevich, as well as those of Goncharova and Larionov (figs. 10, 11). Goncharova was born in 1881 in the village of Nagayevo in Tula Province, southwest of Moscow (see fig. 3). Her father, Sergei Mikhailovich Goncharov, was an architect and the grandson of Sergei Nikolaevich, younger brother of Natalia Nikolaevna Goncharova, who married Alexander Pushkin. Her mother was the daughter of a professor at the Moscow Academy of Theology. The proximity of Tula to the capital city and Goncharova's descent from rural Russian gentry distinguish her origins from the provincial families of her fellow futurists. Her family was a classic example of the old, impoverished nobility. They owned numerous vast estates in Tula Province, but none of the estates generated much income.

Photographs of Goncharova wearing peasant attire and occupied in rural activity (for example, cracking sunflower seeds) show her affinity with the "time-honored traditions of peasant Russia" and, at the same time, her delight in masquerade (fig. 12).[47] She grew up on the estate

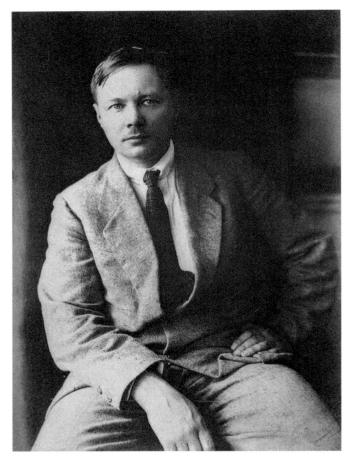

of her paternal grandmother, in the village of Ladyzhino in Tula Province, until her family moved to Moscow in 1892. There she attended the Fourth Grammar School for Girls, and because for generations her family had maintained a house in Moscow, she was able to live in the house built by her father.[48] Nonetheless, she wrote to her mother of the difficulty of going back and forth between Moscow and the countryside. In grammar school, her studies of botany, scripture, and zoology all grew out of her childhood experience.

Fig. 10.
Natalia Goncharova, 1912.
Private collection.

Fig. 11.
Mikhail Larionov, ca. 1915–17.

Fig. 12.
Natalia Goncharova (center) in peasant
attire, 1900s.

Uncertain of her direction after graduating from school in 1898, Goncharova pursued medicine, then history. In 1901, she enrolled in the Moscow School of Painting, Sculpture, and Architecture as a student of sculpture. Sometime in 1900, and possibly at the Moscow School, she met the painter Mikhail Larionov, who became her lifelong partner. Their careers by and large followed similar trajectories. Larionov was also born in 1881, and his family arrived in Moscow in 1895. His family came, however, not from a gentry's estate in a province near Moscow but from

the distant city of Tiraspol, on the river Dniester (present-day Moldavia), on the southwestern border of Ukraine (see fig. 3). Larionov's father served as a military pharmacist in Archangel, the northern city where his grandfather was mayor.[49] In 1898, Larionov enrolled in the preparatory class of the Moscow School of Painting, Sculpture, and Architecture and, like Goncharova, settled apart from his family in a separate district of Moscow. After the two artists met, Larionov moved into the Goncharov home, where they together maintained a studio and living quarters. He was her most important teacher and sometimes repainted or corrected her work.

In 1902, Larionov transferred to the Special Paintings Department of the Moscow School, and, that same year, his works in a student exhibition were deemed obscene, prompting his dismissal from the school until spring 1903.[50] In summer 1903, Goncharova traveled with Larionov to Tiraspol, Moldova, and to Crimea, Ukraine. When they returned to Moscow, she ceased her classes at the Moscow School of Painting, Sculpture, and Architecture and took up pastel painting independently in the studio of Konstantin Korovin.[51] Sometime around 1905, she began working in oil painting.

In 1906, at age twenty-five, Larionov participated in the exhibitions *Union of Russian Artists* (Moscow), *World of Art* (Saint Petersburg), and *Moscow Society of Artists*. He had met Sergei Diaghilev in late 1902/early 1903, and in 1906 both he and Goncharova were invited to contribute work to Diaghilev's exhibition of Russian art at the Salon d'Automne in Paris. Larionov took this opportunity to make his first visit to Paris, where he assisted Diaghilev with the exhibition and became acquainted with the work of Cézanne, Gauguin, the Nabis, and the Fauves.[52]

In 1906–7, Goncharova began to create work modeled after Russian folk and primitive art. In 1907, she traveled across central Russia and painted her first pictures inspired by peasant life, popular and folk imagery, and ancient forms such as the *kamennye baby*. Larionov's fascination with the primitive, particularly provincial signboards, emerged in 1907, and in the summer he traveled to Tiraspol to study Turkish life, gypsies, and shop signs. The two artists declared their interest in rural imagery well before the neoprimitivist movement was announced in Alexander Shevchenko's manifesto *Neoprimitivism: Its Theory, Its Potentials, Its Achievements,* in 1913. They collected the popular print called the *lubok,* as well as Russian icons, and between 19 and 24 February 1913, Larionov and a young architect named Nikolai Vinogradov organized the first exhibition of Russian icons in the halls of Moscow's School of Painting, Sculpture, and Architecture.[53] Through their association with Roman Jakobson, Larionov and Goncharova may

have met Khlebnikov at the Stray Dog cabaret or at the Alpine Rose restaurant in Moscow. As previously mentioned, Kruchenykh and Malevich were part of the circle around Matiushin in Saint Petersburg (then Petrograd).

Toward the Futurist Book

Whereas their poet-collaborators did not venture outside Russia, with the exception of Khlebnikov's trip to Persia in 1921, both Goncharova and Larionov were more cosmopolitan, traveling extensively and building international reputations during their lifetimes. In 1914, the two artists went to Paris to mount set designs for Sergei Diaghilev's Ballets Russes, returned briefly to Moscow in 1915 when Larionov was enlisted, then traveled with Diaghilev's company to Spain and Italy in 1917, before settling permanently in Paris. But as different as the reach of their artistic lives was, the poets and artists shared the same years of radical innovation and discovery between about 1912 and 1914, years marked by their creation of a new form of book art.

The futurists' distinctive approach to book design had its precedents in a collaboration on a series of postcards that Kruchenykh initiated with Goncharova and Larionov in 1912. The artists hand lithographed drawings in black and white on one side of the postcard, while on the reverse Kruchenykh printed the artist's name, the title of the drawing, "published by A. Kruchenykh," and the name of the firm of printers ("tip-lit V. Richter Moscow"). When he turned to the production of the lithographic books *Starinnaia liubov'* (Old-fashioned love) and *Igra v adu* (A game in hell), Kruchenykh repeated the precedent of typesetting the name of the printing firm and its location on the back cover (fig. 13). Probably because the typeset text looked incongruous in a hand-lithographed book, Kruchenykh adopted a different method for *Mirskontsa,* hand writing the printer's information and the word *lithografia* on the first page of the book, rather than typing and abbreviating it (fig. 14).[54]

The poets and painters collaborating on *Mirskontsa* voiced their new aesthetic in manifestos, which they published in collections of transrational poetry and prose. A review of these statements and of related literary and artistic theory of the period reveals a shared adherence to intermedia (what James Joyce called the "verbivocovisual") and to *mirskontsa,* articulated broadly as the invention of multiple interpretations in order to overturn the rational, linear norm and replace it with the experimental and the nonsignifying.

Fig. 13.
Mikhail Larionov (Russian, 1881–1964).
Back cover of Alexei Kruchenykh,
Starinnaia liubov' (Old-fashioned love)
(Moscow, 1912).
Los Angeles, Getty Research Institute,
88-B26416.

Fig. 14.
Mikhail Larionov (Russian, 1881–1964)
and Alexei Kruchenykh
(Russian, 1886–1969).
Design and poetry for "Kak trudno
mertvykh voskreshat'" (How difficult
to resurrect the dead).
From Velimir Khlebnikov and Alexei
Kruchenykh, *Mirskontsa* (Worldback-
wards) (Moscow, 1912).
Los Angeles, Getty Research Institute,
88-B27486.

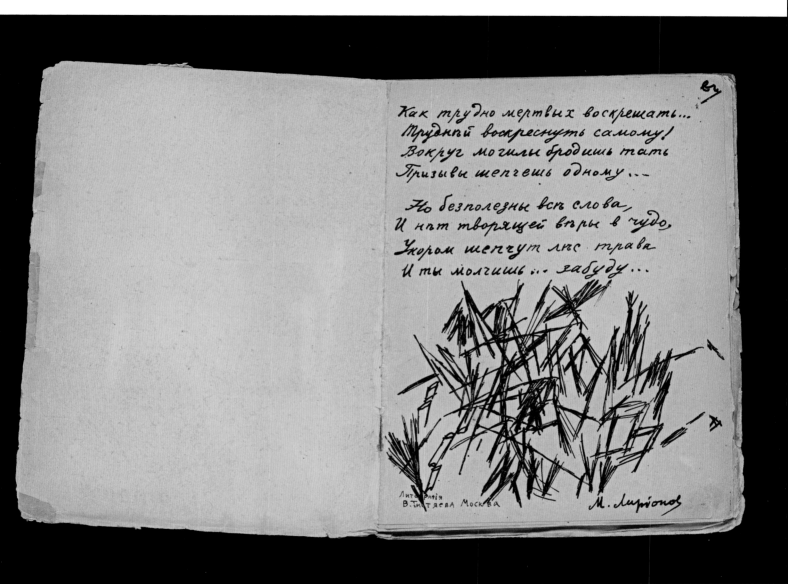

Какъ трудно мертвыхъ воскрешать...
Труднѣй воскреснуть самому!
Вокругъ могилы бродишь тать
Призывы шепчешь одному...

Но безполезны всѣ слова,
И нѣтъ творящей вѣры в чудо,
Укоромъ шепчутъ лисъ трава
И ты молчишь... забуду...

Литографія
В. Титяева Москва

М. Ларіоновъ

Notes

1. Susan Compton, *The World Backwards: Russian Futurist Books, 1912–16* (London: British Library Board, 1978); Gerald Janecek, *The Look of Russian Literature: Avant-Garde Visual Experiments, 1900–1930* (Princeton, NJ: Princeton University Press, 1984); Margit Rowell and Deborah Wye, eds., *The Russian Avant-Garde Book, 1910–1934*, exh. cat. (New York: Museum of Modern Art, 2002); and Nina Gurianova, *The Aesthetics of Anarchy: Art and Ideology in the Early Russian Avant-Garde* (Berkeley: University of California Press, 2012).

2. Jane Ashton Sharp, "The Russian Avant-Garde and Its Audience," *Modernism/Modernity* 6, no. 3 (1999): 101, 114n36.

3. Elena Basner culls this description of futurist performances from A. V. Krusanov, *Russkii avangard: 1907–1932 (Istoricheskii obzor)*, vol. 3, tome 1, *Boevoe desyatiletie* (Saint Petersburg: Novoe literaturnoe obozrenie, 1996). See Elena Basner, "The Artist Richest in Colors," *Natalia Goncharova: The Russian Years*, Elena Basner et al. (Saint Petersburg: State Russian Museum, 2002), 15. Vladimir Markov discusses the Pink Lantern in Vladimir Markov, *Russian Futurism: A History* (Washington, D.C.: New Academia, 2006), 134.

4. Roman Jakobson, *My Futurist Years*, ed. Bengt Jangfeldt and Stephen Rudy, trans. Stephen Rudy (New York: Marsilio, 1997), 105.

5. Paul Bushkovitch, *A Concise History of Russia* (Cambridge, UK: Cambridge University Press, 2012), 218–19.

6. For statistics on immigration to Moscow, Sharp cites Joseph Bradley, *Muzhik and Muscovite: Urbanization in Late Imperial Russia* (Berkeley: University of California Press, 1985). See Sharp, "The Russian Avant-Garde," 95.

7. See "Sounding the Accidental ('Death to Symbolism')," this volume.

8. For advances in Khlebnikov's career, see Velimir Khlebnikov, *Collected Works of Velimir Khlebnikov*, vol. 1, *Letters and Theoretical Writings*, ed. Charlotte Douglas, trans. Paul Schmidt (Cambridge, MA: Harvard University Press, 1987), 4–5, 7.

9. Quoted from V. V. [Velimir] and A. V. [Alexander] Khlebnikov, "Ornithological Observations in the Pavdinsk Preserve," in Khlebnikov, *Collected Works*, 1:211–12, 1:219.

10. For the description of Khlebnikov's interest in nature tamed and for mention of his earliest poem, see Khlebnikov, *Collected Works*, 1:7.

11. Markov, *Russian Futurism*, 8.

12. Markov, *Russian Futurism*, 12.

13. Khlebnikov, *Collected Works*, 1:6–8n13, 1:38.

14. The Pan-Slavic movement opposed the annexation of Bosnia and Herzegovina by Austria. On his name change, see letter 23 in Khlebnikov, *Collected Works*, 1:55.

15. The World of Art group was a circle of young artists, philosophers, writers, and musicians that appeared in the early 1890s in Saint Petersburg. Opposing the naturalistic style of the Wanderers, who incorporated political and social themes, they called instead for an "art for art's sake" approach and a Wagnerian synthesis of the arts. Their leader was Sergei Diaghilev, and their main theoretician was the artist and art critic Alexander Benois.

16. For this chronology, see Velimir Khlebnikov, *The King of Time*, ed. Charlotte Douglas, trans. Paul Schmidt (Cambridge, MA: Harvard University Press, 1985), 14. See also Khlebnikov, *Collected Works*, letter 18, 1:52n1. The prose poem "O sad! Sad!," which Khlebnikov sent to Ivanov on 10 June 1909, was first printed in *Sadok sudei* in 1910.

17. Khlebnikov, *Collected Works*, 1:13.

18. See letter 9 in Khlebnikov, *Collected Works*, 1:41–42.

19. Khlebnikov, *Collected Works*, letter 11, 1:43–44. Douglas explains the reference to "Vladimir the Shining Sun" as an epithet for Vladimir I, Grand Prince of Kiev (978–1015). She identifies *byliny* as Russian epic oral poems dating back to the Middle Ages; rural singers still performed them in the early part of the twentieth century.

20. See letter 16 in Khlebnikov, *Collected Works*, 1:49.

21. For the date of Khlebnikov's visit to Chernianka, see Benedikt Livshits, *The One and a Half-Eyed Archer*, trans. John E. Bowlt (Newtonville, MA: Oriental Research Partners, 1977), 53, 66n8. Scholars differ on this date. I will be relying on Livshits's memoir, which Vladimir Markov considers "not only the best source on the history of Russian futurism, but also one of the best among Russian memoirs." Markov, *Russian Futurism*, 33.

22. Livshits, *The One and a Half-Eyed Archer*, 55.

23. Livshits, *The One and a Half-Eyed Archer*, 58–59.

24. Chernianka, the Burliuks' residence, was located in Hylaea.

25. Biographical information is culled from Alexei Kruchenykh, *Our Arrival: From the History of Russian Futurism* (Moscow: RA, 1995), 14, 173n1.

26. Kruchenykh, *Our Arrival*, 35, 178n40.

27. Kruchenykh, *Our Arrival*, 15.

28. Kruchenykh, *Our Arrival*, 35–36.

29. Beginning in letters from April 1911 to Matiushin and to his sister, Khlebnikov wrote about studying the "Laws of Time," which involved working on numbers and the fates of nations. He would continue this study for the rest of his life. See Khlebnikov, *Collected Works*, 1:15.

30. Most Khlebnikov scholars agree that he wrote the play *Mirskontsa* in 1912. See Gerald Janecek, "Mirskontsa u Khlebnikova i u Kruchenykh," in *Iazik kak tvorchestvo: Sbornik statei k 70 letiiu V. P. Grigor'eva* (Moscow: Institut Russkogo Iazyka RAN, 1996), 80–87. The Vroon/Schmidt volume dates the play to 1912. See Velimir Khlebnikov, *Collected Works of Velimir Khlebnikov*, vol. 2, *Prose, Plays, and Supersagas*, ed. Ronald Vroon, trans. Paul Schmidt (Cambridge, MA: Harvard University Press, 1989), 249. Their source text is M. Ia. Poliakov, V. P. Grigoriev, and A. E. Parnis, eds., *Tvorneniia* (Works) (Moscow: Sovetsky pisatel, 1986), 42.

31. Janecek states that Kruchenykh wrote his poem in response to Khlebnikov's play. See Janecek, "Mirskontsa u Khlebnikova," 80–81. On the origins of the term

mirskontsa, see Vladimir Poliakov, *Knigi russkogo kubofuturizma* (Moscow: Gilea, 1998), 169. Poliakov also dates the play to 1912 and explains that Kruchenykh tried to take credit for the neologism. See Poliakov, *Knigi russkogo kubofuturizma*, 346–347n22. It is true that, in his memoirs, Kruchenykh takes responsibility for suggesting that Khlebnikov replace the title "Olia and Polia" with "Mirskontsa." See Kruchenykh, *Our Arrival*, 48.

32. According to the Russian edition of Khlebnikov's collected works, Khlebnikov sent Kruchenykh a letter in September 1912 in which he thanked his friend for the poem "Starye shchiptsy zakata" (but showed his disdain by giving it the title "Rattletrap Roof-Ends, a Mishmash"). I date the poem based on this letter. See Rudolf Duganov, ed., *Velimir Khlebnikov: Sobranie sochinenii v shesti tomakh*, vol. 6 (Moscow: Nasledie, 2000), 144–46. Note that in Khlebnikov, *Collected Works*, 1:71–73, Charlotte Douglas dates this letter to early 1913.

33. Compton, *The World Backwards*, 19.

34. Eugene Ostashevsky, ed., *Victory over the Sun: The First Futurist Opera by Aleksei Kruchenykh*, trans. Larissa Shmailo (W. Somerville, MA: Červená Barva, 2014), n.p.

35. Translated in Khlebnikov, *Collected Works*, 1:74. The letter was first published in the Soviet edition of Khlebnikov's selected writings: Velimir Khlebnikov, *Tvoreniia*, ed. M. Poliakova (Moscow: Sovetskii pisatel, 1986), 689. *The World in Reverse* refers to Khlebnikov's play, *Mirskontsa*.

36. Jakobson, *My Futurist Years*, 3–4.

37. For this quote from the letter to Kruchenykh, see S. M. Sukhoparov, *A. Kruchenykh: Sud'ba budetlianina* (Munich: Verlag Otto Sagner in Kommission, 1992), 54–55. Translation by Antanina Sergieff.

38. S. R. Krasitskii, "O Kruchenykh," in Kruchenykh, *Stikhotvoreniia, Poemy, Romany, Opera* (Saint Petersburg: Akademischeskii proekt, 2001), 15; cited in Firtich, "Worldbackwards," 603, full citation on p. 606.

39. For this and the previous quote, see Kruchenykh, *My Arrival*, 46.

40. *Mirskontsa* (1912; Worldbackwards); *Slovo kak takovoe* (1913; The word as such); *Bukh lesinnyi* (1913; Forestly rapid); *Starinnaia liubov': Bukh lesinnyi* (1914; Old-fashioned love: Forestly rapid); and *Te li le* (1914).

41. Khlebnikov, *Collected Works*, 1:25–27.

42. For this and the following quotation, see Kazimir Malevich, "Chapters from an Artist's Autobiography," in *Kazimir Malevich: Letters, Documents, Memoirs, Criticism*, 2 vols., ed. Irina A. Vakar and Tatiana N. Mikhienko, trans. Antonina W. Bouis (London: Tate, 2015), 1:17.

43. For the biographical information, see Malevich, "Chapters," 1:19n3, 21.

44. Malevich, "Chapters," 1:21.

45. For this recollection of the visiting artists, see Malevich, "Chapters," 1:21–23.

46. He continues, with reference to ideas he shared with Goncharova, Larionov, and Alexander Shevchenko: "Our conclusions were such that we determined that art must be 'as such.' My own attitude toward the world was exclusively painterly, poetic, musical. There can be no attitude from the point of view of ideological content. We stood for pure art and would not permit the mixing of painting with the inherently non-painterly content of an objectified worldview." See Malevich, "Chapters," 1:38–39.

47. Basner, "The Artist Richest in Colors," 10; and Elena Basner, "Chronicle of the Life and Work of Natalia Goncharova," both in *Natalia Goncharova: The Russian Years* (Saint Petersburg: State Russian Museum, 2002), n.p.

48. In addition to Basner, see Sharp, "The Russian Avant-Garde," 112n12; and Jane A. Sharp, "Natalia Goncharova," in *Amazons of the Avant-Garde: Alexandra Exter, Natalia Goncharova, Liubov Popova, Olga Rozanova, Varvara Sepanova, and Nadezhda Udaltsova*, ed. John E. Bowlt and Matthew Drutt (New York: Solomon R. Guggenheim Foundation, 1999), 156, 158.

49. Yevgeny Kovtun, *Mikhail Larionov* (Bournemouth, UK: Parkstone, 1998), 13.

50. G. G. Pospelov and E. A. Iliukhina, *Mikhail Larionov* (Moscow: Galart, 2005), 362.

51. Jane Sharp writes that Goncharova did not officially withdraw from the Moscow School until 1909. See Sharp, "Natalia Goncharova," 158.

52. For this account of Goncharova and Larionov's studies at the Moscow School and their participation in the Salon d'Automne, see Basner, "Chronicle of the Life."

53. Kovtun, *Mikhail Larionov*, 81

54. Compton, *The World Backwards*, 70.

Sounding the Accidental
("Death to Symbolism")

In their untitled manifesto of February 1913, which appears at the beginning of the anthology *Sadok sudei* 2 (A trap for judges 2), David and Nikolai Burliuk, Elena Guro, Velimir Khlebnikov, Alexei Kruchenykh, and Benedikt Livshits announce: "We've ceased to regard word-construction and word-pronunciation according to grammatical rules, having begun to see in letters only *directions of speech*. We shook syntax loose." The first in a series of "new principles of creativity," this point leads directly to the following: "We've begun to endow words with content based on their graphic and *phonic charac- teristics*." And later in the manifesto: "We've shattered rhythms. Khlebnikov has advanced a poetic meter of the living spoken word."[1]

These three principles share in common the futurist poets' humorous disregard for nine- teenth-century lyric poetry and their conviction that, in their transrational language of *zaum,* sound takes precedence. "Living" connects "the word" to speech, which in turn likens "the word" to sound. Implicit, moreover, in the "shaking loose of syntax" is a challenge to the linearity of sentence structure and a new attention to the independent word. Precisely on this theme, a mani- festo titled *Slovo kak takovoe* (1913; The word as such) by Khlebnikov and Kruchenykh traces the futurists' concept of the self-referential word back to 1908—thus predating the founding mani- festo of the Italian futurists (1909)[2]—and proposes: "Henceforth a work of art could consist of a *single word,* and simply by a skillful alteration of that word the fullness and expressivity of artistic form might be attained.... A work of art is the art of the word." The poets make a point of con- trasting their concept of "the word as such"—in all its materiality and phonic play—with the the- ory of the Italian futurists, which they criticize for reverting to emotional content. The "[Russian futurist] word-worker," they conclude, "remains face to face, always and ultimately, with the word (itself) alone."[3]

A second manifesto with the title *Slovo kak takovoe* was written by Khlebnikov and Kruchenykh and published in September 1913 in a fifteen-page pamphlet of prose and poetry. Here the call is less for *zaum* as pure sound poetry than for a dismissal of the clichés of symbolist poetry, which the manifesto enumerates as "clarity, purity, propriety, sonority, pleasure (sweetness for the ear), forceful expression (rounded, picturesque, tasty)."[4] Rejecting these as requirements of symbolist language that are "more applicable to woman than to language," the poets assert: "It is true that these days one is forced to metamorphose Woman into the Eternal Feminine, into the elegant lady, and so the skirt is *mystical....* As for us, we believe that language should first of all be *language,* and if it is to remind us of anything, let it remind us of a saw or the poisoned arrow of a savage."

The double reference to primitivism (here, the intentionally crude) and abstraction conveys the same polarity explored by Kazimir Malevich in his cubo-futurist paintings and by poets and painters in their futurist books. Moreover, Malevich calls attention to this opposition, and reinforces the word-image-sound relationship in collaborative book art, by pasting a drawing onto the cover of the *Slovo kak takovoe* pamphlet (fig. 1). Unlike the Italian futurists, who published their manifestos in newspapers and broadsides, the Russians included manifestos and drawings in their collaborative books—their signature art form. The title of Malevich's cover drawing, handwritten to the left of his signature, is *Zhnitsa,* the feminine form of the word *reaper.* Indeed, we see a hand holding a scythe on the right and a dynamic visualization of the reaper's skirt and her shoes as she moves. From there, Malevich takes his primitive subject matter in abstract directions. The reaper's body is built of cones, especially visible in the skirt, the inverted cones of the legs, and the arm that holds the scythe. A loose grid of lines that do not form right angles creates a network extending across the reaper's body, while a number of single lines continuing beyond her figure serve as planar forces that counteract her ambiguous three-dimensionality. Her head is scarcely visible.

The placement of this cover collage on a booklet about "language as such" could not be more apt. Khlebnikov and Kruchenykh refer in their manifesto to *zaum* as a transrational language in which "Futurian wordwrights use chopped-up words, half-words, and their odd artful combinations."[5] Every phoneme in these verbal combinations assumes importance. Moreover, the poets draw an analogy to "Futurian painters," who "love to use parts of the body, its cross sections." Such verbal and visual techniques are the fruits of a collaborative process (wordwrights and painters) and challenge linearity, just as they cultivate abstraction. Because the futurists associated

sound with the transrational, it too plays a role in connecting the themes of the poets' manifesto to the visual abstraction of Malevich's reaper.

Another manifesto, this time by Kruchenykh and provocatively titled *Novye puti slova (iazyk budushchago, smert' simbolizmu)* (New ways of the word [the language of the future, death to symbolism]), appeared in September 1913 in the collection *Troe* (The three), with verse and prose by Guro, Khlebnikov, and Kruchenykh. Once again, a futurist book provides the container and the context for a manifesto and poetry. In the course of this manifesto, Kruchenykh states in capital letters: "THE WORD BROADER THAN SENSE," his concise formula for a claim that the word, rather than being reduced to nonsense, expands our ordinary awareness.[6] He continues

with the following definition: "The word (and its components, the sounds) is not simply a truncated thought, not simply logic, it is first of all the transrational (irrational parts, mystical and aesthetic)." Kruchenykh's emphasis here on the abstraction of *zaum* and on the phonic character of the self-sufficient word leads him to a phonetic analogy. Selecting two neologisms that have different meanings—*mechari* (swordsmen) and *smekhiri* (laughers)—Kruchenykh connects them on the basis of their common sound. He then observes that these two words have more in common than *mechari* has with a different word, *gladiatory* (gladiators)—even though the latter shares a similar meaning, because "it is the phonetic composition of the word which gives it its living coloration, and the word is perceived and keenly affects you only when it has that coloration."[7]

A critique of symbolism runs through *Novye puti slova*. Kruchenykh makes a point of writing, for instance, "We do not need intermediaries—the symbol, the thought—we convey our own new truth, and do not serve as the reflection of some sort of sun (or a wood log?)." His defense of futurist "irregularities" in speech structure, such as "arbitrary word-novelty (pure neologism)" and "unexpected phonetic combination," contains an implicit attack on symbolist purity and consonance.[8] And in the manifesto from the *Slovo kak takovoe* pamphlet, Khlebnikov and Kruchenykh attack symbolist expressions of inner feeling, femininity, and nuance with decidedly unsymbolist language: "As if it were written with difficulty and read with difficulty, more uncomfortable than blacked boots or a truck in a drawing room."[9] The appeal of these and other futurist manifestos lies in their unabashed preference for new poetic devices and material form, which sometimes involved a dismissal of referentiality altogether. Indeed, Kruchenykh makes sure to distinguish the symbolists' stress on verbal suggestibility and synaesthesia from the futurists' concern for the precedence of form: "A new content *becomes manifest only* when new expressive devices are achieved, a new form. Once there is a new form, a new content follows; form thus conditions content."[10]

Novye puti slova also contains a direct reference to the *mirskontsa* principle, with its suggestion of a move from linearity to nonreferentiality. Kruchenykh writes: "We learned how to look at the world backward, we enjoy this reverse motion (with regard to the word, *we noticed that it can be read backward, and that then it acquires a more profound meaning!*)"[11] Reading backward heightens the word and takes it to new planes. By interesting coincidence, only two years later, in 1915, Malevich wrote his manifesto *Ot' kubizma i futurizma k suprematizmu: novyi zhivopisnyi realizm* (From cubism and futurism to suprematism: The new painterly realism), a paean to abstraction in which he reached creation by starting anew (going backward) in the zero of form:

I have transformed myself *in the zero of form* and have fished myself out of the *rubbishy slough of academic art.*

I have destroyed the ring of the horizon and got out of the circle of objects, the horizon ring that has imprisoned the artist and the forms of nature.

This accursed ring, by continually revealing novelty after novelty, leads the artist away from the *aim of destruction.*

The forms of suprematism, the new painterly realism, already testify to the construction of forms out of nothing, discovered by intuitive reason.[12]

In a *zaum* poem taken from his carbon copy book, *Nosoboika* (1917; Nosebrawl), Kruchenykh identifies his principle of "worldbackward" with Malevich's founding principle of suprematism—defined by Kruchenykh as "to bring everything to zero" and then to "pass beyond zero."[13] Kruchenykh's poem reads: "If there is no *zaum* (objectless, Supremus) poetry, then there is no poetry at all!…worldbackward [*mirskontsa*] and eco-po and eco-art (ho-bo-ro)."[14]

Collaborative art, the aesthetic of the accidental and the reversible, the elevation of phonic values, the relation of sound to verbal abstraction—all find expression in the futurists' manifestos. Malevich's suprematist manifesto praises one overriding principle by offering the most radical treatment of nonobjectivity. What we might call the futurist aesthetic, as it encompassed the collaborative and the verbivocovisual, gains subtlety and clarity when contextualized in relation to the system of scientific poetics called Russian formalism—which futurism helped shape—and the hyperspace philosophy of P. D. Ouspensky.

But first a brief, but broader, review of the debate between the Russian futurists and the symbolists, the latter of whom upheld figuration. Frequently critiqued in futurist manifestos, symbolism played an important role as a precursor to Russian futurism and yet, paradoxically, as a movement vehemently opposed by Russian as well as Italian futurists. From the literary standpoint, this opposition expressed itself as a reaction against the symbolists' principal goal, which was to convey complex, suggestive meanings that could not be paraphrased in prose. In lieu of symbolist synaesthesia and the mediation of symbols (signs) to perceive art and life, the Russian futurists advocated visual and literary abstraction. Here they reacted against both realism and symbolism.

Scholars such as John Bowlt, Susan Compton, Nina Gurianova, and Vladimir Markov discuss differences between Russian symbolism and Russian futurism as a basis for defining the innovations of the futurists, especially their approach to book art. According to Gurianova, the symbolist sensibility prioritized fixed ideas over the process of creation. Both art and life were always perceived through the mediation of a symbol, a sign, which became an absolute model that controls reality. The futurists, by contrast, intertwined notions of art and life. And whereas the symbolists "tried to reconstruct life around them as a work of art, the futurists submitted their art to the evasive flux of life."[15]

Compton, in her book *The World Backwards,* opens her section on graphic design with a description of *Mir iskusstva* (The world of art) magazine (1898–1904) as "the first of a large number of lavish journals to succeed one another in Russia."[16] These symbolist magazines combined new prose and poetry with reproductions of artwork and art criticism. Compton contrasts later silver-embossed journals such as *Zolotoe runo* (1906–9; The golden fleece) with the pocket-sized futurists' miscellany *Sadok sudei* (1910; A trap for judges), which marked the first anthology of Russian avant-garde poetry (figs. 2, 3). In an antisymbolist gesture, contributors chose to print the poetry on the reverse side of patterned wallpaper and to glue the title label to the wallpaper

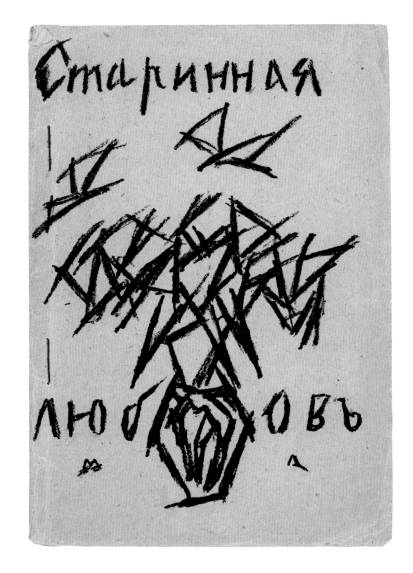

Fig. 4.
Mikhail Larionov (Russian, 1881–1964).
Cover of Alexei Kruchenykh,
Starinnaia liubov' (Old-fashioned love)
(Moscow, 1912).
Los Angeles, Getty Research Institute,
88-B26416.

cover, thus introducing nonbook materials into a poetic anthology. Compton continues her discussion by turning to a more overtly antisymbolist book, *Starinnaia liubov'* (1912; Old-fashioned love), which is postcard-sized, stapled, hand-lithographed on thin paper, and replete with verse mocking symbolist love poetry, as well as imagery approaching the nonfigurative (fig. 4).[17]

Mystic Formalism

Futurist theories of form and abstraction played a significant role in the development of Russian formalism. As linguists, philologists, and critics, formalists sought a new methodology for studying modern Russian poetry. In the first decades of the twentieth century, Russian literary scholarship occupied itself chiefly with biography, rather than with the poetic work. Linguists were aware, however, that if literary history were to acquire a method and become a science, "it had to find a 'hero,'" that is, a distinct and integrated province of study. Moreover, it had to shift its investigation from *what* the authors (poets, novelists) were saying to *how* they were saying it—how the language sounds and how it means.[18]

For help in analyzing the function of language, the Moscow linguists turned to the German philosopher Edmund Husserl and his Russian disciple Gustav Spet. The latter argued that "all forms of expression, including language, should be treated not as by-products or sensory symptoms of psychological processes, but as realities in their own right, as *sui generis* objects requiring structural description."[19] From there, the Moscow linguists focused specifically on poetics, calling it a "functional" type of speech in which all the components were subordinated to the same constructive principles. Indeed, they identified poetic speech as the "hero" of Russian literary history. Inspired both by the futurists' elevation of "the word as such" and by the exploration in transrational poetry of sounds with no definite meaning, the formalists developed a doctrine positing that poetic speech differed sharply from all other forms of communicative speech.[20]

Roman Jakobson, for instance, emphasized the verbal materials of poetry and alluded to the minor role that denotative meaning should play: "But poetry—which is simply *utterance for the purpose of expression*—is governed, so to speak, by its own immanent laws; the communicative function, essential to both practical language and emotive language, has only minimal importance in poetry. Poetry is indifferent to the subject of the utterance."[21]

Viktor Shklovsky opens his first published essay, "The Resurrection of the Word," with the declaration that the most ancient poetic creation of humans was the creation of words. Like Jakobson and the futurists before him, Shklovsky deals exclusively with poetic speech, distinguishing

"new, living words" from old ones and arguing that when words become too familiar, they are recognized but cease to be seen. He asserts, for example, "We do not see the walls of our rooms, it is so hard for us to spot a misprint in a proof—particularly if it is written in a language well-known to us, because we cannot make ourselves see and read through, and not 'recognize' the familiar word."[22] He refers to the splashing waves of the sea and the thousand-voiced roar of the town as sounds so well known and familiar to us that they disappear from our consciousness—we do not see or hear, but only recognize them.[23]

Shklovsky also speaks globally, not only about language but about life itself. He deplores the present situation in which "we have lost our awareness of the world," do not love our houses and clothes, and "easily part from a life of which we are not aware." The challenge for the artist is thus to render words living, unfamiliar, and poetic by basing them on new forms of art that "can restore to man [sic] sensation of the world, can resurrect things and kill pessimism."[24] Moreover, Shklovsky endorses "breaking down" the word and "mangling it up" in order to give birth to the "arbitrary" and "derived" words of the futurists, who built their words from old roots or from the application of incorrect stress. He praises their new poetic language, because it was incomprehensible, difficult, not "sweet," and "tight" (the latter, from Kruchenykh, means "directed at seeing," not at recognition).[25]

In developing the idea of the distinctive character of poetic speech, the formalists helped theorize the themes of the futurists, including their belief in the primacy of form over content. The futurists' invention of "trans-sense" language (Shklovsky's term) was considered by the formalists to emancipate the word by investing it with meaning through its graphic and phonic characteristics and by loosening the bond between the sign and its object, the word and its referent.[26] With form no longer seen as being connected to some other external element of a work of art—that is, to content—the formalists conceived of "form as the totality of the work's various components." Tsvetan Todorov explains, "Analysis of form, in other words of the totality of the work of art, leads to the identification of its functions, i.e. the relation between its various components."[27]

The futurists' designation of the signifier as "the self-sufficient word" and "the word as such" shaped the formalist debate. It inspired Jakobson to accentuate the close relation of word to sound (the "verbal sound"), and hence to call the sign "the sound as such," leaving the object in the shadows.[28] Shklovsky made "the word as such" the impetus behind his "resurrection of the word."[29] For the formalists, however, no poetry could dispense completely with meaning: "The

denotative precision arrived at by 'practical' language gives way to connotative density and a wealth of associations."[30]

As they heightened poetic speech, the formalists introduced what they called "devices" of general linguistic thought processes, which they connected to the new creative devices of the futurists' poetry.[31] The futurist devices upheld the unfamiliarity and partial comprehensibility of the word through the introduction of new forms, thus avoiding the word's degeneration from lively poetry to old prose. Similarly, Shklovsky based his "device of making it strange" on the assumption that the purpose of art is to avoid habitualization: "[Art] exists to make one feel things, to make the stone *stony*.... The technique of art is to make objects 'unfamiliar'...to increase the difficulty and length of perception because the process of perception is an aesthetic end in itself.... *Art is a way of experiencing the artfulness of an object; the object is not important.*"[32]

In specific literary terms, Shklovsky advocated a "semantic shift" (*sdvig*), in which the image (object) depicted was transferred to a different plane of reality and thus made strange to the perceiving subject. By interposing artificial obstacles between the subject and the object perceived, the poet broke the chain of habitual associations. The habitual was presented as if it were seen for the first time.[33]

This defamiliarization was part of the formalist device of "laying bare." Formalists used speech sounds and verbal play to lay bare the phonic texture of the word and to add new verbal material, so that the irrational structure of poetry might once again disturb us. Jakobson describes the laying bare of a "temporal shift" in Khlebnikov's play *Mirskontsa* (Worldbackwards). Because the play has the "effect of a motion picture film run backwards," and Khlebnikov provides no motivation or justification for narrating the events in reverse order, Jakobson considers the poet's device a "laying bare" that is "not motivated."[34] Through temporal displacement, the reader's awareness of time and its linear unfolding is sharpened and made strange.

Another method of defamiliarization—which the formalists called the device of "orientation toward the neighboring word" ("deformed semantics")—derives the meaning of the poet's word from its context to a much greater extent than in ordinary speech.[35] Just as words placed next to each other in verse tend to acquire new, lateral (semantic) associations through the unexpected "crisscrossing of meanings," so in Khlebnikov's poem *Zakliatie smekhom* (1910; Incantation by laughter), the word *smekh* (laughter) is transformed by its varied placement in each line and by the different parts of speech it assumes through shifting neologisms.

In the view of the formalists, Italian futurism epitomized all that poetics should work against. This assessment, directed specifically at Filippo Tommaso Marinetti, who visited Saint Petersburg and Moscow in February 1914, indicates the formalists' unwillingness to acknowledge the many poetic and artistic innovations shared by the Russian and Italian futurists. In the realm of Russian futurist book art and its Italian futurist analogue—the *parole-in-libertà* (words-in-freedom)—poetic language was transformed by the elimination of grammar and syntax, the experimentation with new arrangements of words and letters on the page, and the highlighting of language for its sonic expressivity. Both Russian futurist book art and the *parole-in-libertà* incorporated verbal, visual, and sonic elements into their art forms, although the Russians ventured much further into the verbivocovisual than did the Italians.

Common to the manifestos of the Russian futurists, who learned manifesto writing from the Italians, was a nihilistic concept of confirmation through negation. This took the form of a call to "purge the old" and declare war against "common sense" and "good taste" in art and poetry; a hatred of "ossified" language; and a championing of "disrupted" syntax and of the destruction of punctuation.[36] Thus, both the Russian and the Italian futurists sought to rid language of its conventional structures.

Yet the formalists were not entirely wrong in their judgment of Italian futurism and in their insistence on crucial differences from Russian futurism. Let me first insert some differences not mentioned by Jakobson and the formalists, namely: the Russians did not share the Italians' glorification of war as "the world's only hygiene," nor did they celebrate technology and speed. Rather than rejecting the past, as did the Italians, the Russians excavated ancient forms of their own culture, such as the icon, Scythian sculpture, and the *lubok* (popular print) and incorporated them into their modern art. Most importantly, whereas Italian visual poems used onomatopoeia to depict specific events and occurrences, whether on the battlefield or in a café, Russian futurist book art ventured much further into nonmimetic terrain. A reading of the Italian *parole* by Marinetti titled "In the Evening, Lying in Her Bed…" (1917) (see "Introduction," fig. 9), for example, paints a sonic field of explosions and bombardments through literal, pictorial sounds such as "trac" and "tumb tumb."

Jakobson may well be referring to this pictorial poetry when he argues, persuasively, if somewhat too combatively, that the Italians were making reform "in the field of reportage, not in poetic language."[37] He points out that the Italians' innovation consisted of "new facts in the material and psychological worlds," rather than a poetry of the "self-developing, self-valuing word." And he criticizes the Italians for being caught up in subject matter and emotive language

("interjections and exclamations of hysterical discourse"), contrasting their work with the poetic speech of the Russians.[38] Although Jakobson unfairly overlooks the avant-garde experimentation of the *parole-in-libertà* and makes claims that are extreme, he is ultimately correct in asserting that the Italians could not pull off the nonfigurative and thus remained closer to symbolism than to the abstraction of the Russian futurists. In Jakobson's words, "It is the conversion of real images into figures, their metaphorization, that forms the basis of Symbolism as a poetic school."[39] The Russians, by contrast, left metaphors behind.

Jakobson's attacks on Italian futurism disclosed by contrast what he considered to be the defining and superior qualities of the Russian futurists. Not surprisingly, these were literary principles also touted in formalist criticism, such as the exploration of trans-sense language and Kruchenykh's observation, quoted by Jakobson, that "it is not new subject matter that defines genuine innovation."[40] Rather, according to Kruchenykh, it was the "word as such": "We were the first to say that in order to depict the new—the future—one needs *totally new words and a new way of combining them.*"

Sound as Such, Image as Such, the Word Made Strange in the Russian Artist's Book

In the course of his essay on "The Newest Russian Poetry," Jakobson tries to extend the futurist concept of the "the self-developing, self-valuing word" to the other arts: "The plastic arts involve the shaping of self-sufficient visual impressions, music the shaping of self-sufficient sound material, dance the organization of the self-sufficient gesture, and poetry is the formulation of the self-sufficient, 'selfsome,' word, as Khlebnikov puts it."[41]

Yet what in fact does it mean to apply the formalist devices of "defamiliarization," "semantic shift," "laying bare," and "making the word strange" to the visual arts and to sound? How was one to transfer to the other arts Shklovsky's mandate to heighten poetic speech by rendering words living and unfamiliar, as well as by "seeing," rather than "recognizing," them?

The answers can be found if we turn to futurist book art. The book *Te li le* (1914), for example, contains a cover by Olga Rozanova, imagery by Rozanova and Nikolai Kulbin, and poetry by Khlebnikov and Kruchenykh that they culled from earlier books (fig. 5). Rozanova fabricated this book using the technique of hectography, which in this case resulted in a palette of seven different colors.[42] Already on the cover, Rozanova presents a verbivocovisual design that defamiliarizes its image of an urban landscape by contrasting it with the simple sound alternation of the book's title, which is Kruchenykh's contribution.

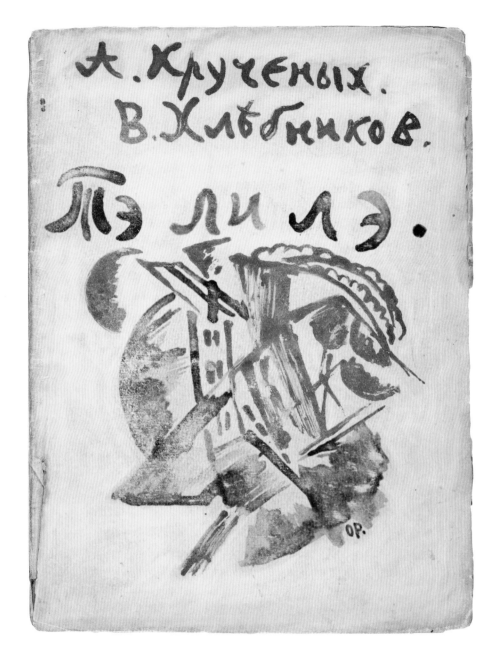

Fig. 5.
Olga Rozanova (Russian, 1886–1918).
Cover of Velimir Khlebnikov and
Alexei Kruchenykh, *Te li le*
(Saint Petersburg, 1914).
Los Angeles, Getty Research Institute,
88-B28007.

In the middle of the cover, a gray skyscraper and a gray factory tower emit smoke as they are swept up in a maelstrom of chaos.[43] The adjacent purple hints at a continuing urban landscape but is essentially abstract and more calm. The minimal title words, "Te li le," are *zaum,* childlike, and characterized by assonance on repeated vowels (*E* alternating with *I*) and consonance on *T* and a repeated *L*. Their sonorous sounds defamiliarize the city towers by offering a dramatic opposition to the hints of urban frenzy and noise. Rozanova called attention to the title's rhyme by giving "Te" and "le" the same purple color and by drawing "li" in a shade of blue that appears nowhere else on the cover. Visual rhyme emerges from the repetition of the letterforms *L* and *E* in each sound cluster. Rozanova punctuated the *zaum* title with a large period, another act of defamiliarization, because periods do not typically follow book titles.

We thus have a book cover that adheres to the poetic abstraction advocated by Russian formalism but is rendered here through a multilayered interchange of word, image, and sound. The poet and painter collaborated to create this texture through the abstract sounds of the title, the use of color to articulate verbal rhyme, and the suggestions of an urban cityscape hovering on the edge of abstraction.

A comparison between two visual settings of Kruchenykh's sound poem "Dyr bul shchyl" offers a different example of the word made strange—"the sound as such," as realized verbally and visually in the futurist book. In the first example (fig. 6), the book *Pomada* (Pomade), a collaboration between Kruchenykh and Mikhail Larionov from 1913, Kruchenykh introduces a set of *zaum* poems with these words: "3 poems / written in their own language / it differs from oth. / its words have no definite meaning." The first poem, preceded by the number 1 on the page, transliterates as follows:

dyr bul shchyl
ubeshshchur
skum
vy so bu
r l ez

It consists entirely of morphemes that carry no semantic meaning. This nonfigurative language becomes highly evocative, however, when the poem is heard aloud. Meaning, although indefinite, as Kruchenykh tells us, emerges from the intricate relationship between Larionov's

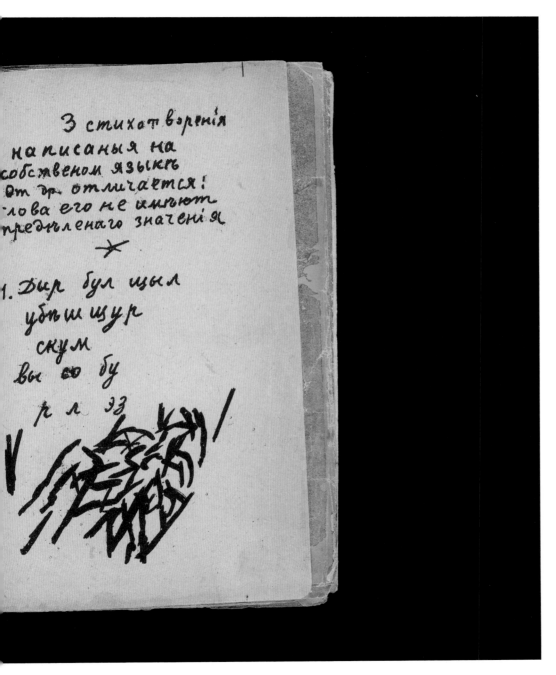

З СТИХОТВОРЕНІЯ
написаныхъ на
собственомъ языкѣ
от др. отличается:
слова его не имѣютъ
опредѣленаго значенія

№ 1 дыр бул щыл
убѣщур
скум
вы со
бу
р л эз

Fig. 7. ◀))
Olga Rozanova (Russian, 1886–1918)
and Alexei Kruchenykh (Russian,
1886–1969).
Design and poetry for "Dyr bul shchyl."
From Velimir Khlebnikov and
Alexei Kruchenykh, *Te li le*
(Saint Petersburg, 1914).
Los Angeles, Getty Research Institute,
88-B28007.

handwritten scrawl, his drawing beneath it, and the live sound poem with its gruff syllables comprised of repeated phonic *U* and *Y*. Amid abstract, interlocking angles, the drawing conceals a suggestion of the bent knee and splayed legs of a reclining nude woman. This visual reference to a female with open legs is consistent with the imagery on the cover and throughout *Pomada*, depicting or alluding to urban prostitutes. The visual, moreover, inflects the vocal. Our ears become especially attentive to the poem's monosyllabic, primordial, and erotic sounds. ◀))

Kruchenykh brought back his "3 poems" in the book *Te li le*, this time with handwriting by Rozanova using the hectographic technique (fig. 7). Her setting of "Dyr bul shchyl" (again preceded by the number 1) is primarily in blue, with some highlighting in brown. Instead of dividing the page into text (writing) and image (drawing), as Larionov did, Rozanova inserted strokes of ink amid and around the words of the poem. Letters are frequently rendered illegible as they transform into abstract drawings or become too faint to decipher. The result is a sound poem comprised of primitive consonant clusters made strange and abstract by Rozanova's pastoral, visual rendering.

Malevich praises Kruchenykh's "Dyr bul shchyl" as an example of freeing up the word by using so few letters that it ceases to be a word: "Then there are no words, there are the sounds *dyr bul shchyl*. Since these are sounds then it follows that we must begin from points of pure sound. Then we must hear, but not think."[44] He calls the letter a "new sound sign" and groups of letters "sound masses." Sound belonged to speech, and never to music.

Russian Futurism Beyond Formalism

In addressing the relationship between poetic sounds and the notations of those sounds—that is, letters—Jakobson's foregrounding of the visual element was likely inspired by Khlebnikov and Kruchenykh's manifesto *Bukva kak takovaia* (The letter as such).[45] Jakobson insisted, however, that "the sound as such" should take precedence over the letter and that the most important phenomenon was the breaking down of the word into sounds.[46] This insistence reveals a limited recognition, on the formalists' part, of the futurist concept of the word as possessing visual as well as linguistic characteristics. It also shows a narrow understanding of futurist collaborative media, specifically of the word-image-sound interplay that was so crucial to the concept of the futurist book. Futurist poets had already proclaimed the significance of poetry's visual, phonic, and verbal dimensions in the untitled manifesto in *Sadok sudei* 2 (1913; A trap for judges 2). Yet Jakobson, Shklovsky, and their formalist colleagues did not carry through with the visual. Formalism remained a theory of the word, inadequate to the full verbivocovisual dimension of the artists' books.

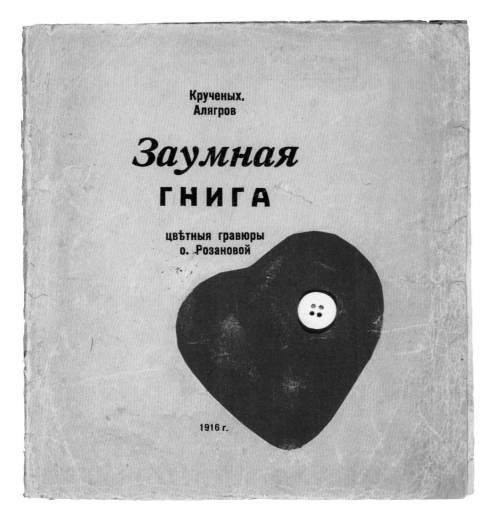

Among the formalists, Jakobson alone was a practicing poet who wrote futurist verse and expressed interest in the resonance of abstract painting and sound. In 1914, before the war began, he and Kruchenykh collaborated on the book *Zaumnaia gniga* (Transrational boog), which they published in 1915. Kruchenykh inscribed the cover, which features both poets' names, with the date 1916, so that it would be seen as a book of the future (fig. 8). Jakobson followed Kruchenykh's lead in contributing two *zaum* poems; they appear on the last page of the book in black typescript

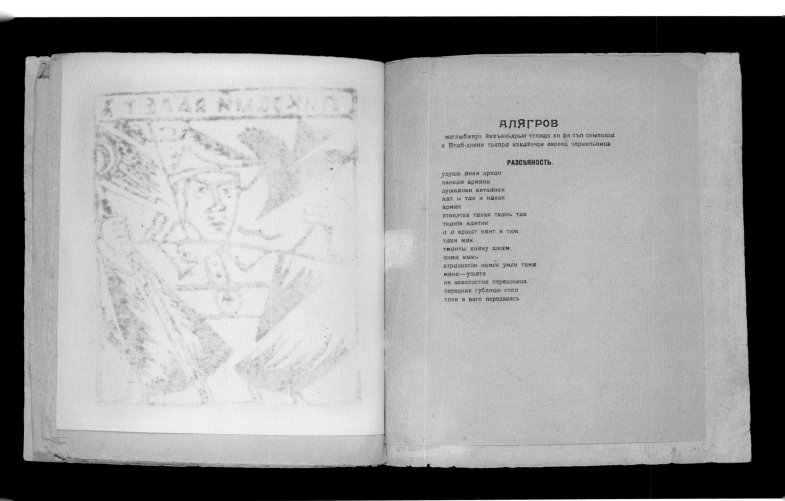

under the pseudonym Aliagrov (this is also the name that Kruchenykh wrote on the cover) (fig. 9). According to Jakobson, "Alja" was the name of his girlfriend and "ro" was an abbreviation for Roman Osipovish, the latter his patronymic name.[47] More revealing and convincing than this gloss is Jakobson's enlargement of the "IA" in the printed pseudonym, which refers both to the first-person singular pronoun in Russian and to the first letter (ИА) of his surname.[48]

The two lines of mostly tongue-twisting consonants that comprise Jakobson's first poem look more like prose. The only intelligible word, *evreets,* a compound of *every* (Jew) and *evropeets* (a European), suggests that this might be some kind of nonsensical naming or identification of the poet. The second poem, titled "Razsenanost'" (Distraction) and written in verse, is Jakobson's attempt at a *zaum* poem, but the repeated sound patterns do not cohere, nor does an English translation offer the kind of suggestiveness and ambiguity that pulls one back for repeated readings, as with poems by Khlebnikov and Kruchenykh.[49] Visually, Jakobson's static, black typographic verse contrasts with the vibrant, red rubber-stamped poetry of Kruchenykh in *Zaumnaia gniga* (Transrational boog). In an abstract design that we might call visual *zaum,* letters are set deliberately askew, and lines vary in length, because of the uneven spacing of the words.

"Intuitive Logic," Noncausality, and the Fourth Dimension

Critics such as Susan Compton, Charlotte Douglas, Linda Dalrymple Henderson, and Andrei Nakov argue that the mystical ideas of the Russian mathematician and hyperspace philosopher P. D. Ouspensky had a major influence on Russian futurist and suprematist thought. According to Henderson, Ouspensky's writings—especially his book *Tertium Organum: The Third Canon of Thought, A Key to the Enigmas of the World,* published near the end of 1911—provided the major source of information for members of the Russian avant-garde interested in higher consciousness.[50]

As is apparent from their manifestos, the futurists favored nonrepresentation, which they articulated through the theory of "the word as such"; the significance attributed to material form, as opposed to content; and links between *zaum* and the irrational, mystical, and aesthetic. An emphasis on sound and speech-sounds followed directly from this call for a spiritual and mysterious abstraction. Ouspensky's ideas, published for the first time only a few years before the futurists' first manifesto, *Poshchechina obshchstvennomu vkusu* (1912; A slap in the face of public taste), also provided a source for the futurists' embrace of reversibility and the accidental. And his philosophy of weightlessness, of liberation from the earth's gravitation, and of "the sensation of infinity" as an additional phase in the transition to cosmic consciousness contributed to what Malevich later called the "white, free chasm, infinity."[51]

The first painter and art theoretician to document the Ouspensky-futurism connection was Mikhail Matiushin, who lived in Saint Petersburg at the same time as the hyperspace philosopher and wrote essays on the subject of the fourth dimension, the first as early as 1911 and a second, titled "The Sensation of the Fourth Dimension," during the winter of 1912–13.[52]

Matiushin also contributed a preface to the book *Troe* (The three), of 1913, in which he writes: "And perhaps that day is not far off when the vanquished phantoms of three-dimensional space, of seemingly droplike time, of melancholy causality and many other things will prove to be for all of us exactly what they are: the annoying bars of a cage in which the human spirit is imprisoned—and that's all."[53]

This comparison of three-dimensional space to a cage of causality that only a new philosophy can overcome took slightly different form in the words of Kruchenykh, whose *Novye puti slova* (New ways of the word) quotes directly from *Tertium Organum:* "At present there are three units in our psychic life: sensation, representation, concept (and the idea), and a fourth unit is beginning to take shape—'higher intuition' (P. Uspensky's *Tertium Organum*)." For both Matiushin and Kruchenykh, Ouspensky's fourth dimension is synonymous with an extension of consciousness and ordinary awareness. In advocating *zaum*—that is, "the word broader than sense"—Kruchenykh posits that this transrational language would become possible once "higher intuition" had been formed.[54]

Such higher intuition belongs to the mystical outlook that the futurists shared with the hyperspace philosophy of Ouspensky. The concept of logic, as crafted by Ouspensky, entails a mysticism that built its system "*outside of logic* or above logic, unconsciously going along those paths of thought paved in remote antiquity. The higher logic existed before *deductive* and *inductive* logic was formulated. This higher logic may be called *intuitive* logic—the logic of infinity, the logic of ecstasy."[55] Ouspensky also associates the mystical, as well as the mysterious, with the unknown. Here he writes: "The idea of the *fourth dimension* arose from the assumption that in addition to the three dimensions known to our geometry there exists still a fourth, for some reason unknown and inaccessible to us, i.e., that in addition to the three known to us, a mysterious fourth perpendicular is possible."[56]

According to Ouspensky, the fourth dimension cannot be measured, because "there are things and phenomena in the world undoubtedly *really existing,* but quite incommensurable in terms of length, breadth, and thickness."[57] On this topic of measurement, Khlebnikov argues in a letter to Matiushin (16 December 1914) that the origin of the fourth dimension lies in the "assumption that there is nothing inherent in the nature of space that limits it to three powers only, that it is similar to numbers, which can be raised to powers ad infinitum."[58]

Perhaps because of this difficulty in measuring the fourth dimension, Ouspensky considers time to be "the most formidable and difficult problem that confronts humanity."[59] After

establishing that "every motion in space is accompanied by that which we call *motion in time*," he introduces the concept of "what was before, what now becomes, and what will follow after." This is Ouspensky's language for past, present, and future, and for arguing that the present—defined as "the moment of transition of the future into the past"—does not exist. He writes, "We can never catch it.... That which we did catch *is always the past*." His writing here bears interesting affinities to a letter that Khlebnikov sent to Kruchenykh on 31 August 1913, in response to Kruchenykh's new manifesto, *Deklaratsiia slova kak takovogo* (Declaration of the word as such): "Look around you and write: if youth follows age, then what comes later might have come earlier. First you have the old men, then the young ones."[60] Ouspensky, focusing similarly on the relationship between past and future, states in *Tertium Organum:* "As a matter of fact, in reality our relation both to the past and to the future is far more complicated than it seems to us. In the past, behind us, lies not only that which really happened, *but that which could have been.* In the same way, in the future lies not only that which will be, *but everything that may be.*"[61]

Both comments explore the possibility of indeterminate time, of time existing outside of a three-dimensional space. Ouspensky says as much when he writes, "The past and the future are equally undetermined, equally exist in all their possibilities, and equally exist simultaneously with the present."[62] His definition of *time* "includes in itself *two ideas:* that of a certain to us unknown space (the fourth dimension), and that of a motion upon this space." By inferring a "new dimension of space," Ouspensky sets himself up for the following definition of the fourth dimension: "Consequently, *extension in time* is extension into unknown space, and therefore time is *the fourth dimension of space.*"

The implications of these concepts of nonlinear time and spatial extension for futurist aesthetics are significant. They allow for the possibility of reversibility and for gestures of chance and the accidental that result in slight modifications of each copy of a futurist book. Ouspenky's discussion of simultaneity and the collapsing of time is especially evocative of noncausality in futurist book art:

> Our usual psychic life proceeds upon some definite plane (of consciousness or matter) and never rises above it. If our receptivity could rise above this plane it would undoubtedly perceive *simultaneously,* below itself, a far greater number of events than it usually sees while on a plane. Just as a man, ascending a mountain, or going up in a balloon, begins to see *simultaneously* and *at once* many things which it is impossible to see simultaneously and

at once from below—the movement of two trains towards one another between which a collision will occur; the approach of an enemy detachment to a sleeping camp; two cities divided by a ridge, etc.—so consciousness rising above the plane in which it usually functions, must see simultaneously the events divided for ordinary consciousness by *periods of time*. These will be the events which ordinary consciousness *never* sees together....Within the limits of its moment such a receptivity will not be in a position to discriminate between *before, now, after;* all this will be for it *now.*[63]

Elevation to the fourth dimension thus folds time into an infinite "now," albeit surprisingly, given that Ouspensky believes there is no present.

The scholarly literature on Russian futurism, suprematism, and the hyperspace philosophy of Ouspensky does not extend to the reverberations of the fourth dimension in futurist book art. Here we must look to the artists themselves. Discussions of the *mirskontsa* principle and its Ouspenskian embrace of reversibility, intuitive logic, mysticism, the nonsignifying—all were taken up by the poets and painters who collaborated on the book *Mirskontsa*. Ouspensky's interest in higher consciousness, moreover, could apply to the abstraction of sound as it plays out with the verbal and the visual in futurist book art. A close reading of *Mirskontsa* in the context of contemporary theories of formalism and the fourth dimension will, I hope, help us to infuse new meaning into techniques of verbal and visual punning, mirror writing and drawing, and sound poetry as explored in word and image.

Notes

1. David Burliuk et al., *A Slap in the Face: Four Russian Futurist Manifestos*, trans. Boris Dralyuk (Los Angeles: Insert Blanc, 2013), 17–18.

2. Filippo Tommaso Marinetti, *The Founding and Manifesto of Futurism*, in Umbro Apollonio, ed., *Documents of 20th Century Art: Futurist Manifestos*, trans. Robert Brain et al. (New York: Viking Press, 1973), 19–24.

3. Velimir Khlebnikov, *Collected Works of Velimir Khlebnikov*, vol. 1, *Letters and Theoretical Writings*, ed. Charlotte Douglas, trans. Paul Schmidt (Cambridge, MA: Harvard University Press, 1987), 255–56. This version of *Slovo kak takovoe* was a single text written in 1913 and subsequently published by Kruchenykh, without a title, in *The Unpublished Khlebnikov*, vol. 18 (Moscow, 1930). See Anna Lawton, ed., *Russian Futurism through Its Manifestoes, 1912–1928*, trans. and ed. Anna Lawton and Herbert Eagle (Ithaca: Cornell University Press, 1988), 55.

4. For this translation of symbolist requirements and the following quotations in this paragraph, see Marjorie Perloff, *The Futurist Moment: Avant-Guerre, Avant-Garde, and the Language of Rupture* (Chicago: University of Chicago Press, 2003), 125, 258n17. Translations are derived from Vladimir Markov, ed., *Manifesti y programmy russkikh futuristov = Die Manifeste und Programmschrifte der Russischen Futuristen*, Slavische Propylaen (Munich: Wilhelm Fink Verlag, 1967), 56.

5. For this and the subsequent quotation from the manifesto in the pamphlet *Slovo kak takovoe* (The word as such), see Lawton, *Russian Futurism*, 61. "Futurian" is the *zaum*-like translation of an invented Russian word,

budetlianin, which translates literally as "will-be person." Based on the word *rech'* (speech), *wordwright* can also be translated as "speechist."

6. For this quotation from *New Ways of the Word*, see Lawton, *Russian Futurism*, 70. Modification of the Russian word *smysl* from "thought" to "sense" is mine.

7. Lawton, *Russian Futurism*, 71.

8. Lawton, *Russian Futurism*, 73–76.

9. Translation by Vladimir Markov in Lawton, *Russian Futurism*, 129.

10. Lawton, *Russian Futurism*, 77.

11. Lawton, *Russian Futurism*, 76.

12. John E. Bowlt, ed., *Russian Art of the Avant-Garde: Theory and Criticism* (New York: Thames & Hudson, 1988), 118, 130.

13. Irina A. Vakar and Tatiana N. Mikhienko, eds., *Kazimir Malevich: Letters, Documents, Memoirs, Criticism*, trans. Antonina W. Bouis (London: Tate, 2015), 2:109n22.

14. Vakar and Mikhienko, *Kazimir Malevich*, 2:109.

15. Nina Gurianova, *The Aesthetics of Anarchy: Art and Ideology in the Early Russian Avant-Garde* (Berkeley: University of California Press, 2012), 29–31.

16. Susan Compton, *The World Backwards: Russian Futurist Books, 1912–16* (London: British Library Board, 1978), 68.

17. Compton, *The World Backwards*, 69. For further references to Russian symbolism, see Vladimir Markov, *Russian Futurism: A History* (Washington, D.C.: New Academia, 2006), 2–7; and Bowlt, *Russian Art of the Avant-Garde*, 3–38.

18. Victor Erlich, *Russian Formalism: History—Doctrine* (The Hague: Mouton, 1965), 54–56. Erlich is very critical of the "impressionistic" biography that characterized Russian literary study prior to formalism.

19. Erlich, *Russian Formalism*, 62–63. This disputed the neogrammarian school, which addressed itself to the most "natural," "artless" types of speech and shunned studies of poetic diction.

20. Erlich, *Russian Formalism*, 60, 63.

21. Roman Jakobson, *My Futurist Years*, ed. Bengt Jangfeldt and Stephen Rudy, trans. Stephen Rudy (New York: Marsilio, 1997); and Roman Jakobson, "The Newest Russian Poetry: Velimir Khlebnikov [Excerpts]," in idem, *My Futurist Years*, 178.

22. Viktor Shklovsky, "The Resurrection of the Word (1914)," in *Russian Formalism: A Collection of Articles and Texts in Translation*, ed. Stephen Bann and John E. Bowlt (New York: Barnes & Noble, 1973), 42.

23. Shklovsky, "Resurrection," 43.

24. Shklovsky, "Resurrection," 46.

25. Shklovsky, "Resurrection," 46–47.

26. This translation of *zaumnyi yazyke* is taken from Gerald Janecek and Peter Mayer's translation of Viktor Shklovsky's oft-cited article "On Trans-Sense Language," *October* 34 (1985): 3–24. Erlich used this translation consistently in *Russian Formalism*, beginning on p. 45.

27. Tzvetan Todorov, "Some Approaches to Russian Formalism," in Bann and Bowlt, *Russian Formalism*, 9.

28. Roman Jakobson, "Memoirs," in idem, *My Futurist Years*, 24.

29. Applying "resurrection" to poetry and the poetic word brings to mind the theme of the book *Mirskontsa* (Worldbackwards), which invokes the end of the world followed by resurrection (in the first poem), as well as a reversal to the beginning of the world, itself a resurrection.

30. Erlich, *Russian Formalism*, 185.

31. Shklovsky, "Resurrection," 41, 47.

32. Victor Shklovsky, "Art as Technique," in *Russian Formalist Criticism: Four Essays*, trans. Lee T. Lemon and Marion J. Reis (Lincoln: University of Nebraska Press, 1965), 12.

33. Erlich, *Russian Formalism*, 76.

34. Jakobson, "The Newest Russian Poetry," 187–88.

35. For this and the following quote in this paragraph, see Erlich, *Russian Formalism*, 225.

36. For this analysis about common nihilistic concepts, see Nina Gurianova, *The Aesthetics of Anarchy*, 63.

37. Jakobson, "The Newest Russian Poetry," 177.

38. Jakobson, "The Newest Russian Poetry," 177, 179.

39. For Jakobson's definition of symbolism, see Jakobson, "The Newest Russian Poetry," 187.

40. Lawton, *Russian Futurism*, 72. For further criticism of the Italian futurists, see Alexei Kruchenykh and Velimir Khlebnikov, *Slovo kak takovoe*, in Khlebnikov, *Collected Works*, 1:255.

41. Jakobson, "The Newest Russian Poetry," 179.

42. As Nina Gurianova explained, hectography uses a duplicating machine that transfers ink from the original (drawing?) to a slab of gelatin treated with glycerin, from which prints are made.

43. Rozanova's cityscape refers back to her cover for the book, see Alexei Kruchenykh, *Vzorval* (Saint Petersburg, 1913), which features a city in destruction.

44. Vakar and Mikhienko, *Kazimir Malevich*, 1:93. See also Jakobson on the relation of sound to speech, but not to music.

45. See the chapter "Mirskontsa: Collaborative Book Art and Transrational Sounds," this volume.

46. Jakobson, "Memoirs," 23–24, 277n54. He specifically says that he did not like "the letter as such"; he thought "the word as such" should have been followed by "the sound as such."

47. Jakobson, *My Futurist Years*, 276n44.

48. Gerald Janecek provides an interesting analysis of both poems in *Zaum: The Transrational Poetry of Russian Futurism* (San Diego: San Diego State University Press, 1996), 186–89.

49. Jakobson's spelling of the Russian word for "distraction" is unconventional.

50. The title of Ouspensky's book, *Tertium Organum*, refers to the "system of higher logic," the "third canon" (third instrument) of thought after those of Aristotle (deductive logic) and Francis Bacon (inductive reasoning, empiricism). For this historical background, see Linda Dalrymple Henderson, *The Fourth Dimension and Non-Euclidean Geometry in Modern Art* (Princeton, NJ: Princeton University Press, 1983), 245–49. P. D. Ouspensky, *Tertium Organum*, trans. Claude Bragdon (New York: Cosimo Classics, 2005).

51. Henderson takes both Malevich quotes about "infinity" from his essay "Non-Objective Creation and Suprematism" [1919], in Henderson, *The Fourth Dimension*, 288.

52. Although Matiushin prepared "The Sensation of the Fourth Dimension" for publication by the newspaper *The Crane* in 1917, it and other essays on the subject remained in manuscript form in the Institute of Russian Literature, Leningrad. See Henderson, *The Fourth Dimension*, 257–58n75.

53. Cited in Compton, *The World Backwards*, 102. Alla Povelikhina, trans., "Matiushin's Spatial System," in *The Isms of Art in Russia, 1907–1930*, exh. cat. (Cologne: Galerie Gmurzynska, 1977), 27–41.

54. Lawton, *Russian Futurism*, 70. For the original passage in Ouspensky's *Tertium Organum*, see pp. 83–84. See Henderson, *The Fourth Dimension*, 251, for Ouspensky's usage of "higher intuition" in 1911, but not in 1916.

55. Ouspensky, *Tertium Organum*, 261.

56. Ouspensky, *Tertium Organum*, 28.

57. Ouspensky, *Tertium Organum*, 29.

58. Khlebnikov, *Collected Works*, 1:97.

59. Ouspensky, *Tertium Organum*, 39, 38, 40.

60. Khlebnikov, *Collected Works*, 1:81.

61. Ouspensky, *Tertium Organum*, 45.

62. Ouspensky, *Tertium Organum*, 47.

63. Oupsensky, *Tertium Organum*, 48–49.

Mirskontsa:
Collaborative Book Art and Transrational Sounds

Principles of reversibility and the accidental were deeply embedded in the aesthetic of Velimir Khlebnikov and Alexei Kruchenykh. When they collaborated on the artist's book *Mirskontsa* with the two principal painters, Natalia Goncharova and Mikhail Larionov, this title word became a guiding principle for decisions about the sequencing of pages, the legibility and arrangement of handwritten lines, and the uncanny opposition between "primitive" imagery and advanced abstraction. Poets and painters applied formalist devices throughout the book in order to defamiliarize word, image, and sound, while also pursuing an Ouspenskian transcendence of causality and linear time. *Mirskontsa* was without a doubt a book that spoke to contemporary theories of its time, just as it stood poised to be emblematic of future intermedia, surpassing most in its subtlety and originality.[1]

The book's title was invented by Khlebnikov, a master of the neologism. Typically, his neologisms extend the meaning of carefully chosen Russian roots. For instance, he derived his preferred epithet for the futurists, *budetlianin* (usually translated as "futurian"), from *budet,* the third-person singular form of the future tense of the verb "to be," and combined it ungrammatically with a masculine noun ending that is used to denote belonging to a place or group. *Krestianin* (peasant), *khristianin* (Christian), and *ostrovitianin* (islander)—words that use *ianin* to signify a social or geographical group—must have served as models for Khlebnikov. To take another of countless examples, Khlebnikov explored the genealogical relationships between *chert* (devil) and *chernyi* (black) to derive the neologism *chernotvorskie* (blackcreating), which he used in his prologue to the opera *Pobeda nad solntsem* (*Victory over the Sun*), by combining *chernyi* with *tvorit* (to create). The word *chernyi* also had associations with *chernaia nauka* (black magic).[2] Thus, Khlebnikov layered multiple references within his neologisms.

In the case of *mirskontsa,* sound plays an active role. Composed of three words strung together, the neologism can be translated as *mir* (world), *s* (from), and *kontsa* (the end): "world

from the end." When the Cyrillic words are elided into one, the result is a compound word that, in its Russian pronunciation, contains a stress shift. Instead of pronouncing *kontsa* with an emphasis on the final syllable, "konTSA" (as is correct when this genitive form of *konets* [end] is used), the stress shifts to the second syllable, "SKON," resulting in the pronunciation "mirSKONtsa."[3] Sound, in the form of a stress shift, calls attention to the neologism, which is commonly translated as a run-on word, "worldbackwards," meaning a straight time reversal. If we use the more accurate literal translation "worldfromtheend," however, the Russian neologism takes on a suggestive set of references. It evokes the end of the world, which may happen at any moment in the future, as well as the beginning of the world, which is arrived at by going backward and then forward from the end.[4] The linear norm is thus replaced by reversibility. The simultaneous movement forward and backward and the ambiguity that circles around how we interpret "the end"—is it the apocalypse or the resurrection?—give *mirskontsa* a quizzical, even ominous tone that colors the title's also comical implications.

We first encounter the title as part of a cover collage by Goncharova (fig. 1). Kruchenykh designed this book using a square format, a stapled binding, and cheap, brittle paper with rough edges. Working to enhance this handmade look, Goncharova made a cutout in the shape of a flower from a single sheet of green paper, and she designed a second collage out of a white strip of paper that bore the title and the authors' names. The lower stem of the flower is partially covered by the white strip, while the three petals at top and upper right appear to have originally extended beyond the cover itself, although they have since been torn or cut off. These experiments with partial views and gestures of incompletion move away from linearity and accentuate the intentionally crude, equivocal aspect of Kruchenykh's design. Goncharova's lettering of the title, МИРСКОНЦА, and the authors' names, А. КРУЧЕНЫХ and В. ХЛЕБНИКОВ, mixes print (OH of the title, ЕН of Kruchenykh, ОВ of Khlebnikov) with cursive (the Р in МИР and the У in КРУ), the latter partially concealing the archaic letterform Е of ХЛЕБНИКОВ. The obscuring of letters and the general disorderliness of the writing are offset by the strict alignment of the first initials of first and last names (A and B, and K and X) and the clarity of the letter M in the title word.[5] Highlighted and, in the case of the K and X, made similar in shape, these self-sufficient "letters as such" become abstract, independent forms that signal the move toward the nonfigurative in this book.

Indeed, Goncharova's green cutout exemplifies the mysterious tension between "primitivism" and nonobjective art that we saw in the painting *Morning in the Village after a Snowstorm,* by Malevich (see "Introduction," fig. 1). But in the case of *Mirskontsa,* this polarity unfolds on the

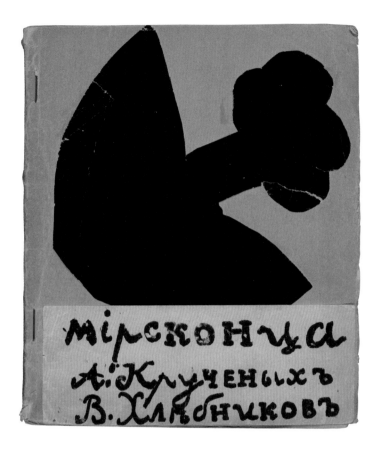

cover of a book that contains pages of figurative and abstract imagery, as well as poetry that is by turn transrational, lyric, and metrical. Whereas a painting is unique, a book is by definition a multiple. The Russian futurists subverted the idea of the multiple by publishing their artist's books in small runs and applying slight changes to each copy.[6] As Goncharova completed one copy of *Mirskontsa* and began the next, she made subtle modifications to the color, shape, and material of the cover's flower collage. By varying the shape, she caused some cutouts to look more like flowers than others. She varied her colors (shiny black, glossy or matte green) and materials (marbleized papers, gold-and-silver foil with printed patterns) (figs. 2, 3). These variants reflect Goncharova's shifting approach to nonrepresentation and her tendency, even in a cover that instantly suggests a flower, to introduce formal ambiguity. For instance, the Getty cover (see fig. 1),

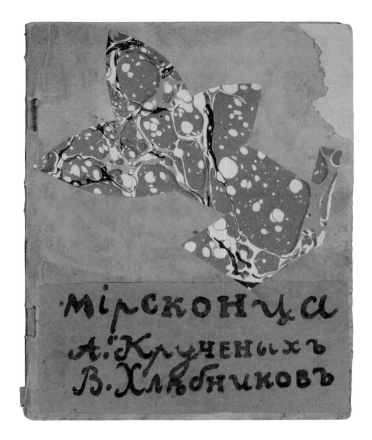

seen one way, evokes a flower stem tilted at a diagonal so that petals on the left appear closer, and therefore larger, than those on the right. Viewed differently, it becomes a human form with head and splayed legs and arms. Copies at the Museum of Modern Art, New York, similarly oscillate between a boat-shaped flower cup with a stem and blossom (see fig. 2) and a stylized cutout evocative of a human figure (see fig. 3).

At the turn of the century, members of Sergei Diaghilev's society, Mir iskusstva (The World of Art), published an eponymous journal consisting of gilded leather bindings, original drawings, and essays on art, sculpture, and literature illustrated with photographs and printed on sumptuous paper. The contrast between deluxe objects such as *Mir iskusstva* and the hand-sized, makeshift futurist books is telling. A copy of *Mirskontsa* from the collection of the State Mayakovsky

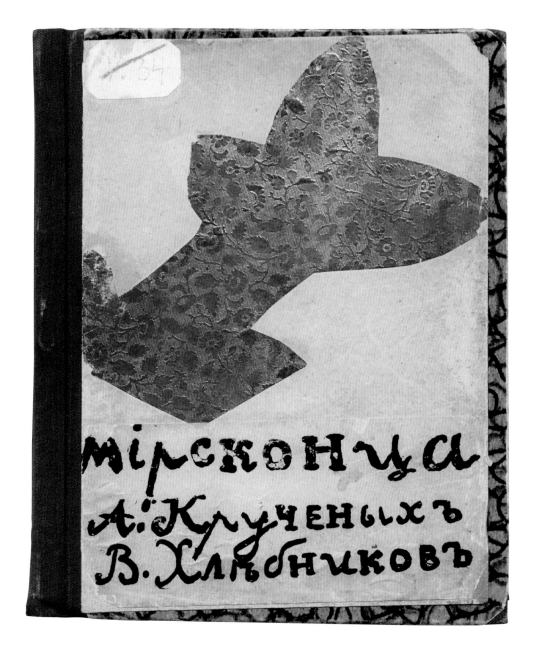

Fig. 4.
Natalia Goncharova (Russian,
1881–1962).
Cover of Velimir Khlebnikov and
Alexei Kruchenykh, *Mirskontsa*
(Worldbackwards) (Moscow, 1912).
Moscow, State Mayakovsky Museum.

Museum in Moscow has a cover collage fabricated from gold-patterned foil cut to resemble a "primitive" human form (fig. 4). The gold creates an unnatural effect far removed from the earthy green of the Getty copy, and it is no longer evocative of a flower. Our attention hovers between this awkward figure and the gold foil, which may be a parodic reference to the elegant materials of Russian symbolist journals. For Khlebnikov and Kruchenykh, two of the many implications for *mirskontsa* may have been a verbal parody of *Mir iskusstva* and a phonic play on these words.

Even if such references were unintentional or coincidental, they are consistent with the humor of futurist book art, which presents a provocatively different concept of the medium. In *Mirskontsa,* and to a lesser degree in futurist books such as *Vzorval'* (1913; Explodity) and *Pomada* (1913; Pomade), collaborating poets and painters applied variation from copy to copy, not only to book covers but also to contents, so that, for example, new poetry and imagery replace or supplement existing material; paper size and texture differ; images are sometimes hand-colored; and the ink color and typographic design of individual rubber-stamped pages changes dramatically.[7] By favoring change and variability over a fixed work of art, the futurists showed their inclination for the accidental and the noncausal, thus aligning their book art intriguingly with the philosophy of the fourth dimension. The labor involved in altering the visual design of every rubber-stamped page in *Mirskontsa*—that is, the upper- and lowercase letter combinations, the asterisks, the potato-cut letters—suggests that Kruchenykh's aesthetic made each copy of this book unique.

The transrational language of *zaum,* itself an utterance of higher intuition and consciousness, makes an early appearance in *Mirskontsa* through its startling phonic dimension.[8] A live reading of the poetry yields chains of neologisms, disconnected words, and pure vowel and consonant sounds that do not convey meaning in a traditional sense. Yet the phonic valence of these morphemes, when heard in conjunction with the visual design and the reading of word and image, carries a rich and subtle array of tones, moods, and associations. For the Russian futurists, it was not only the "word as such" but also, to quote Roman Jakobson, the "sound as such."[9] Its presence in futurist book art transformed an essentially visual and verbal medium into an auditory one. Futurist books are meant to be heard, not merely read. Inside them we find the first examples of the form known today as sound poetry.[10]

The subtle interplay of verbal, vocal, and visual elements and the disorienting theme of the book's title operate on a large scale, moreover, through the heterogeneous genre of *Mirskontsa,* which has no clear models or precedents in Russian book art.[11] On the first in a succession of four pages that display this collage structure, Goncharova creates an image and handwriting for

Kruchenykh's sonorous one-word poem, "Veselie," which means "gaiety" or "merriment" (fig. 5). This collaborative practice, in which the visual artist designs the page, including the hand lettering of the poetry, appears throughout *Mirskontsa* and was boldly articulated by the poets in their manifestos. Khlebnikov believed that the mood of the poetry alters the artist's handwriting during the process of hand lettering the poem onto the pages of a book, and that the handwriting, thus changed, conveys this mood to the reader independently of the words. Hand-lithographed books interested him because "the writer's hand tuned the reader's soul to the same wave length."[12] In the manifesto *Bukva kak takovaia* (The letter as such), written with Kruchenykh in 1913, the two poets coin the word *rechar*—from *rech'* (speech)—which Gary Kern translates as "speechist," Paul Schmidt as "wordwright," and Gerald Janecek as "worder," all designating the actual writer who is expert in questions of poetic language. Kern's "speechist" is optimal, because it incorporates sound as well as writing:

> But just ask any speechist, and he'll tell you that a word written by one hand or set in one type is completely unlike the same word in a different inscription.
>
> After all, you wouldn't dress all your pretty women in the same regulation peasant coats, would you?...
>
> Of course, it is not obligatory that the speechist also print the book in his own hand. Indeed, it would be better if this were entrusted to an artist.[13]

Khlebnikov and Kruchenykh even call for the founding of a special profession of "handwriting artists."[14] Their readers thus confront the challenge of interpreting poetry not as something that has already been written and finalized in print but rather as an ensemble of calligraphy, imagery, and visual design produced by an entrusted artist in collaboration with a poet or "speechist." The return of some of these poems (for example, Kruchenykh's "Dyr bul shchyl" and Khlebnikov's "Nash kochen'") in entirely new visual settings in later futurist publications attests to the close working relationship between poets and painters and to the significance of their handwriting aesthetics in transforming the look of word and image.[15]

On the page of *Mirskontsa* in question, Goncharova called attention to the Russian word ВЕСЕЛИЕ (*veselie*) by writing it twice at the bottom of the page and isolating it from the rest of the text (see fig. 5). The crooked, childlike letters, with their use of the archaic letterform *i*, rather than its modern form И, and their mixture of block and cursive writing, dance beneath her

Fig. 5. ◀))
Natalia Goncharova (Russian, 1881–1962) and Alexei Kruchenykh (Russian, 1886–1969). Design and poetry for "Spasi nozhnitsy rezhut" and "Veselie." From Velimir Khlebnikov and Alexei Kruchenykh *Mirskontsa* (Worldbackwards) (Moscow, 1912). Los Angeles, Getty Research Institute, 88-B27486.

large central lithograph.[16] By floating the repeated word apart from the text and image above, Goncharova highlights the assonance (repeated E) created by the repetition, and she shifts the emphasis from the word's semantic content to its phonetic and graphic representation—that is, to what the word sounds and looks like. Unexpectedly, Goncharova also instigates a change in our awareness when she transforms *veselie* by juxtaposing its abstract sounds with the ominous free

verse above. The effect is to defamiliarize the sound word and make us feel as if we are seeing and hearing it for the first time. The *zaum* text at the top of the page omits syntax and punctuation and speaks in precise, disjointed phrases about scissors, pain, and suicide:

SPAsi NOZHnitsy REzhut	save scissors are cutting
RODnyia pleMIAnitsy podGLIAdy-	nieces peep
vaiut BOlen ne VYlezt'	sick not to crawl out
streLIAiutsia khoroSHO	shooting well
LISH' RAZ	only once [17]

Spoken as a sound poem, the five-line free verse opens with two lines of three stresses each (indicated by capital letters). This pattern breaks up when Goncharova wraps the long Russian word *podgliadyvaiut* (peep) onto the next line of text and follows it with cryptic phrases lacking a subject. The lines become progressively shorter, moving from two lines of three stresses to two lines of two stresses, and closing with the two shortest words. ◀)

Goncharova's visual writing enhances this sonic disjointedness by compressing some letters while inserting extra space between others. Lettering and orthography produce a poem that is difficult to decipher and therefore well in keeping with the cryptic language of Kruchenykh's verse. As a collage text, this verse finds a visual parallel in the cutout leaves and petals of Goncharova's drawing. It inserts a theme of cutting into the sonic "Veselie." Yet unlike the sinister text, the drawing has a folklike charm matched by the assonance of "Veselie." This charm and the drawing of a flower in the form of a collage recall the cover of *Mirskontsa*. Moreover, to cut something renders it incomplete, just as no copy of *Mirskontsa* is final.

The "Veselie" page is followed by a contrasting page of green rubber-stamping that announces "Stikhi V. Khlebnikov" (Poetry by V. Khlebnikov) (fig. 6). Kruchenykh produced this and all the rubber-stamped pages in the book with a child's typeset primer. Here he split the poet's surname in two by using a potato cut (a potato carved into a letter or shape, inked, and applied like a stamp) or a rough stencil to form an oversize Cyrillic H (equivalent in sound to the Latin *n*). He inserted spaces on both sides of the letter.[18] By stamping the name Khlebnikov as two morphemes, each difficult to decipher and each therefore emerging as an abstract sound, he defamiliarized it.[19] On a title page designed to introduce his fellow poet, Kruchenykh stamped letters that look blurry and tenuous, an illegibility enhanced by the diagonal arrangement of the text and the inconsistencies in inking and letter size. This push against linearity heightens the reference to the

◀) Listen to "Spasi nozhnitsy rezhut"
www.getty.edu/ZaumPoetry

mirskontsa principle and to the intuitive logic of P. D. Ouspensky. Kruchenykh's shortened forms of Khlebnikov's name might also be a comical play both on long Russian names and patronymics and on the Russian practice of abbreviations and acronyms.

The collage-like shifts of disparate graphic and phonic materials continue with a transcription by artist Nikolai Rogovin of Khlebnikov's lyric "O dostoevskiimo begushchei tuchi" (O

Dostoevskiimo of a running cloud) (fig. 7).[20] Rogovin selected a poem originally written as a quatrain in iambic tetrameter and applied a fanciful arrangement of the text that breaks up lines and words, alters capitalization, and effectively transforms "O dostoevskiimo" into an irregular free-verse lyric.[21] Visual ambiguities caused by fusing graffiti-like writing with drawing and word with image occur to the left of the second line, which invokes the poet Alexander Pushkin. Here, Rogovin drew a *pushka* (cannon) and gave it a handle that resembles a Cyrillic П (equivalent to the Latin *p*). In similar fashion, the hair of the man-cat leaning against a slope on the lower right unfurls like skywriting and could be read as the final syllable of the poem's penultimate word, *bezmernym* (measureless). To the left of *zamernoe* (beyond any measure), which opens the final line, Rogovin inserted curves that suggest the clouds of the title and echo but invert the Cyrillic З (equivalent to the Latin *z*).

Rogovin's verbal-visual play is a response to Khlebnikov's sound poem, which transforms the proper names Dostoevsky and Pushkin into magical words with abstract qualities:

O dostoevskimo begushchei tuchi!　　O Dostoevskiimo of a running cloud!
O pushkinoty mleiushchevo poldnia!　O Pushkinotes of sizzling midday!
Noch cmotritsia, kak Tiutchev,　　　Night stares at you like Tiutchev,
Zamernoe bezmernym polnia.　　　　Filling the beyond measure with
　　　　　　　　　　　　　　　　　the measureless.[22]

Neologisms in the last line (*zamernoe* and *polnia*) overdetermine the concepts of "measureless" and "filling" by adding the prefix *za-* (beyond) and turning the modifier for *polny* (full) into an invented noun, *polnia,* which is strengthened by its partial rhyme with *poldnia* (midday). Rogovin's iconography, with its composites of letters and pictures, comments visually on the combined sounds that produce neologisms in Khlebnikov's poetry. The incantatory, celebratory recitation that characterizes the first two lines, with their repeated long *o* and *u* vowel sounds, contrasts with the short consonant sounds of the next two (*och, ot, tch, mer*). Is Khlebnikov making playful homage to Russia's canonical writers, or is he anticipating the famous command to "throw Dostoevsky and Pushkin overboard from the ship of Modernity," which he and others would publish in 1912 in the manifesto *Poshchechina obshchestvennomu vkusu* (A slap in the face of public taste)?[23] The additional reference to the nineteenth-century romantic poet Fyodor Tiutchev, who was rediscovered by the symbolists and is now considered, with Pushkin and Mikhail Lermontov, to be the last of the three great Russian poets of the nineteenth

Fig. 7.
Nikolai Rogovin (Russian, act. 1910s)
and Velimir Khlebnikov
(Russian, 1885–1922).
Design and poetry for
"O Dostoevskiimo begushchei tuchi."
From Velimir Khlebnikov and
Alexei Kruchenykh *Mirskontsa*
(Worldbackwards) (Moscow, 1912).
Los Angeles, Getty Research Institute,
88-B27486.

century, underscores the ongoing importance of theories of language, both symbolist and futurist. Tiutchev's poem "Silentium" (1830) may explain why Khlebnikov associates him with night and the unknown in the last two lines.

The arrangement of word and image on the fourth page of this heterogeneous sequence likewise plays with legibility, and hence linearity, of writing and drawing (fig. 8). This time, the artist is Larionov, who hand printed a two-line sound poem by Khlebnikov in mirror version so that it reads from right to left. Larionov inverted some of the Cyrillic letters and contrasted them with the symmetrical Cyrillic Ж and Н, and with the cursive and print forms of T, which do not change appearance when inverted. This verbal-visual expression of the *mirskontsa* principle continues with the image, which Larionov drafted so that we must tilt our heads or rotate the book. When we do so, we see a menacing rooster with a tooth-like comb contemplating a knife, while the poem, already in mirror version, becomes two vertical columns of tumbling letters. In both viewings, the lack of alignment between text and image creates an uneasy humor.

Larionov's ominous rooster vies with the comical sounds of Khlebnikov's poem, even as it calls attention to their threatening semantic implications. The poem is a phonic sequence of rhyming participles built around the common word sound *ochen'* (very). Because sound plays such an important role in driving word choice, an analysis of the poem must begin by focusing entirely on the sounds (without translation, for the moment). Here is the poem in transliteration: "Nash kochen' ochen' ozabochen / Nozh ottochen tochen ochen.'" ◀))

With its repeated, rhyming *ochen'* embedded into nearly every word, the poem sounds like a nonsensical tongue twister, and, on a purely sonic level, it is. Yet Khlebnikov did not use neologisms. Rather, he derived adjectives from verbs in their past passive participle forms to emphasize their common *-en* endings (see *ozabochen* and *ottochen*). Moreover, the key word "KOchen" has multiple etymologies. It is a variant spelling, with a different stress, of the word "koCHAN," meaning "cabbage head," when followed by the word *kapusty*. In etymological dictionaries that Khlebnikov would have had access to—such as the dictionary of 1893 by I. I. Sreznevsky—both *kochan* and its variant spelling *kochen* are derivatives of the Latin *membrum virile* (the male reproductive organ).[24] Another etymologically related word, *kochet*, which is graphically similar to *kochen*, can be traced to southern dialects of Russia, where it means *petukh*, or "cock" (the male bird). By suggesting this form of the word as well, Khlebnikov expanded its male connotations.[25]

Khlebnikov's punning on *kochan*, with its associative meanings of cabbage head, phallus, and cock, takes us directly to Larionov's image, which offers a witty response in the form of a

Fig. 8. ◀))
Mikhail Larionov (Russian, 1881–1964)
and Velimir Khlebnikov
(Russian, 1885–1922).
Design and poetry for "Nash kochen'."
From Velimir Khlebnikov and
Alexei Kruchenykh, *Mirskontsa*
(Worldbackwards) (Moscow, 1912).
Los Angeles, Getty Research Institute,
88-B27486.

◀)) Listen to "Nash kochen'"
www.getty.edu/ZaumPoetry

phallic rooster comb and knife, as well as spiky arc forms suggestive of a head of cabbage. As collaborators, Khlebnikov and Larionov created a page in which word plays off image in a highly evocative way. Referentiality is indeterminate, posing a real challenge for translators. Indeed, the two translations that Khlebnikov's poem has yielded fail to capture the puns or the disturbing mood expressed by the word-image interplay. The first, a literal translation by Gerald Janecek, reads: "Our cabbage head is very very worried / The sharpened knife is very very sharp."[26] The second, by Paul Schmidt, is marvelous at both mimicking Khlebnikov's pattern of sound repetition and capturing the absurd plight of the anthropomorphized cabbage: "Let us all be heads of lettuce / Let us not let knives upset us."[27]

As Schmidt's translation reveals, Khlebnikov was experimenting with the formalist "orientation toward the neighboring word" by rhyming *kochen* with *ozabochen* (worried), although they share no semantic connection. *Kochen* is made strange through its personification. Contributing to this contrast between phonic rhyme and semantic inequivalence are *nash* (our) and *nozh* (knife), which differ from one another in meaning and belong to different parts of speech but are linked phonically through their opening consonant, contrasting vowel, and monosyllabic form. Khlebnikov also paired them by using each to open the poetic line.

These phonic affinities and semantic differences are humorous, yet they do not take into account Khlebnikov's punning, and hence the sinister encounter of cock and knife. His sound poem, however, makes room for a range of verbivocovisual implications. A reading that emphasizes the repeated vowel *o* (of *ochen'*) highlights the laughable, childlike sounds of the verse, whereas a dwelling on the repeated consonants (*sh, zh, ch*) harshly accentuates the threat posed by the knife, as well as the disturbing transformation of knife into phallus.[28] Sound thus triggers a complex interweaving of word and image. Moreover, the phonic texture of Khlebnikov's poem, with its repeated sound *ochen',* lays bare the verbal texture so that simple words are rendered strange. And although the poetry lacks neologisms, its playful and repetitive sound patterns defamiliarize the language and make it sound like nonsense.

The four successive pages of *Mirskontsa* that I have addressed relate to one another as materials in a collage. In place of narrative (or even logic), poets and painters juxtaposed one page against the next with little stylistic connection apart from the shared commitment to handmade processes—whether hand lithography or rubber-stamping. Let's now consider a different part of the book, which likewise contains visually striking shifts between rubber-stamping and lithography. In this section, however, the first three pages work together to make a portrait.[29]

Fig. 9.
Alexei Kruchenykh (Russian, 1886–1969).
"Stikhi A Kruchenykh" (detail).
From Velimir Khlebnikov and Alexei Kruchenykh, *Mirskontsa* (Worldbackwards) (Moscow, 1912).
Los Angeles, Getty Research Institute, 88-B27486.

The "Akhmet" section was created by Kruchenykh and Larionov, who explored nonreferential elements and the verbivocovisual. The opening page introduces "Stikhi A Kruchenykh" (Poetry by A Kruchenykh) with three rubber-stamped lines in green ink (fig. 9). Like the rubber-stamped page announcing Khlebnikov, so here Kruchenykh applied surprising techniques that distract us from a linear reading of the text. He omitted punctuation, specifically the period following "A," and scattered asterisks, which have no syntactic or grammatical function but serve to weaken the prominence of the letters. Kruchenykh also mixed large and small letters, lined them up unevenly, and inked some letters faintly so that they can scarcely be read.[30] The rubber-stamping is thus *mirskontsa*—that is, not legible in its design.

Fig. 10.
Mikhail Larionov (Russian, 1881–1964).
Portrait of Akhmet.
From Velimir Khlebnikov and
Alexei Kruchenykh, *Mirskontsa*
(Worldbackwards) (Moscow, 1912).
Los Angeles, Getty Research Institute,
88-B27486.

Fig. 11.
Mikhail Larionov (Russian, 1881–1964).
Sobstvennyi portret Larionov
(Self-portrait of Larionov), 1911–12,
oil on canvas, 104 x 89 cm.
Artist's collection.

Fig. 12.
Tichvine Mother of God, first half
of the seventeenth century,
tempera on wood, 90.5 x 69 cm.
Recklinghausen, Germany,
Ikonen-Museum, Inv. Nr. 47.

We turn the page and, rather than immediately encountering Kruchenykh's poetry, discover a hand-lithographed portrait signed "Larion," with a suggested fragment of the *ov* barely visible below (fig. 10). The fictional character, who could be Turkish or Georgian, gazes out at the reader with stylized frontality. His bulky, oversize neck and head and prominent ears, together with the perfect symmetry of his features, give him a humorous, "primitive" demeanor. To the left of the head, Larionov floated the syllables *AX* and *ME*, presumably the first two syllables of the character's name, and distributed one above and one below the ear, thereby transforming them into independent sounds to be listened to.

In his paintings of this period, Larionov often placed handwritten names around human figures, as in *Sobstvennyi portret Larionov* (Self-portrait of Larionov) (fig. 11). Both the frontal gaze and the dispersal of syllables hark back to Russian Orthodox icons, which typically surround the upper torsos of saints, Christ, and the Virgin with identifying names written in Old Church Slavonic (fig. 12).[31] Marks called "titlo signs" are drawn like a zigzag line or a sideways square bracket over a

А Ж мет
ЧАШУ дЕржеТ
Ꙗо еНный поРтрѣт

ГЕНэРаЛ
* ЧЕРез 5 лѣт
УМет

Ангел лѣтѣл
* БУДЕт поэт

<ДРАМУ ПиШет
* ⇒🖑
* ⇒🖑

word and indicate an abbreviation when a letter has been omitted or is written as a superscript. Even though the word should be pronounced as is customary in spoken speech, the visual alteration alerts the reader to the extraordinary power attributed to certain words.[32] Indeed, abbreviated forms are used because the full name cannot be written. In borrowing this practice for his self-portrait and for "Akhmet," Larionov followed the tradition of omitting individual letters and syllables (*en* from *sobstvennyi, t* from *portret,* and *ov* from Larionov). Like the borrowed frontal gaze, the effect is comical and parodic, because he secularized the imagery and abbreviated words that are not sacred.[33]

The concealed final syllable of the artist's name, *ov,* anticipates a missing letter—the final *T* of the character's name (see fig. 10). This letter, which produces the sound "ET" (the suffix *-et*) when placed after *AKH* and *ME,* does not reveal itself until the following page, where a green rubber-stamped poem by Kruchenkyh begins with the full name, Akhmet (fig. 13). Looking back at the drawing, Larionov may have disguised the *T* in the nose by stylizing the Cyrillic printed *T* as a cursive letter. He also transformed the Cyrillic cursive *T* into a poet's lyre (upper right)—a symbol of poetic sound—by rotating the letter while retaining its three bars and symmetrical curves. Hidden in the drawing, the *T* as the completed sound "ET" becomes the focus of the verbal portrait.

Drawing and poem serve as companion pieces. We cannot be sure that Larionov drew Akhmet before Kruchenykh wrote about him—the drawing precedes the poem in the book— or whether the work was done simultaneously as part of a give-and-take between painter and poet. The green rubber-stamping that runs throughout the Getty's copy of *Mirskontsa* signals Kruchenykh's contribution of poems he wrote expressly for this book. It is therefore likely that Kruchenykh invited Larionov to create the drawing and that the two worked together. The verbivocovisual interplay was certainly a crucial impetus. Just as the handwritten syllables in Larionov's drawing convey abstract sounds when recited aloud, so the unusual visual configurations in the poem suggest its startling phonic experiments (see fig. 13). Words splay diagonally across the page, and stamped letters mix with large, blackish letters that have a handwritten look (Х, В, Л, А) and were made with potato cuts. We see the poem as a visual configuration before we determine what it says and how it sounds.[34]

In other copies of *Mirskontsa,* Kruchenykh dramatically varied the visual design of his poem "Akhmet." In the copy now held in the State Mayakovsky Museum, for example, a scruffy brown ink replaced the green, and Kruchenykh rubber-stamped the opening lines of the poem and wrote the rest in cursive (fig. 14). In lieu of the thicker, yellowing paper of the Getty's copy, Kruchenykh

Fig. 13. ◀))
Alexei Kruchenykh (Russian, 1886–1969).
Design for "Akhmet."
From Velimir Khlebnikov and Alexei Kruchenykh, *Mirskontsa* (Worldbackwards) (Moscow, 1912).
Los Angeles, Getty Research Institute, 88-B27486.

chose a sheet so transparent that it reveals the drawing by Larionov on the next page. Although words are unevenly spaced and lack linearity, Kruchenykh's page has none of the potato-cut letters or diagonal experimentation that distinguish the Getty's copy. Such different settings must be kept in mind as we listen to a poem in which "sound as such" takes precedence, resulting first and foremost in sound poetry (see fig. 13). ◀)

◀) Listen to "Akhmet"
www.getty.edu/ZaumPoetry

PERLOFF

ахмет	Akhmet	Akhmet
чашу держет	chashu derzhet	holds a cup
военный портрет	voennyi portret	military portrait
генерал	general	general
через 5 лет	cherez 5 [*piat'*] let	in 5 years
умет	umet	"dies"
ангел летел	angel letel	an angel flew
будет поэт	budet poet	will be a poet
драму пишет	dramu pishet	is writing a play[35]

Kruchenykh playfully emphasized the missing "ET" sound by creating a comical sequence of full and partial rhymes on the stressed and unstressed -*et* suffix. Full rhymes occur in nouns that take a second syllable stress ("portrET," "poET"), while partial rhymes arise from verbs in which the stress falls on the first syllable ("BUDet," "PISHet"). These rhymes are partial because, according to Russian pronunciation, if the first syllable of a word receives the stress, the *e* in the second syllable is pronounced as a short *i* ("BUDit," "PISHit"). Kruchenykh created contrast, and therefore surprise, by introducing two new words: Akhmet, a foreign male first name that receives its stress on the second syllable, and *umet*, a neologism derived from *umret* (умрет), the third-person singular form of the verb *umeret* (умереть) (to die). By cutting the *r* out of *umret*, Kruchenykh was consistent with the collaged cover and the techniques of juxtaposition that characterize *Mirskontsa*. The result is a new word and an altered sound that preserve the poem's full rhymes on "ET." Kruchenykh's respelling of the third-person singular of the verb "derZHAT'" (to hold), transforming "DERzhit" into the invented "derZHET," inserts an unusual stress in order to emphasize the rhyme with Akhmet, *portret, 5 let, umet,* and *poet*. In a second gesture of alogical twists, Kruchenykh inserted two pairs of framing words in his poem—"chashu derzhet," in the second line, and "dramu pishet," in the last—both featuring nouns with first-syllable stress and rhymed endings (*chashu, dramu*) that have no sonic connection to the other nouns in the poem.

The verse of "Akhmet" hovers on the edge of nonsense. "Sound as such" drives word choice, resulting in surprising and parodic juxtapositions, such as that between the consecutive lines "general / cherez 5 let / umet / angel letel" (General / In 5 years / Dies / An angel flew).[36] The guiding force here is the repeated "ET." In order to maintain the rhyme, Kruchenykh shifted tense

from the present (*umet*) to the past (*letel*) to the future (*budet*) to the present (*pishet*). "An angel flew" and "Will be a poet" take us back to Larionov's portrait of "Akhmet," which shows the poet's lyre hovering next to the figure's ear and serving as a stand-in for the letter T (see fig. 10).

Two more pages in the "Akhmet" section of *Mirskontsa* extend the verbivocovisual, principally as evocations of the materiality of sound. The first, an image by Larionov visible beneath the transparent paper of the "Akhmet" poem in the State Mayakovsky Museum copy, shows the syllables "MEE MEB" scrawled on the side of a horse-drawn cart (see fig. 14). Forms suggestive of a street lamp and telephone poles are visible, but the crude sounds of "MEE MEB" evoke country as well as city and therefore leave the identity of the scene ambiguous. The second page, also by Larionov, shows a human figure (either male or female) uttering the sound "oZZ," which appears as a graphic of sound's materiality (fig. 15). It does not mean, but rather suggests. The increasing size of the letters visualizes an increase in volume, and the C outlining the ear can be read as a Cyrillic S (the preposition "with") to create the sound "SoZZ." Unlike the narrative onomatopoeia of the Italian futurists, the sounds "oZZ" and "SoZZ" are evocative but nonreferential. Khlebnikov would call them "magic words": "What about spells and incantations, what we call magic words, the sacred language of paganism, words like 'shagadam, magadam, vigadam, pitz, putz, patzu'— they are rows of mere syllables that the intellect can make no sense of, and they form a kind of beyonsense [*zaum*] language in folk speech. Nevertheless an enormous power over mankind is attributed to these incomprehensible words."[37]

We will see more such evocative "beyonsense" words and neologisms in the next chapter, in a reading of the book *Vzorval'* (Explodity). Here my attention focuses on sound as it emerges from the scansion of verse and on the relation of sound to image. The verbivocovisual again unfolds in a realm between abstraction and the figurative.

Fig. 15.
Mikhail Larionov (Russian, 1881–1964). Design for "oZZ."
From Velimir Khlebnikov and Alexei Kruchenykh, *Mirskontsa* (Worldbackwards) (Moscow, 1912). Los Angeles, Getty Research Institute, 88-B27486.

Notes

1. I use the term *intermedia* to refer to the verbivocovisual. Hence, it should be distinguished from Dick Higgins's interpretation of *intermedia*, which emphasizes the "dialectic between the media" and art forms such as Happenings and event pieces existing between the genres.

2. Rosamund Bartlett provides annotations for the neologisms that Khlebnikov invented for the prologue of *Pobeda nad solntsem*. See Rosamund Bartlett and Sarah Dadswell, eds., *Victory over the Sun: The World's First Futurist Opera* (Exeter, UK: University of Exeter Press, 2012), 20. For Khlebnikov's further experiments with neologisms, see Velimir Khlebnikov, *Collected Works of Velimir Khlebnikov*, vol. 1, *Letters and Theoretical Writings*, ed. Charlotte Douglas, trans. Paul Schmidt (Cambridge, MA: Harvard University Press, 1987), letter 54 to Kruchenykh, 84–85.

3. Kruchenykh recalls suggesting to Khlebnikov that he give his play *Olia and Polia* the more suitable title *Mirskontsa* (Worldbackwards), and he describes how Mayakovsky joked, "It's a good name for a Spanish count—Mirskontsa (stress on the 'o')." See Alexei Kruchenykh, *Our Arrival: From the History of Russian Futurism* (Moscow: RA, 1995), 48.

4. Susan Compton notes that the "end" might happen anytime in the future. See Susan Compton, *The World Backwards: Russian Futurist Books, 1912–16* (London: British Library Board, 1978), 19.

5. For a discussion of the abstract, equivocal lettering, see Marjorie Perloff, *The Futurist Moment: Avant-Garde, Avant-Guerre, and the Language of Rupture* (Chicago: University of Chicago Press, 2003), 136–37.

6. At 220 copies, the run of *Mirskontsa* was smaller than that of the two futurist books that preceded it, *Starinnaia liubov'* (1912; Old-fashioned love) and *Igra v adu* (1912; A game in hell), each published in an edition of 300. Futurist books that followed *Mirskontsa* appeared in editions of 300 or higher, with the exception of *Te li le* (1914), in an edition of 50, and *Zaumnaia gniga* (1915; Transrational boog), numbering 140. See Margit Rowell and Deborah Wye, eds., *The Russian Avant-Garde Book, 1910–1934*, exh. cat. (New York: Museum of Modern Art, 2002), 250–53.

7. For a valuable discussion of variant copies, see Gerald Janecek, "Kruchenykh contra Gutenberg," in Rowell and Wye, *The Russian Avant-Garde*, 43–44, 48n13. He quotes Andrei Shemsurin, who mentioned as early as 1928 that "it often happened that one and the same publication had all the copies completely varied." See Andrei Shemsurin, "Slishkom zemnoi chelovek," in Sergei Sukhoparov, ed., *Alexei Kruchenykh v svidetel'stvakh sovremennikov* (Munich: Verlag Otto Sagner, 1994).

8. The word *zaum* was not formally introduced in a publication until 1913, in *Novye puti slova (iazyk budushchago, smert' simbolizmu)* (The new ways of the word [the language of the future, death to symbolism]) and *Pomada* (Pomade).

9. Roman Jakobson, *My Futurist Years*, ed. Bengt Jangfeldt, trans. Stephen Rudy (New York: Marsilio, 1992), 24.

10. I have written about sound poetry as a hybrid poetic form that works between media, is intended for live performance, and rejects meaning in favor of a focus on the concrete, phonic aspect of language. The Russian avant-garde initiated sound poetry, which they wrote in the "beyonsense" language of *zaum*. See Nancy Perloff, "Sound Poetry and the Musical Avant-Garde," in *The Sound of Poetry/The Poetry of Sound*, ed. Marjorie Perloff and Craig Dworkin (Chicago: University of Chicago Press, 2009), 97–99. Subsequent futurist books that call for live readings of the poetry are *Vzorval'* (1913; Explodity), *Pomada* (1913; Pomade), *Utinoe gnezdyshko… durnykh slov* (1914; A duck's nest of bad words), *Te li le* (1914), and *Zaumnaia gniga* (1915; Transrational boog).

11. Janecek, "Kruchenykh contra Gutenberg," 43, including his translation of Evgeny Kovtun, *Russkaia futuristicheskaia kniga* (Moscow: Izd. Kniga, 1989), 79. In highlighting the heterogeneous character of *Mirskontsa*, Janecek's and Kovtun's emphasis is largely on contrasts in script, lettering, and graphics, rather than on the changing relation of word-image-sound.

12. Velimir Khlebnikov, *Stikhi* (Moscow: Khudozhestvennaia pechatnia, 1923), 52. Cited in Evgeny Kovtun, "Experiments in Book Design by Russian Artists," *Journal of Propaganda and Decorative Arts* 5 (1987): 49.

13. Velimir Khlebnikov and Alexei Kruchenykh, "The Letter as Such," in *Velimir Khlebnikov Snake Train: Poetry and Prose*, ed. Gary Kern (Ann Arbor, MI: Ardis, 1976), 199.

14. Kovtun introduces this term in "Experiments in Book Design," 49.

15. The futurists used a process of transfer lithographs. They created their drawings on special transfer papers using a lithographic crayon or pen. A professional printer used a lithographic stone or sometimes a zinc plate for the printing. See Compton, *The World Backwards*, 70–71.

16. The *i* was officially replaced by an *И* in the "Resolutions of the Orthographic Subcommission of the Imperial Academy of Sciences," 11 May 1917. Before these resolutions passed, artists often used the new orthography, but not consistently. See Gerald Janecek, *The Look of Russian Literature: Avant-Garde Visual Experiments, 1900–1930* (Princeton, NJ: Princeton University Press, 1984), 249.

17. I use a translation by Antanina Sergieff, PhD candidate in Slavic languages and literatures, University of California, Los Angeles.

18. On the rubber-stamping and potato-cut techniques, see Vladimir Poliakov, *Knigi russkogo kubofuturizma: S prilozheniem kataloga futuristicheskikh izdanii* (Moscow: Gileia, 2007), 402; Compton, *The World Backwards*, 72; and Janecek, "Kruchenykh contra Gutenberg," 45.

19. One can note that *khleb* is the Russian word for "bread."

20. Nikolai Efimovich Rogovin was a lesser-known artist of the Russian avant-garde who worked in Moscow in the 1910s and was close to Larionov. See Kovtun, *Russkaia futuristicheskaia kniga*, 167.

21. My verbal-visual reading of Rogovin's setting of Khlebnikov, "The Book as Such from Neo-Futurism to Futurism" (paper presented at the 43rd meeting of the Association for Slavic, East European, and Eurasian Studies, Washington, D.C., 17–20 November 2011). For a free translation, see Velimir Khlebnikov, *Collected Works of Velimir Khlebnikov*, vol. 3, *Selected Poems*, ed. Ronald Vroon, trans. Paul Schmidt (Cambridge, MA: Harvard University Press, 1997), 29.

22. I used Gerald Janecek's translation in Janecek, *The Look of Russian Literature*, 82.

23. Anna Lawton, ed., *Russian Futurism through Its Manifestoes, 1912–1928*, trans. and ed. Anna Lawton and Herbert Eagle (Ithaca: Cornell University Press, 1988), 51.

24. A. G. Preobrazhensky, *Etymological Dictionary of the Russian Language* (New York: Columbia University Press, 1964), 372–73. In his definition of *kochan* as "membrum virile," Preobrazhensky cites I. I. Sreznevsky, *Materialy dlia slovaria drevne-russkogo iazyka po pis'mennym pamiatnikam*, vol. 1 (Saint Petersburg: Tipografiia imperatorskoi akademii nauk, 1893), 1305. I am indebted to Antanina Sergieff for assistance with the etymological research on *kochen*.

25. Ronald Vroon discusses the "twilight" meaning or "double meaning" of words in Khlebnikov's poetry and references Sreznevsky's dictionary of Old Russian and Old Church Slavic to illuminate the etymology of *kochen* and *kochan*. See Ronald Vroon, "Velimir Khlebnikov's 'Kuznechik' and the Art of Verbal Duplicity," in *Readings in Russian Modernism*, ed. Ronald Vroon and John Malmstad (Moscow: "NAUKA" Oriental Literature, 1993), 349–50.

26. Translated by Janecek, *The Look of Russian Literature*, 82.

27. Khlebnikov, *Collected Works*, 3:38.

28. Nina Gurianova pointed out to me these two different readings of the poem. The theme of implied castration recalls Larionov's series of "Barbers" paintings, executed between 1907 and 1911.

29. Since each copy of *Mirskontsa* is slightly different, it is important to emphasize that the two sections of the book I analyze remain constant in every copy of the book that I have examined.

30. Pages that were rubber-stamped could not be run through the lithographic press, hence the mostly blank page.

31. Old Church Slavonic, or Church Slavonic, is a literary language that developed out of the language used by ninth-century missionaries from Byzantium to translate the Bible and other religious works.

32. I owe this information to Ksenya Gurshtein, personal communication, 16 February 2015.

33. For an excellent discussion of Larionov's parody of Russian icons, see John E. Malmstad, "The Sacred Profaned: Image and Word in the Paintings of Mikhail Larionov," in *Laboratory of Dreams: The Russian Avant-Garde and Cultural Experiment*, ed. John E. Bowlt and Olga Matich (Stanford, CA: Stanford University Press, 1996), 161.

34. See Marjorie Perloff's analysis of the verbal-visual elements in "Akhmet," in Perloff, *The Futurist Moment*, 139–40.

35. Translated by Allison Pultz and Gerald Janecek for the Getty Research Institute exhibition *Tango with Cows: Book Art of the Russian Avant-Garde, 1910–1917*, 18 November 2008–19 April 2009.

36. "Angel letel" (An angel flew) is a direct quotation from Mikhail Lermontov's poem "The Angel." It opens: "Across the midnight sky an angel / flew and sang a quiet song."

37. Khlebnikov, *Collected Works*, 1:370.

Unlocking the Semantics of Sound in *Vzorval'*

I take my title from the Scottish poet and translator Edwin Morgan, who produced Scots translations of Russian *zaum*. He recognized uncannily that *zaum* derived its meaning from sound. To "unlock the semantics of sound" was to take as a given that "all aspects of a language have meaning, including its sounds and its morphological units."[1] Yet far from constituting all language—or, conversely, from being nonsense—*zaum* (best translated by Paul Schmidt as "beyonsense") relinquishes definite meaning and attempts to "increase the play of reference and achieve an ever greater indeterminacy."[2]

In the book *Vzorval'* (Explodity), the futurist poet Alexei Kruchenykh intensified such referential play through careful use of morphemes, neologisms, and ordinary words, the latter chosen for their phonic "coloration" and placed in verbal settings that often defamiliarized them. While the verbivocovisual language of *Vzorval'*, like *Mirskonsta,* operates between advanced abstraction and the figurative, the two editions of this book, published in June and December 1913, postdated *Mirskontsa* by at least seven months and coincided with the first theorizing of *zaum* in futurist books and manifestos. It is therefore not surprising that word, image, and sound move further in *Vzorval'* than in *Mirskontsa* into the realm of nonreferentiality.[3]

In the summer of 1913, at precisely the time when he was working on *Vzorval'*, Kruchenykh wrote a manifesto titled *Deklaratsiia slova kak takovogo* (Declaration of the word as such), in which he numbered his points and scrambled their order—a gesture that defied linearity. He then presented his comments on sound (excerpted here) as follows:

(2) consonants render everyday reality, nationality, weight—vowels, the opposite: A UNIVERSAL LANGUAGE. Here is a poem exclusively of vowels:

o e a
i e e i
a e e E

(3)…It is better to replace a word with one close in sound than with one close in meaning.…(1) A new verbal form creates a new content, and not vice versa. (6) INTRODUCING NEW WORDS, I bring about a new content WHERE EVERYTHING begins to slip (the conventions of time, space, etc.…).[4]

In a letter of 31 August 1913, Velimir Khlebnikov responds enthusiastically to Kruchenykh's *Deklaratsiia,* especially to its proposal for poems composed exclusively of vowels: "I agree that the sequence *aio, yeyeye* has a certain meaning and content, and that in skillful hands it might become the basis for a universal language."[5]

In his essay "The Newest Russian Poetry" (1921), Roman Jakobson identifies the "thesis of the Russian Futurists" by quoting from a second Kruchenykh manifesto, *Novye puti slova* (New ways of the word), published in early September 1913. The passages that interest Jakobson are those arguing that the speech-sounds of words—rather than subject matter—represent true innovation. For example (and here he quotes Kruchenykh): "Our creative shaping of speech throws everything into a new light. It is not new subject matter that defines genuine innovation."[6]

A year later, in 1914, Kruchenykh and Khlebnikov wrote an essay on vowels that, like the statements above, advocates the selection of words based on their abstract sonic quality:

Now we can write not only using vowels or consonants but using a mere single sound, where variety and nuances are provided by its different outline, by different letters…or, to give verbal art complete freedom, we use arbitrary words to liberate ourselves from the subject and study the *color,* the *music* of the word, syllables, sounds. To get away from the definiteness of former words and notions and create words without any definite logical meaning.[7]

Placing a primacy on "sound as such," Kruchenykh and Khlebnikov imply in their essay that transrational words are phonic, and that this phonic dimension—expressed through speech, letters, vowels, and consonants—becomes itself the content. For Kruchenykh, transrational words also cause slippages in time and space, which link them to the formalist device of *sdvig* (shift, dislocation) and to the hyperspace philosophy of the mathematician P. D. Ouspensky. The relevance of *sdvig* and of concepts of nonlinear time and spatial extension to a theory of transrational language is significant. As a semantic shift displaces the referent (signified) or, in Khlebnikov's poetry, as a slip of the tongue alters the sound character and meaning of a word, arbitrary words

and words with new roots liberate the poet from habitual associations. Jakobson puts it poetically: "The word is apprehended as an acquaintance with a suddenly unfamiliar face."[8]

The commentary by Kruchenykh and Khlebnikov quoted above introduces a new concept of the word: a shift in emphasis from content (meaning) to form (speech and sound). Among futurist books, *Vzorval'* represents an especially revealing case study for Kruchenykh's experiments with the semantics of sound and with sound poetry. It distinguishes itself from artists' books such as *Mirskontsa* (Worldbackwards), *Pomada* (Pomade), and *Zaumnaia gniga* (Transrational boog) by testing the limits of Russian versification without abandoning its rules altogether. Sound takes the lead but depends upon visual imagery and a distinctive hand-lettered calligraphy that varies in style and legibility from poem to poem.

Vzorval' is the result of a collaboration between Kruchenykh and the painters Natalia Goncharova, Nikolai Kulbin, Kazimir Malevich, and Olga Rozanova. Among these artists, Kulbin and Rozanova contributed the most extensively, with Rozanova playing a lead role in the second edition. For this edition, Kruchenykh asked the artist to provide hand-lithographed pages in lieu of the rubber-stamped poetry he had used for the first edition. Because my analysis of *Vzorval'* focuses on the second edition, a brief survey of Rozanova's career is important, especially as it sheds light on her working relationship with her poet-collaborator, Kruchenykh.

Rozanova was born in 1886 in the small town of Melenki, near Vladimir (about 120 miles northeast of Moscow) (see "From the Provinces," fig. 3). She enrolled at the Vladimir Women's Gymnasium, graduating in 1904 and then moving to Moscow to study painting. In 1907, she began attending the private art schools of Konstantin Iuon and Nikolai Ulianov, who were both Russian painters and theater designers teaching in Moscow, and she continued at Iuon's school through 1910. At Iuon's, she met fellow students Kruchenykh and Liubov Popova. In 1911, she joined the Saint Petersburg Union of Youth and showed her painting for the first time at the second Union of Youth exhibition in April. She also frequented the Stray Dog cabaret, and in 1911 she moved to Saint Petersburg.

June 1913 marked Rozanova's initial collaborations with Khlebnikov and Kruchenykh on *Bukh lesinnyi* (Forestly rapid) and with Kruchenykh on *Vozropshchem* (Let's grumble) and *Vzorval'*. For the first edition of *Vzorval'*, she contributed only two full-page drawings, but, in a letter of June 1913 to her sister Anna, she describes creating about forty drawings altogether for these three collections, including both editions of *Vzorval'*, and mentions that *Vozropshchem* contains the following dedication from Kruchenykh: "To O. Rozanova, the best artist in Petrograd."[9] A close, life-long partnership with Kruchenykh grew out of their early collaborations, and the two produced

many more books together, as well as *Voina* (War), an album of colored linocuts, with verses by Kruchenykh, published in January 1916.

In the fall of 1916, having moved to Moscow, Rozanova became the editorial secretary of Malevich's journal, *Supremus,* and participated with him in the selection of materials and the articulation of its program (fig. 1). Like Khlebnikov, Rozanova was in severe financial straits in January and February 1917, when she joined the Moscow Union of Cities, a community organization that collected provisions for the front. Working with Kruchenykh from late February to early March, she experimented with writing transrational poetry. She died of diphtheria in November 1918 at

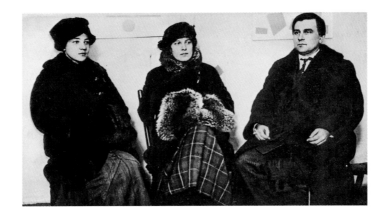

the age of thirty-two, after taking part in street decorations in Moscow to celebrate the first anniversary of the October Revolution.[10]

Although most active as a painter, Rozanova was a remarkable book-art collaborator who understood poetry and contributed drawings that ultimately set the book's tone. Each edition of *Vzorval'* has its own cover design (the first by Kulbin, the second by Rozanova), a slightly different selection of poems, and a preference for rubber-stamped poetry in the first edition and hand-lithography in the second. For both editions, Kruchenykh chose an unusual, makeshift format characterized by differently sized pages, with larger pages protruding behind smaller ones. In the second edition, he sharpened the disorderly, nonlinear appearance by scattering the pages at multiple angles and then stapling them so that they appear off-kilter (fig. 2). This irregular design subverts the traditional vertical alignment of pages in a book and alludes to the principle of reversibility (*mirskontsa*) and the Ouspenskian fourth dimension, with its transcendence of linearity and temporality.

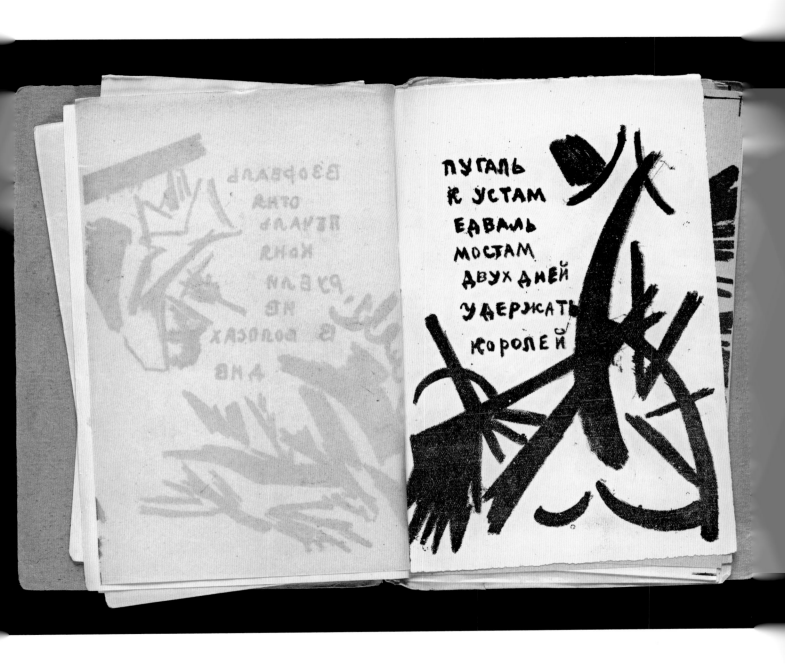

The production of multiple editions—as opposed to variant copies—is extremely rare in futurist book art. Only *Igra v adu* (A game in hell) appeared in a second edition in 1914, two years after its first publication and featuring new artists and an expanded poem.[11] Differences between the two editions of *Vzorval'* are less extensive, because the artists remained the same. However, as we shall see in the ensuing analysis, the second edition contains a compelling, well-articulated Kruchenykh/Rozanova section that replaces the first edition's plain, brown rubber-stamped poetry with black handwriting and drawings that provide a distinctive visual component. Whereas the first edition is principally verbivocal, the second edition pursues a verbivocovisual play.

Rozanova's contribution to *Vzoval'* begins with her cover, which differs markedly from Kulbin's cover design (figs. 3, 4). Evoking a turbulent cityscape, Rozanova laid the wobbly, differently sized letters of her title word above cascading skyscrapers and chimney stacks, which, lacking plasticity, fall on top of each other like sheets of folded paper. Nonobjectivism, in the form of swirling and dotted lines of motion, combines with fragments of windows, towers, and smoke. In this way, Rozanova's image links the book's title to the theme of apocalypse, which she continued to explore in interior drawings. Kulbin, by contrast, presented us with a cartoonish drawing of an orator addressing an audience of stick figures, who gesticulate wildly in different directions and collapse on the floor. His handwriting accentuates the theme of verbal explosiveness. The contrast between the geometric stability of speaker and podium and the curved, mobile forms of audience members creates the effect of a noisy din. Kulbin's cover thus anticipates the vital role of sound in this futurist volume, but it is too cartoonish to connect to the apocalyptic themes and soundscapes of *Vzorval'*.

"Beliamatokiiai" and "Zabyl povesit'sia"

The title *Vzorval'* is a neologism. Kruchenykh derived it from the masculine past-tense form of the verb *vzorvat'* (to explode, to blow up). By inserting a soft sign normally used only in nouns at the end of *vzorval'*, he transformed this verb form—which translates as "he exploded" or "he caused a commotion"—into a new noun. It is, in his words, an "artful combination" typically translated as "explodity." In the letter of June 1913 to her sister, Rozanova defines the book, *Explodity*, as "a bomb."[12]

Kulbin opened the book with a portrait of Kruchenykh, which he animated by using small curved lines to highlight features of the face and capture its mobility of expression (fig. 5). The portrait introduces a page showing Kulbin's visual design for a single *zaum* word invented by Kruchenykh: беляматокияи (Beliamatokiiai) (fig. 6).[13] Kulbin distributed the long word diagonally

Fig. 3.
Olga Rozanova (Russian, 1886–1918). Cover of Alexei Kruchenykh, *Vzorval'* (Explodity), 2nd ed. (Saint Petersburg, 1913). Los Angeles, Getty Research Institute, 85-B4913.

Fig. 4.
Nikolai Kulbin (Russian, 1868–1917). Cover of Alexei Kruchenykh, *Vzorval'* (Explodity), 1st ed. (Saint Petersburg, 1913). Los Angeles, Getty Research Institute, 85-B4921.

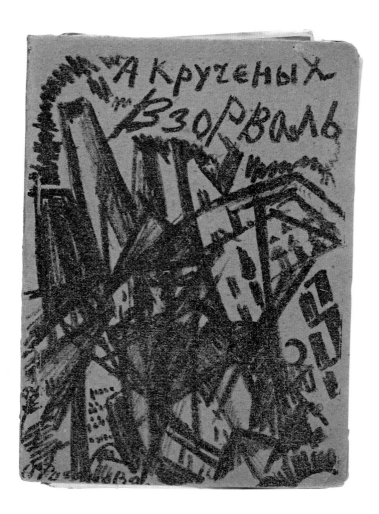
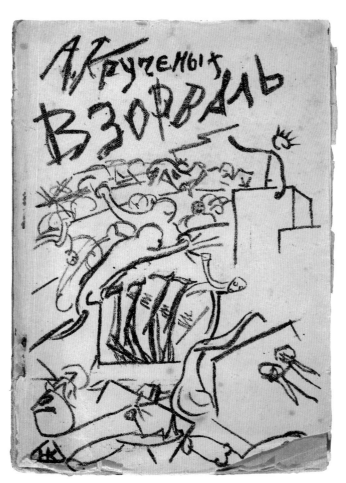

Fig. 5.
Nikolai Kulbin (Russian, 1868–1917).
Portrait of Alexei Kruchenykh.
From Alexei Kruchenykh,
Vzorval' (Explodity), 2nd ed.
(Saint Petersburg, 1913).
Los Angeles, Getty Research Institute,
85-B4913.

Fig. 6.
Nikolai Kulbin (Russian, 1868–1917)
and Alexei Kruchenykh
(Russian, 1886–1969).
Design and poetry for "Beliamatokiiai."
From Alexei Kruchenykh, *Vzorval'*
(Explodity), 2nd ed. (Saint Petersburg,
1913).
Los Angeles, Getty Research Institute,
85-B4913.

across the page and, most likely under Kruchenykh's direction, scattered Cyrillic letters below it to introduce consonant sounds (Н, Т, П) that do not belong to the word. These consonants might serve to complete the open vowel endings of all but the first syllable: *bel ia ma to ki ia i*. Their insertion does not violate the Russian language principle prescribing only one stress per word, no matter the length.[14] But "Beliamatokiiai" is primarily an example of what might be called visual *zaum*. It contains no individual stress and, because it exists in isolation, no poetic meter. The V-shaped forms scattered around the page suggest flying birds, but they hover between abstraction and the figurative. This ambiguity distinguishes Kruchenykh's poetry throughout the book, as we shall see.

His opening poem appears as verse that he rubber-stamped in purple ink on an otherwise blank page (fig. 7). Beginning with the line "zabyl povesit'sia" (forgot to hang myself), the poem contains surprising and unpredictable sound patterns, which can best be understood as Kruchenykh's deliberate deviation from the norm of Russian poetry. Typically, Russian verse since the eighteenth century adhered to what is called "syllabo-tonic poetry," in which stress determines the poetic organization, exactly as in German and English poetry. The defining feature of syllabo-tonics is the regular alternation of stressed (accented, notated as x) and unstressed (unaccented, notated as /) syllables. Five patterns, comparable to the "feet" that are the basis of English meter, define syllabo-tonic poetry: iambic (/ x), trochaic (x /), dactylic (x / /), amphibrachic (/ x /), and anapestic (/ / x).

It is important to note that in Russian poetry, the most common meter is iambic tetrameter—in contrast to English, where iambic pentameter dominates.[15] How then does the poetic meter that Kruchenykh introduces in his short poem adhere or not adhere to the rules of syllabotonic poetry? The first two lines contain six syllables each and two iambic feet per line. Thus, they follow an iambic dimeter (/ x / x), with added syllables at the end of the second foot, and form a pair. The transliteration below shows this accent pattern, as well as the scansion of subsequent lines, by using capital letters to indicate stressed syllables.

Fig. 7. ◀))
Alexei Kruchenykh (Russian, 1886–1969).
Design for "Zabyl povesit'sia" (Forgot to hang myself).
From Alexei Kruchenykh, *Vzorval'* (Explodity), 2nd ed. (Saint Petersburg, 1913).
Los Angeles, Getty Research Institute, 85-B4913.

zaBYL poVEsit'sia	forgot to hang myself
leCHU k aMERikam	i'm flying to the Americas
na koraBLE poLEZ li	on the ship did crawl
kto	someone
xot' byl pred NOsom	although he was right under my nose

The paired lines of iambic dimeter do not share rhymed endings, nor do they rhyme with any of the remaining lines in the poem. This absence of rhyme scheme breaks dramatically from the tradition of rhyme in Russian poetry. Moreover, Kruchenykh abandons his iambic stress pattern in the third line by introducing one foot of four syllables ("na koraBLE"), followed by a two-syllable foot ("poLEZ") and a monosyllable ("li").[16] Aside from the common stress on final syllables, this

line lacks a metric scheme, and its syllabic count and stress do not recur in a later line. Instead, the fourth line contains the monosyllabic *kto* ("who/he/someone"—a relative pronoun), followed in the fifth line by a chain of three monosyllabic words ("xot' byl pred"), which, even with the subsequent accent on "NOsom," do not display a pattern of regular stresses and metric feet.[17] ◀))

"Zabyl povesit'sia" may lack regular stress and rhyme, but it is a poem with a distinctive phonic language. The opening two lines, containing assonance on the vowels *e* and *u* ("zaBYL poVEsit'sia leCHU k aMERicam"), convey a smooth, sonorous tone that leaves us unprepared for the abrupt irregularities in line three and the monosyllabic writing of the final two lines. The melodious sounds also clash with the semantics, which speak of suicide ("hang myself"), although in oddly humorous and disjointed terms. Suicide becomes connected to flight ("flying to the Americas"), and the link between flight and death anticipates a lithograph by Malevich, *Smert' cheloveka odnovre menno na aeroplane i zhel. doroge* (Death of a man simultaneously in an airplane and on the railroad), which appears later in *Vzorval'* (see fig. 17). As modes of transport shift from an airplane to a ship, the text becomes increasingly fragmented and nonsensical, paralleling the increased irregularity of the verse. Words are connected by sound—meter, assonance, monosyllabic writing, and the recurrence of *byl* in line five—rather than by syntax or stress pattern. We might say that Kruchenykh's highlighting of sound and his disregard for the norms of Russian verse introduce a new kind of poetry—minimal, enigmatic, both comical and dark—in which sounds unlock their own semantics.[18]

Going a step further, sound takes primacy in "Zabyl povesit'sia," because assonance *(e, u, o)* and choppy metrics assume a life of their own. Detached from the poem's few hints at narrative, which dissolve by line three, words gain presence and resonance as individual *zaum* words, as "sounds as such"—each possessing an abstract, sonic materiality that can only be recognized when they are heard aloud.

"Tianutkoni"

We turn the page to discover two words rubber-stamped in purple ink on an otherwise blank sheet (fig. 8). Neologisms of Kruchenykh's invention, they read "noni: umertviteli"—with *noni* an imaginary sound word and *umertviteli* an invented noun derived from the verbs *umertvliat'* (to kill) and *umirat'* (to die). The colon, taken from dictionary entries, indicates equivalence and therefore suggests that *noni* are killers, even executioners.[19] Consider how Kruchenykh used rubber-stamping to challenge a linear reading of this text. He angled the words on the page, shifted the size of individual

◀)) Listen to "Zabyl povesit'sia"
www.getty.edu/ZaumPoetry

Fig. 8.
Alexei Kruchenykh (Russian, 1886–1969).
Design for "Noni: umertviteli."
From Alexei Kruchenykh, *Vzorval'* (Explodity), 2nd ed. (Saint Petersburg, 1913).
Los Angeles, Getty Research Institute, 85-B4913.

НОЧЬ УМЕРТВИТЬ

letters, and sometimes lightened the ink. The final two letters are so tiny that they can scarcely be read. The two neologisms serve a purpose, however, as a caption or anticipation of the next poem, "Tianutkoni" (Haulhorsies), a more elaborate and irregular verse than "Zabyl povesit'sia" (fig. 9). "Tianutkoni" is also the first of Rozanova's handwritten collaborations with Kruchenykh.

tianutKOni [A]	haulhorsies
neponIATnye NOni [A]	incomprehensible nonies
zver' ispuGALsia [B]	the beast got scared
otKUda GAL' SIA [B]	from where it sca ed
veZUT oSInovyi KOL [c]	[they] bring an aspen stick
ub'IUT ZHIVYKH CHOL [c]	[they] will kill the living hick
siDIT VaVULa [D]	sits Vavula
droZHAT SKULy [D']	quiver the cheekbones
vDAli [E]	in the distance
KOL [c]	stick
daleKO [c']	far away

The poem's opening word is a composite, and hence a neologism, that strings together two actual words: *tianut* (haul) and *koni* (horses). Spoken as a single word, it can have only one stress ("tianutKOni"), which precludes the possibility of meter in this line. The second line, by contrast, follows a more regular anapestic dimeter (/ / x, / / x) and contains a *ni* ending that mirrors the ending in line one. Indeed, if we scan the next four lines, we see Kruchenykh using rhymed couplets through line six, in a scheme of A A B B c c.[20] Lines seven and eight, while not following an exact rhyme, share a common hard consonant internal ending *t* ("sidit" / "drozhat") and an approximate rhyme—with its minimal requirement of adjacent stressed vowel and consonant—in their final words: "VaVULa" and "SKULy."[21] The last three lines, if adjusted graphically to read as two ("vdali kol / vdaleko"), reveal Kruchenykh's further use of approximate rhyme.[22]

Kruchenykh's observance of Russian rhyme thus lies well within tradition, but his approach to rhythm and meter diverges from the norm. In the broadest terms, this is because rather than using the classic Russian iambic tetrameter, he changed the meter in each line. For instance, line three contains only one stress on "GAL," which is introduced by three weak syllables and followed by a weak one, thus avoiding a regular meter. Line four begins with two iambs ("otKUda GAL'"), but

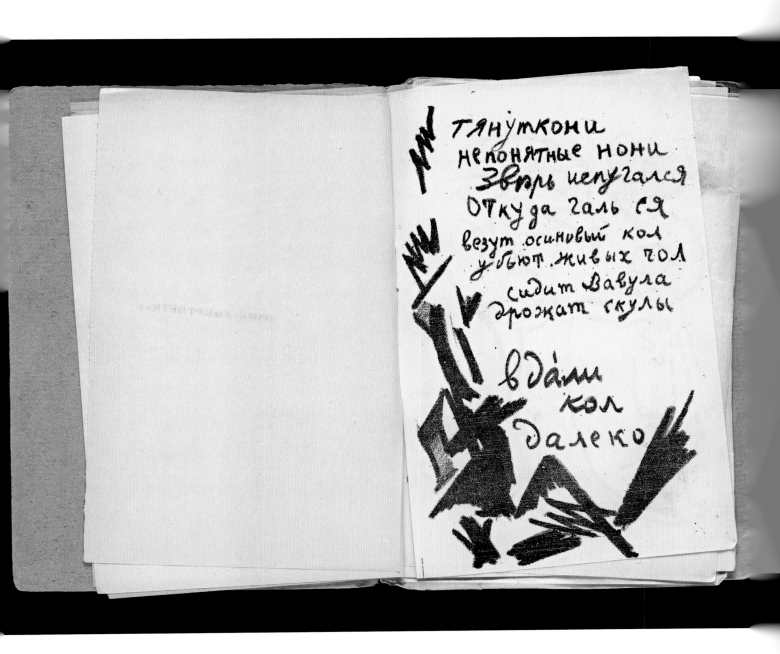

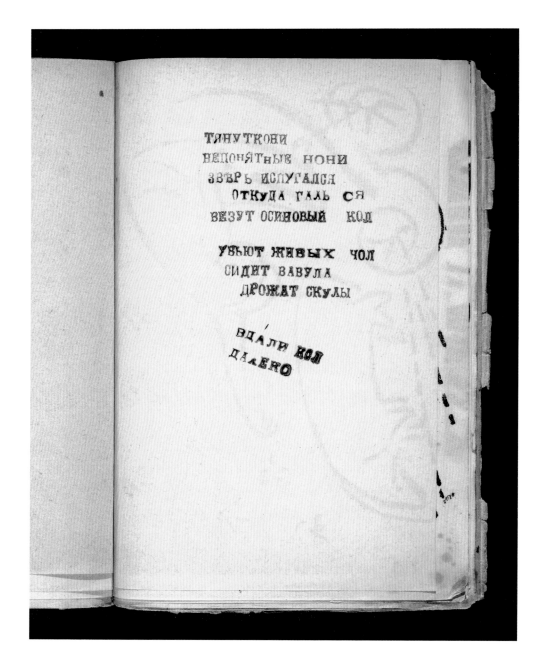

ТЯНУТКОНИ

НЕПОНЯТНЫЕ НОНИ

ЗВѢРЬ ИСПУГАЛСЯ

ОТКУДА ГЛАЬ СЯ

ВЕЗУТ ОСИНОВЫЙ КОЛ

УБЬЮТ ЖИВЫХ ЧОЛ

СИДИТ ВАВУЛА

ДРОЖАТ СКУЛЫ

ВДАЛИ КОЛ
ДАЛЕКО

Fig. 10. ◀))
Alexei Kruchenykh (Russian, 1886–1969).
Design for "Tianutkoni" (Haulhorsies) (detail).
From Alexei Kruchenykh, *Vzorval'* (Explodity), 1st ed. (Saint Petersburg, 1913).
Los Angeles, Getty Research Institute, 85-B4921.

the pattern changes abruptly with a pause and an accent on the next sound, "SIA" (a reflexive suffix). Line five sets up a regular iambic trimeter ("veZUT oSInovyi KOL"), which line six disrupts by inserting a word with two stressed syllables (a spondee) directly after the iamb ("ubIOT ZHIVYKH CHOL"). Lines seven and eight follow a similar approach, setting up and then interrupting iambic feet. The effect of these stops and starts is a rhyming poem with a decidedly irregular rhythm evocative of speech. ◄))

◄)) Listen to "Tianutkoni"
www.getty.edu/ZaumPoetry

Kruchenykh's *zaum* poem brings back the invented word *noni,* from "noni: umertviteli," now rhyming with *koni,* which is the plural form of *kon'* (horse). The Russian word for *horse,* in its plural and accusative forms, returns in the next two poems. This recurrence, amid poetry that is otherwise abstract and alogical from line to line, inserts a figurative element that piques our curiosity about how Rozanova will respond. Kruchenykh also interjects ominous words into "Tianutkoni": *scared* in line three (repeated in the next line without the *r*), *stick* in line five, *kill* in line six, and a return of *stick* at the end. These words mix with the neologisms (*tianutkoni, noni,* and *gal' sia*) and with enigmatic lines such as "carry an aspen stick / kill the living hick" to create an eerie, ambiguous mood. Rozanova interpreted the poetic language by drawing abstract, darting, fork-like forms suggestive of hands pointing away from the text (see fig. 9). A V-shape that could be the bent knees of a human form returns with more referentiality in her image for the next poem. In sharp contrast to the brown, rubber-stamped page in the first edition of *Vzorval'* (fig. 10), Rozanova handwrote her poem in both print and cursive and varied the scale and spacing of her letters to give her rendition a scrawled, illegible appearance. Her page thus becomes a visual gesture that approaches the nonfigurative and works in parallel with the phonic abstraction of the poetry.

When spoken aloud, "Tianutkoni" becomes more abstract and nonsensical than when it is read. This is because the rhymed endings of Kruchenykh's paired lines are more audible as spoken verse and tend to dominate the verbal. Adhering to a consistent succession of rhymes and approximate rhymes (see transliteration of poem, p. 126), "Tianutkoni," as spoken recitation, is a *zaum* poem in which pulsing, rhyming sonorities overshadow the menace evoked by the semantic details of single words (for example, *scared* and *stick,* and lines such as "kill the living hick"). The "vocal" thus asserts itself with the verbivisual and assumes prominence.

Beginning with "Tianutkoni," Kruchenykh devoted a section of his book to the visual art and handwriting of Rozanova. Curiously, he inserted a page of imagery by Kulbin between "Tianutkoni" and the subsequent poem, "Tianutkonei" (fig. 11). The fanciful drawing shows a person falling off a chariot that is being pulled by an imaginary animal.[23] The V-shaped forms recall the flying

birds of "Beliamatokiiai" (see fig. 6), but here they look more like stylized flowers. These elements of fantasy, taken together with the need to rotate the book clockwise in order to identify the chariot, offer a playful interlude well at odds with the tone of Rozanova's previous page. What do we make of this insertion? In a book more stylistically unified than *Mirskontsa,* Kruchenykh may have chosen to insert an occasional juxtaposition—call it a *sdvig*—to reintroduce the principle of collage favored by the futurists. The practice of rotating the book invokes futurist reversibility and recalls Mikhail Larionov's "Nash kochen'" from *Mirskontsa,* as well as a lithograph by Malevich that appears later in *Vzorval'.*

A Companion Poem: "Tianutkonei"

Kruchenykh's next poem is a companion to "Tianutkoni." The two explore similar neologisms: *noni* appears here in its accusative form of *nonei,* and *koni* is in its accusative *konei* (fig. 12).

Fig. 11.
Nikolai Kulbin (Russian, 1868–1917).
Design for "Tianutkonei" (Haulhorsies).
From Alexei Kruchenykh, *Vzorval'*
(Explodity), 2nd ed. (Saint Petersburg, 1913).
Los Angeles, Getty Research Institute, 85-B4913.

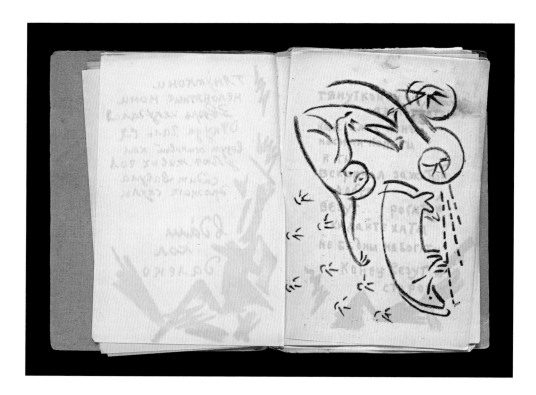

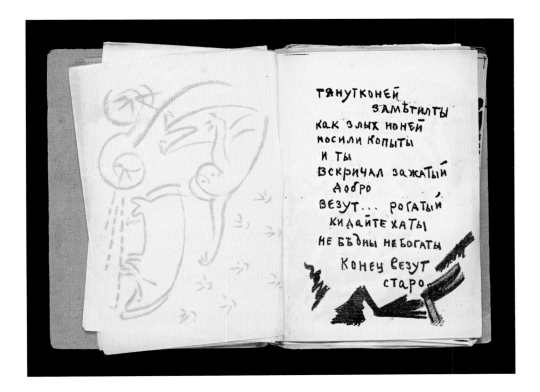

Fig. 12. ◀))
Olga Rozanova (Russian, 1886–1918)
and Alexei Kruchenykh (Russian,
1886–1969).
Design and poetry for "Tianutkonei"
(Haulhorsies).
From Alexei Kruchenykh, *Vzorval'*
(Explodity), 2nd ed. (Saint Petersburg,
1913).
Los Angeles, Getty Research Institute,
85-B4913.

tianutkoNEI [a]	haulhorsies
zaMEtil TY [b]	noticed you
kak ZLYKH noNEI [a]	like angry nonies
noSIli koPYty [C]	took hooves [they worehooves]
i TY [b]	and you
vskriCHAL zaZHAtyi [D]	cried out the crushed one
doBRO [e]	goods
veZUT… roGAtyi [D]	they carry…the horned one
kiDAite KHAty [D']	give up huts
ne bedNY ne boGAty [D']	nor poor nor rich
koNETS veZUT [f]	the end [they] carry
staRO [e]	old

Through their opening neologisms, "Tianutkoni" and "Tianutkonei" share a reference to horses, and the second poem speaks of "hooves" and a "horned one." But in meter, scansion, and rhyme scheme, "Tianutkonei" pursues a different path. Line one, consisting of a neologism, lacks meter. Lines two and three share accents on the second and fourth syllables, forming an iambic dimeter; and line four ("noSIly koPYty"), comprised of six syllables, combines iambic with anapestic (/ / x). This pattern of iambic ("vskriCHAL zaZHAtyi") and anapestic ("ne bedNY ne boGATy") meter continues intermittently throughout the poem, but, in a sharp departure from standard Russian prosody, Kruchenykh breaks up the scansion with surprising two-syllable lines. In lines seven and twelve, the words "doBRO" and "staRO" share the same masculine stress and rhyme but no common rhyme with any other endings in the poem. With line eleven, "veZUT" (to carry or transport), he adds one more nonrhyming ending, although it belongs to an iambic line of two feet. In line five, "i TY" also stands apart due to its two-syllable count. Its masculine stress on "TY," however, forms part of the distinctive rhyme scheme of "tianutkoNEI."

According to this scheme, repeated approximate rhymed endings on the variants *ty, tyi,* and *ei* form masculine rhymes when they receive the stress and feminine rhymes when they do not. Internal rhymes on *i* and *y,* as in "nosili kopyty" (line 4) and "ne bedny ne bogaty" (line 10), strengthen the recurring rhyme and sharpen the contrast with the interrupting words *dobro* and *staro.* Both in Kruchenykh's rubber-stamped version and in the hand-lithographed page by Rozanova, *dobro* and *staro* are highlighted by an indentation, as is "i ty." In this way, two-syllable words with second-syllable stresses are signaled visually for the reader. ◀))

◀)) Listen to "Tianutkonei"
www.getty.edu/ZaumPoetry

As part of her lithographed page, Rozanova devised a handwriting that differs noticeably from that used in "Tianutkoni" (see fig. 9). Rather than mixing print and cursive, she printed very legibly in all capital letters and allowed ample space between them. Her minimal drawing, which occupies only the lower margin of the page, suggests a seated human figure with reclining head and back, arms dropping down, and knees bent. The sharp thrusts and the open spaces in the drawing call attention to the menacing tone of the poetry, with its mysterious references to "angry nonies," the "crushed one," and the "horned one." Kruchenykh took his verse well into the abstract semantics of *zaum,* leaving Rozanova's suggested seated figure unexplained.

Appearing only in the first edition of *Vzorval',* a tiny rubber-stamped poem follows "Tianutkonei" (fig. 13). Kruchenykh confined himself to nouns, two of which are neologisms.

Fig. 13. ◀)
Alexei Kruchenykh (Russian, 1886–1969).
Design for "Pugal': pistolet"
(Scaredity: gun) (detail).
From Alexei Kruchenykh, *Vzorval'*
(Explodity), 1st ed. (Saint Petersburg, 1913).
Los Angeles, Getty Research Institute, 85-B4921.

◀) Listen to "Pugal': pistolet"
www.getty.edu/ZaumPoetry

puGAL': pistoLET
vzorVAL' BOMba

scaredity: gun
explodity bomb

Both *pugal'* and *vzorval'* are masculine past-tense forms of the verbs *pugat'* (to scare) and *vzorvat'* (to blow up, to explode), respectively. Kruchenykh added a Russian soft sign to the end of each verb form, transforming them into newly invented nouns. Each neologism is an iamb, and the two share internal rhymed endings on "AL." However, whereas "puGAL'" is followed by the anapest, "pistoLET," "vzorVAL'" moves abruptly to another stressed syllable—the first syllable of "BOMba." By using his second iamb to set up expectations of meter, only to thwart these expectations, Kruchenkyh creates surprise and even humor, an effect that is especially noticeable when we hear the poem read aloud. The successive sounds, with their sudden accent shift, could be part of a comical children's rhyme. Yet such sonics clash with the semantics of this poem, which dwells on violent causalities and reverses their order: a gun makes one scared; a bomb produces an explosion. ◀)

A Pair of Explodity Poems

In the first edition of *Vzorval'*, Kruchenykh works with pairs of poems but tends to interrupt the pair by inserting new poetry; however, in the second edition, he maintains his sequence of paired poems (beginning with "Tianutkoni"), allowing important visual, verbal, and phonic connections to emerge from poem to poem. Two "explodity" poems thus follow one another sequentially in the second *Vzorval'*.[24] In addition to consisting of only nine words apiece, each adheres to almost identical metric patterns, rhythms, and rhyme schemes and takes on the sound of a chant or incantation.

The first, "Vzorval' ognia" (Explodity of fire), opens with four lines of iambic dimeter that follow an alternating scheme of masculine rhymes (a b a b) (fig. 14).

vzorVAL' [a]	explodity
ogNIA [b]	of fire
peCHAL' [a]	sorrow
koNIA [b]	of a horse
RUBli [C]	cutting off of branches
IV [d]	of willows
v voloSAKH [e]	in the hair
DIV [d]	of wonders

Fig. 14. ◀))
Olga Rozanova (Russian, 1886–1918) and Alexei Kruchenykh (Russian, 1886–1969).
Design and poetry for "Vzorval' ognia" (Explodity of fire).
From Alexei Kruchenykh, *Vzorval'* (Explodity), 2nd ed. (Saint Petersburg, 1913).
Los Angeles, Getty Research Institute, 85-B4913.

The endings of all four opening lines are linked by an assonance on *A*. The iambic meter stops unexpectedly on the neologism *rubli*, in line five, which has a stress on the first syllable. In the sixth line, the only syllable, *iv*, receives the accent. In this way, Kruchenykh varies the successive iambs, not through pyrrhic feet or spondee but by shifting the stress and eliminating the iamb altogether.[25] The last two lines consist of an anapest ("voloSAKH"), followed by a one-syllable word that rhymes with *iv* in line six. Kruchenykh enriches his sound fabric by using alliteration in the form of repeated *V*s, which appear as both initial and final consonants (*iv, v volosakh, div*) and echo the opening word of the poem—*vzorval'*. ◀))

In the same way that the sonic fabric of "Pugal': pistolet" belies its semantics, so "Vzorval' ognia" sounds mellifluous and lilting, although its words and neologisms carry menacing semantic implications. In addition to the recurrence of *vzorval'*, which Kruchenykh reinforces with *ognia* (of fire), he introduces the neologism *rubli*, followed by *iv*, which together can be interpreted as a succinct paraphrase of "obRUBlennye vetki iv" (the cutting off of branches of willows).[26] We have here an example of *sdvig*, in which slips of the tongue alter the sound and meaning and liberate

◀)) Listen to "Vzorval' ognia"
www.getty.edu/ZaumPoetry

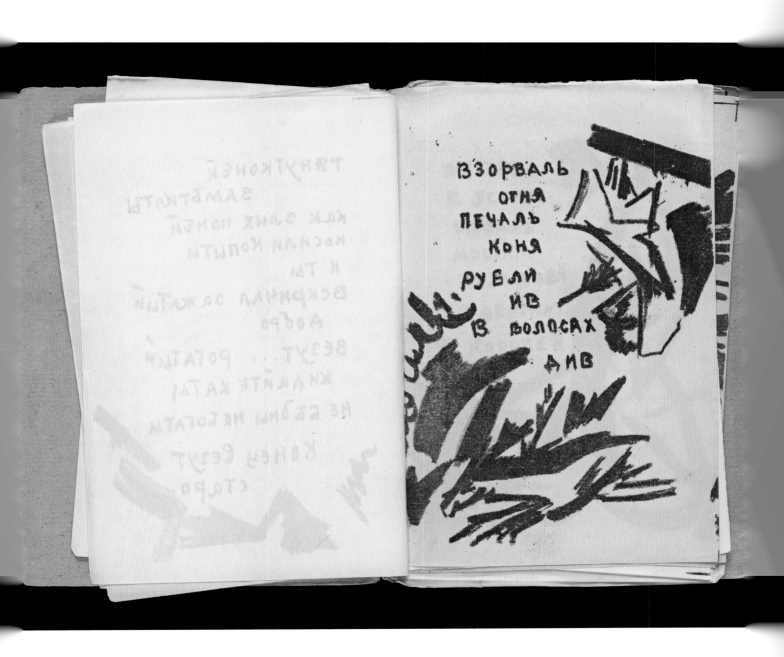

the poet from habitual associations. Danger is intimated by the root of *rubli* in *rubit'* (to cut off) and in *rublennyi* (chopped). As a whole, "rubli iv" juxtaposed against "v volosakh div" (in the hair of wonders), give the poem an ambiguity, which Rozanova's setting corroborates (see fig. 14).

She handwrote the verse with the same legible, all-capital letters that she used in "Tianut-konei." However, in "Vzorval' ognia," the static block printing contrasts with the agitated drawings, which send slabs of lines that resemble tree branches directly into the poetic text. This marks the first page of *Vzorval'* in which Rozanova offers a representation of Kruchenykh's hermetic poem: the *sdvig* word *rubli* prompts a reading of dense, agile branches. Moreover, they appear cut up in shards, like the cut-off branches of willows in Kruchenykh's poem. Intriguingly, and unlike in any of her previous images, Rozanova drew a running horse almost concealed beneath the "branches." Here, she responds to Kruchenykh's frequent references to horses, both here and in previous poems, rotating our viewing between advanced abstraction and the figurative. The poem acquires a subtle verbivocovisual interplay, particularly when heard aloud, because iambic scansion and songlike rhyme tend to dominate the threatening semantics of the verse.

Kruchenykh's interest in short, spare verse keeps him far from the Russian norm of iambic tetrameter. "Pugal' k ustam," the pendant poem to "Vzorval' ognia," begins with four lines of iambic dimeter containing the identical rhyme scheme of a b a b (see fig. 2).

puGAL' [a]	a gun
k usTAM [b]	to the mouth
edVAL' [a]	is hardly
mosTAM [b]	to the bridges
DVUKH DNEI [c]	of two days
uderZHAT' [d]	to detain
koroLEI [c]	kings

The first and third lines adhere to the same rhymed ending of "AL'," and all four opening lines resonate with a rich, reverberating assonance on *a*. Also similar to "Vzorval' ognia" is Kruchenykh's break from iambic meter in line five, this time by introducing two monosyllabic stressed words ("DVUKH DNEI"), which constitute a spondee. The last two lines are more regular than in the previous poem. Each comprises an anapest (/ / x), and the final word, *korolei*, rhymes with *dnei* in line six. ◄))

◄)) Listen to "Pugal' k ustam"
www.getty.edu/ZaumPoetry

PERLOFF

Kruchenykh thus gives us a companion poem that shares the resonant, incantatory quality of "Vzorval' ognia" and hence the odd discordance between mellifluous phonics and dangerous verse ("a gun to the mouth"). While each line conveys meaning, and there are no neologisms, Kruchenykh avoids signification through the pursuit of alogical writing and abrupt semantic shifts from line to line. Rozanova's creation of visual forms again suggestive of tree branches introduces a three-dimensional landscape, which nearly overwhelms her block-lettered text. Fork shapes from the previous drawing give way here to arabesques that echo the sonorous verse (see fig. 2).

Rozanova may have intended the prominence of this drawing to prepare us for the next two pages of the book, which reveal her powerful full-page spreads (figs. 15, 16). The exploding sun, followed by the horse rearing at the sun, are apocalyptic images. As the only pages in *Vzorval'* without text, they mark the final instance of the Kruchenykh/Rozanova collaboration. I say collaboration, even though they are entirely visual, because Kruchenykh's idea of apocalypse—conveyed through the book's title, Rozanova's cover image of a destroyed cityscape, and sinister allusions to guns and a bomb amid the *zaum* poetry—provides an impetus for the drawings. We saw a similar collaborative process on the cover of *Te li le,* where Kruchenykh's invention of the title inspired Rozanova's visual setting, both playful and ominous.

Having prepared us for the image of the horse, Kruchenykh then turned over this image and the theme of explosion to Rozanova, his handwriting artist. She responded with a rendering of the sun that moves against referentiality; it is abundant in suggestive rays that fan out in all directions, with just a hint of the rounded sun in the middle. We might not be sure this is the sun were it not for the image of the rearing horse that follows. As a book artist, Rozanova intended the two pages to be read sequentially. She drew the horse schematically and with broad strokes, evoking the sun's rays behind and above the animal. Both images have a simplicity, the quality of a children's illustration, that refers back to some of Kruchenykh's childlike poems.

At the same time, the apocalyptic narrative of these drawings links the book's title, its cover, and the sinister verbal references and enigmatic sounds of its poetry to an apprehension about the future, even an uncanny pre–World War I foreboding of the end of the world. Were the drawings to occur independently of the preceding poetry and imagery—to be located, for example, at the beginning of the book—they would not have the cumulative impact that they gain here, serving as the peak of successive and recurring phonics, as well as margin imagery.[27] Page sequence (and the pairing of pages) thus plays as important a role in this section of *Vzorval'* as it does in *Mirskontsa,* where it operates by way of collage and juxtaposition, rather than by parallelism.

Following pages:
Fig. 15.
Olga Rozanova (Russian, 1886–1918).
Exploding sun.
From Alexei Kruchenykh, *Vzorval'*
(Explodity), 2nd ed. (Saint Petersburg, 1913).
Los Angeles, Getty Research Institute, 85-B4913.

Fig. 16.
Olga Rozanova (Russian, 1886–1918).
Rearing horse.
From Alexei Kruchenykh, *Vzorval'*
(Explodity), 2nd ed. (Saint Petersburg, 1913).
Los Angeles, Getty Research Institute, 85-B4913.

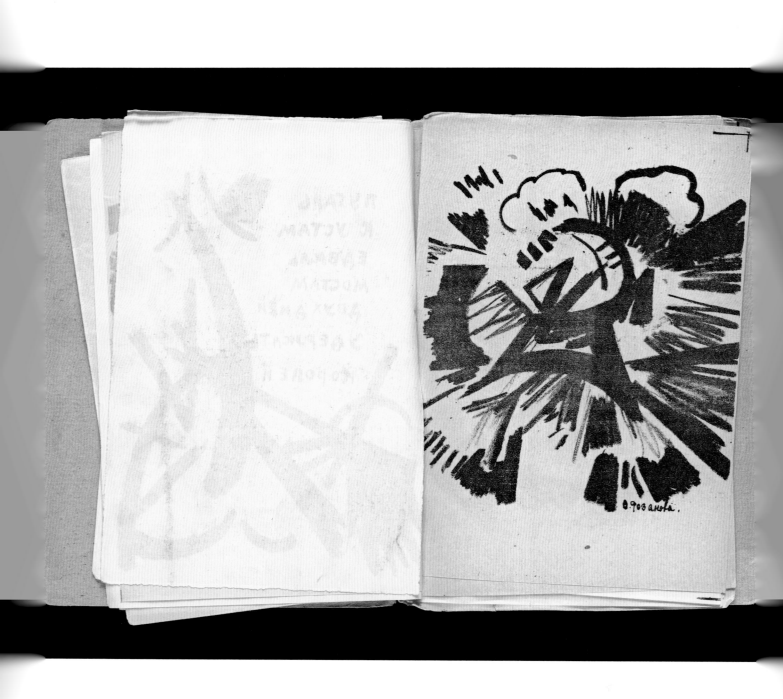

Malevich, Simultaneity of Death, and Flight

Malevich contributed two full-page lithographs to *Vzorval'*.[28] *Smert' cheloveka odnovre menno na aeroplane i zhel. doroge* (Death of a man simultaneously in an airplane and on the railroad) is the title handwritten by the artist in cursive on the lower-right corner of the image (fig. 17). Unlike the collaborative pages of Kruchenykh and Kulbin, and Kruchenykh and Rozanova, Malevich is both poet and artist of his page. He wrote his long title using curious, alogical word breaks and abbreviations: "odnovre menno" (instead of *odnovremenno*, or "simultaneously"), "zhel. doroge" (instead of *zheleznoi doroge* or "iron railway"), "K. Mal." (instead of Kazimir Malevich). As verbal-visual experiments, they invoke the *mirskontsa* principle explored by Kruchenykh when he played with linearity and legibility on his rubber-stamped pages. Thematically, Malevich's lithograph recalls and hence reinforces the verbal and phonic evocations of suicide, flight, and death that recur in the preceding section of *Vzorval'*.

Rotated clockwise for viewing, this drawing confronts us with an abstract network of overlapping trapezoids and triangles from which small telegraph poles and airplane wheels emerge. If we keep the artist's descriptive title in mind, the geometric shapes and the web of lines participate in a simultaneity of stylized airplane wings and railroad tracks, which we view from the elevated plane of the fourth dimension. According to P. D. Ouspensky's hyperspace philosophy, which Malevich's image insists upon, our higher consciousness sees simultaneously the events that ordinary consciousness never sees together. This world without causality allows for an expanded moment in which past, present, and future are visible all at once, and time no longer progresses in linear fashion, but rather it moves backward as well as forward and extends into the unknown space of the fourth dimension.

Malevich's second image, titled *Prayer*, appears four pages later (see figure opposite p. 1, this volume). It comes after a sequence consisting of a drawing of a devil by Goncharova and an insert called "New Scenes from *A Game in Hell*" by Kruchenykh and Khlebnikov. From this point on, the second edition of *Vzorval'*, like the first, becomes a book of individual rubber-stamped *zaum* poems and handwritten essays by Kruchenykh. The essays seek to establish a historical genealogy for *zaum* by placing it in the context of religious glossolalia, or "speaking with tongues." Kruchenykh cites this as proof that we resort to a free, transrational language in "important moments."[29]

Does *Vzorval'* share the aesthetic of *Mirskontsa*? In many respects, the answer is yes. Both books pursue principles of reversibility and illegibility; embrace formalist *sdvig* and defamiliarization; seek the higher consciousness of the fourth dimension; and explore the verbivocovisual. Yet

Fig. 17.
Kazimir Malevich (Russian, 1878–1935). *Smert' cheloveka odnovre menno na aeroplane i zhel. doroge* (Death of a man simultaneously in an airplane and on the railroad). From Alexei Kruchenykh, *Vzorval'* (Explodity), 2nd ed. (Saint Petersburg, 1913), n.p. Los Angeles, Getty Research Institute, 85-B4913.

in *Vzorval'*, Kruchenykh approaches the nonreferential not only through neologism and alogical verse but also through a new form of versification that challenges the norms of Russian poetry.

Ever conscious of the visual as well as the verbal-vocal, Kruchenykh invited Rozanova to collaborate. As his handwriting artist, she interpreted the metric, rhythmic, semantic, and phonic irregularities of his abstract sound poetry. The resulting exchange epitomized essential aspects of Russian futurist collaboration: poet and painter working closely together to transform the book into an intermedia genre that integrates word, image, and sound—while also elevating sound as signifier—and poet and painter applying the principle of *mirskontsa* to legibility and linearity, and to the rotation of images.

The second edition of *Vzorval'*, as analyzed in this chapter, marks a high point in futurist book production and in the aesthetic of variant copies. While more experimentation certainly followed in such books as *Pomada* (Pomade), *Te li le, Slovo kak takovoe* (The word as such), and *Zaumnaia gniga* (Transrational boog),[30] *Mirskontsa* and the first and second editions of *Vzorval'* establish a benchmark from which to pose several broad questions, namely: What was the after-life of the Russian futurist book? Did the futurist verbivocovisual and the principle of *mirskontsa* and the fourth dimension live on and continue to define book art in Russia and the West? My final chapter seeks to provide some answers.

Notes

The translations of Russian poetry in this chapter were produced by Antanina Sergieff.

1. Edwin Morgan, "Flying with Tatlin, Clouds in Trousers: A Look at Russian Avant-Gardes," in *Beyond Scotland: New Contexts for Twentieth-Century Scottish Literature,* ed. Gerard Carruthers, David Goldie, and Alastair Renfrew (Amsterdam: Rodopi, 2004), 102–3.

2. For Paul Schmidt's translation of *zaum* as "beyonsense," see Velimir Khlebnikov, *The King of Time: Selected Writings of the Russian Futurian,* ed. Charlotte Douglas, trans. Paul Schmidt (Cambridge, MA: Harvard University Press, 1985), 113. On ever greater indeterminacy, see Craig Dworkin, "To Destroy Language," *Textual Practice* 18, no. 2 (2004): 187.

3. The word *zaum* first appears in writing in Kruchenykh's manifesto, *Deklaratsiia slova kak takovogo* (Declaration of the word as such), published in April 1913. According to Vladimir Markov, however, Kruchenykh actually uttered the word *zaumnyi* for the first time in the manifesto *Novye puti slova (iazyk budushchago, smert' simbolizmu)* (1913; The new ways of the word [the language of the future, death to symbolism]), which he wrote earlier but did not publish until after *Deklaratsiia.* See Vladimir Markov, *Russian Futurism: A History,* with an introduction by Ronald Vroon (Washington, D.C.: New Academia, 2006), 129, 398n26.

4. Anna Lawton, ed., *Russian Futurism through Its Manifestos, 1912–1928* (Ithaca, NY: Cornell University Press, 1988), 67–68.

5. Velimir Khlebnikov, *Collected Works of Velimir Khlebnikov,* vol. 1, *Letters and Theoretical Writings,* ed. Charlotte Douglas, trans. Paul Schmidt (Cambridge, MA: Harvard University Press, 1987), 81. Markov considers Khlebnikov's reply somewhat patronizing, given that he was in the midst of creating his own transrational language, "an elaborate system by means of which he tried to distill pure meaning from every single consonant." Markov, *Russian Futurism,* 131.

6. Roman Jakobson, "The Newest Russian Poetry," in Edward J. Brown, ed. and trans., *Major Soviet Writers*

(New York: Oxford University Press, 1973). Excerpts published in Roman Jakobson, *My Futurist Years*, ed. Bengt Jangfeldt and Stephen Rudy, trans. Stephen Rudy (New York: Marsilio, 1997), 177.

7. Essay titled "Gamma glaznykh" (Scale of vowels), quoted by Nina Gurianova, *Exploring Color: Olga Rozanova and the Early Russian Avant-Garde, 1910–1918* (Amsterdam: G+B Arts International, 2000), 50–51. Gurianova thanks Alexander Parnis for making these materials available to her.

8. On slips of the tongue in Khlebnikov's poetry, see Jakobson, "The Newest Russian Poetry," 202–3.

9. For an excerpt of this letter, see Nina Gurianova, *Exploring Color: Olga Rozanova and the Early Russian Avant-Garde*, trans. Charles Rougle (New York: Overseas, 2000), 147.

10. This summary of Rozanova's life is drawn from Nina Gurianova's detailed and complete chronology in *Exploring Color*, 135–78.

11. In both editions of *Vzorval'*, perhaps to call attention to the practice of multiple editions, Kruchenykh inserted a supplement titled "New Scenes from *A Game in Hell*," which refers back to the earlier futurist book, *Igra y adu*, published in 1912 and anticipates the second edition, which he and Khlebnikov would publish in 1914.

12. Gurianova, *Exploring Color*, 147.

13. The portrait is a variation on a portrait that Kulbin contributed to an earlier futurist book, *Bukh lesinnyi* (1913; Forestly rapid). We know that the *zaum* word is Kruchenykh's, because he was responsible for the poetry in *Vzorval'*.

14. For attributions of the drawings and stamping, see Vladimir Poliakov, *Knigi russkogo kubofuturizma: Izdanie vtoroe ispravlennoe i dopolnennoe* (Moscow: Gileia, 2007), 423–24; and *Vzorval': Futuristicheskaia kniga v sobraniiakh moskovskikh kollektsionerov M.L. Libermana i I.N. Rozanova: Al'bom-Katalog*, ed. S. E. Strizhneva and A. P. Zimenkov (Moscow: Kontakt-Kul'tura. 2010), 60–63. For information on the lack of secondary stress in Russian, see Michael Wachtel, *The Cambridge Introduction to Russian Poetry* (Cambridge, UK: Cambridge University Press, 2004), 19.

15. For this discussion of syllabo-tonic poetry, see Wachtel, *The Cambridge Introduction*, 18–23. He points out that syllabo-phonics were widely used in other countries before appearing in Russia.

16. *Li* is an interrogative participle.

17. There is a slight stress on the even-numbered words in line four, but it is not enough to comprise meter.

18. In a letter to Matiushin (23 June 1916), Malevich makes a comment that, intentionally or not, sheds light on the last line of "Zabyl povesit'sia"—"although he was right under my nose." He mocks the "consciousness of the crowd," which is "doomed to see what is right in front of its nose," even when those who are departing and trying to lead the crowd away can see countless miles in the distance. See Irina A. Vakar and Tatiana N. Mikhienko, eds., *Kazimir Malevich: Letters, Documents, Memoirs, Criticism*, trans. Antonina W. Bouis, 2 vols. (London: Tate, 2015), 1:90.

19. Nina Gurianova suggested this reading of "noni," personal correspondence, 8 October 2015.

20. Note that masculine rhymes, which contain a stress on the final syllable, are conventionally designated by small letters, while feminine rhymes based on a two-syllable pattern of stressed/unstressed, are indicated by capital letters. Wachtel, *The Cambridge Introduction*, 17, 20. When these are not exact rhymes but approximate rhymes, I use the "accent" mark, as with [D'], as a kind of prime—that is, D prime—to indicate that it is a variant. See below for analysis of approximate rhyme.

21. On phonetic echoes, see Wachtel, *The Cambridge Introduction*, 41. For further discussion of phonetic elements, including consonantal, see B. O. Unbegaun, *Russian Versification* (Oxford: Clarendon, 1956), 117–18.

22. The nineteenth-century poet Konstantin Batiushkov pursued the technique of phonetic echoes, while, in the twentieth century, both Vladimir Mayakovsky and Josef Brodsky abandoned the exact grammatical rhymes of the eighteenth-century poet Mikhailo Lomonosov (nouns rhyme with nouns, verbs with verbs) for a freer pursuit of approximate rhymes. See Wachtel, *The Cambridge Introduction*, 29, 41.

23. For this reading of the drawing, see Poliakov, *Knigi russkogo kubofuturizma*, 423.

24. Kruchenykh organizes this section of his book (the second edition) by pairing poems: "Tianutkoni" and "Tianutkonei"; "Vzorval' ognia" and "Pugal' k ustam"; and two full-pages of imagery by Rozanova.

25. Pyrrhic feet (feet with no stresses) occur in iambic meter when the even-numbered syllable is not stressed, as it normally would be, while the odd-numbered syllable remains unstressed. A spondee is a foot with consecutive stresses that usually occurs in the first foot of an iamb.

26. I owe this reading to Nina Gurianova, personal correspondence, 30 March 2012.

27. Here I take issue with Susan Compton and Gerald Janecek's reading of hetereogeneity in *Vzorval'*. See Susan Compton, *The World Backwards: Russian Futurist Books, 1912–1916* (London: British Library Board, 1978), 76; and Gerald Janecek, *The Look of Russian Literature: Avant-Garde Visual Experiments, 1900–1930* (Princeton, NJ: Princeton University Press, 1984), 94–95.

28. Malevich's important collaborative role in futurist book art often goes unrecognized. In fact, he composed lithographs for the covers or for interior pages of seven futurist books: *Porosiata* (Piglets), *Vozropshchem* (Let's grumble), *Vzorval'* (Explodity), *Slovo kak takovoe* (The word as such), *Troe* (The three), *Pobeda nad solntsem* (Victory over the sun), and *Iga v adu* (A game in hell). The first three were written by Kruchenykh, while the remaining four featured Kruchenykh as principal literary contributor. See Donald Karshan, *Malevich: The Graphic Work, 1913–1930; A Print Catalogue Raisonné* (Jerusalem: Israel Museum, 1975), 33.

29. Markov, *Russian Futurism*, 202–3.

30. *Pomada, Te li le, Slovo kak takovoe*, and *Zaumnaia* are analyzed in "Sounding the Accidental ('Death to Symbolism')," this volume.

The Afterlife of
Russian Futurist Book Art

The Museum of Modern Art's major exhibition *The Russian Avant-Garde Book 1910–1934* opened in New York on 28 March 2002. Displaying over three hundred titles, it was the most comprehensive exhibition of Russian modernist books ever to be mounted in the United States or abroad. Curators drew upon an extraordinary and comprehensive collection of more than one thousand books donated to MoMA by the Judith Rothschild Foundation in 2000, and they published a catalog that documents every book in the Rothschild Foundation gift (with edition size, contributing authors, and dimensions). As the centerpiece of the exhibition, the Russian futurist book had thus arrived.[1] This merits emphasis because, despite the appearance of some important earlier scholarship, the futurist book was not known, studied, or discussed in the West in any extensive way until its twenty-first-century discovery.[2]

Why was this the case? The reasons are noteworthy. In the years immediately following the Russian Revolution of 1917, the Russian avant-garde and the reigning Soviet powers enjoyed a special alliance. Leaders of the avant-garde were given the authority to establish government-sponsored art schools, museums, theaters, and an entire system that espoused the newest utopian concepts. Artists and writers published books and journals under such Soviet imprints as ASIS—for example, Vladimir Mayakovsky's *Chelovek: Veshch* (1918; Man: Thing) and *Oblako v shtanakh* (1918; A cloud in trousers). Yet this union lasted only a few years. After the exported exhibition *Erste Russische Kunstausstellung* (The first Russian art exhibition) was held at the Galerie van Diemen in Berlin in 1922, Soviet authorities began to withdraw support for the avant-garde. The death of Vladimir Lenin in 1924 marked the beginning of a power struggle between Leon Trotsky and Joseph Stalin, with the latter prevailing. In 1925, the resolution adopted by the Communist Party Central Committee, "On the Party's Policy in the Field of Artistic Literature," called for an art "comprehensible by the millions." By the late 1920s, the Soviet regime had begun to

denounce the avant-garde and to favor a more propagandistic aesthetic oriented to the masses. It wasn't long before a decree in 1932 banned all cultural groups. A declaration in 1934 by the First All-Union Congress of Soviet Writers ratified the new style of "socialist realism," requiring all artists to comply.[3] By "socialist realism," the Soviets meant the depiction of "reality in its revolutionary development.... Truth and historical concreteness of the artist's depiction must be combined with the task of ideological transformation and education of the working people in the spirit of Socialism."[4]

The Soviet authorities enforced compliance with the new style by closing schools and museums, destroying artists' studios, and forcing artists to work within socialist realism. Many fled the Soviet Union or disappeared later in the Stalinist purges. In the 1920s and '30s, the Soviet government dispatched Russian avant-garde works from Moscow and Leningrad to provincial centers, where they lay unknown for the better part of the century because of the "indifference, if not outright hostility, of the Soviet authorities."[5] In 1992, when the Guggenheim mounted its major exhibition *The Great Utopia* (with over eight hundred objects), curators unearthed important works from the most distant and unexpected Soviet museums—such as those in Ekaterinburg, Samara, and Saratov—and brought them to the West, furthering a trend of drawing significantly on Soviet holdings that began with the two-part exhibition *Art and Revolution* (1982, 1987) in Tokyo; continued with *Kunst und Revolution* (1987–88) at the Palace of Exhibitions, Budapest, and the Museum of Decorative Arts, Vienna; and concluded with *Art Russa e Sovietica* (1989) at the Lingotto, Turin.

The suppression of the Russian avant-garde beginning in the late 1920s delayed its reception in the West by more than half a century. While the Western movements of fauvism, German expressionism, cubism, Italian futurism, Dada, de Stijl, and surrealism were known by the 1920s and '30s and generated exhibitions and publications (Alfred Barr curated his survey *Cubism and Abstract Art* at MoMA in 1936 and published it the same year), the Russian avant-garde remained comparatively unrecognized well into the 1980s.[6] The British art historian Camilla Gray's monograph *The Great Experiment: Russian Art 1863–1922* (1962)—which accompanied the first survey exhibition on the Russian avant-garde, *Two Decades of Experiment in Russian Art 1902–1922,* held at London's Grosvenor Gallery in 1962—was for some decades the only English-language study that examined the Russian contribution.[7]

In 1980, Stephanie Barron and Maurice Tuchman took the bold step of organizing an exhibition at the Los Angeles County Museum of Art (LACMA) that drew entirely on Russian objects owned by Western collectors. *The Avant-Garde in Russia, 1910–1930: New Perspectives* was a first of its kind. By building an exhibition without Soviet loans, it avoided the fate of galleries and

museums like the Hayward in London (1971) and the Metropolitan Museum of Art in New York (1977), which were granted permission to borrow avant-garde works from the Soviet Union but encountered censorship when the Soviet bureaucracy forced them to seal off sections of their exhibitions or dilute the experimental work with a preponderance of icons and socialist realist objects. In the case of the Hayward, the Soviet Ministry of Culture threatened to remove everything it had lent unless the British closed off the objectionable room of works the Soviets deemed "abstract and decadent."[8] The vast *Paris-Moscou* exhibition at the Centre Georges Pompidou in Paris in 1979, with a catalog written primarily by Soviet art historians, also took on the role of an "official" exhibition because of the Soviet requirement to include many examples of non-avant-garde work.[9] It is important to note that *Paris-Moscou* included a selection of Russian futurist books borrowed from Soviet collections, as well as a handful from the Collection Martin-Malburet in Paris, which would join the archives of the Getty Research Institute in the mid-1980s. Soviet and Western painting, sculpture, photography, and set design, however, dominated this exhibition of over five hundred objects.

And how did the futurist books fare in this story of recovery and rediscovery of the Russian avant-garde in the West? Up through the end of the twentieth century, they played little if any role in thematic exhibitions on the avant-garde. This holds true for MoMA's exhibition *Revolution, Russian Avant-Garde 1912–1930* (1978), the Guggenheim Museum's *The Great Utopia: The Russian and Soviet Avant-Garde, 1915–1932* (1992), the Scottish National Gallery of Modern Art's *Russian Painting of the Avant-Garde, 1906–1924* (1993), and Deutsche Guggenheim's *Amazons of the Avant-Garde* (2001), to name only a few. The exception is LACMA's *The Avant-Garde in Russia* (1980), which featured futurist books as part of a broader display of Russian avant-garde book art. Stephanie Barron credits the art historian Gail Harrison Roman with locating these books for the exhibition. Roman, by turn, explains in her catalog essay that LACMA's show was "the first to present a collection of Futurist and Constructivist books and periodicals with the purpose of displaying the revolution in typography and book design that was initiated by the twentieth-century avant-garde."[10] She also makes the point that until the late 1960s, these avant-garde books and journals were virtually ignored in art historical or bibliographic literature, largely due to Western ignorance, Soviet neglect, and lack of language facility.

LACMA's Russian avant-garde exhibition was thus trailblazing in introducing the American public to futurist and constructivist book art and futurist theater—the latter in the form of a re-creation of the opera *Pobeda nad solntsem* (1913; *Victory over the Sun*). Yet even then, the

exhibition did not instigate critique or engagement by leading art historians of the day. For example, the fall 1985 issue of *October* magazine contains English translations of two primary Russian texts: Viktor Shklovsky's 1916 essay "On Poetry and Trans-Sense Language" and Kazimir Malevich's "Chapters from an Artist's Autobiography." Although this journal issue may have been a follow-up to LACMA's exhibition, it did not lead critics to theorize the Russian avant-garde or the futurist book, nor subject the material to analytic scrutiny, possibly because critics lacked Russian fluency and a familiarity with the work, and they did not have an opportunity to see the books open.

One exception is Marjorie Perloff, who, in her 1986 monograph, singles out futurist books as a then little-known exemplar of the prewar "futurist moment." Inspired by the LACMA exhibition and catalog, her chapter on Russian futurism was made possible through access to the collection of Russian avant-garde books at the British Library, where she had the opportunity to study interior pages as well as cover designs.[11] Another critical response, T. J. Clark's *Farewell to an Idea: Episodes from a History of Modernism* (1999), argues that El Lissitzky did his best work as a Bolshevik artist by using abstraction to further the cause of radical politics. Clark applies this political argument principally to paintings, to Lissitzky's propaganda board of 1919, and to a few gouache and ink works. Futurist books are not part of his equation.[12]

In the latter half of the twentieth century, Western scholars thus had a limited array of options for encountering the work of the Russian avant-garde in general, and futurist books in particular. Writing from the vantage of 1997, Jean-Louis Cohen reminds us that the difficulty of access to Soviet sources and archives of futurist books and architectural drawings was "aggravated by the weakness and incoherence of all but a few Western collections."[13] The well-organized collections in the West that he may have had in mind were established in the late twentieth century, but they were not necessarily exhibited. The Whitney Russian collection, donated by Thomas P. Whitney to Amherst College in Massachusetts in 1991, includes a superb collection of books by early twentieth-century Russian avant-garde writers and artists, such as Natalia Goncharova, Wassily Kandinsky, Velimir Khlebnikov, Alexei Kruchenykh, Malevich, Alexei Remizov, and Olga Rozanova.[14] The Getty Research Institute acquired a collection in the mid-1980s from Paris-based Marc Martin-Malburet, who purchased Russian avant-garde books from Soviet *bukinisty* (second-hand or antiquarian booksellers) in the late 1970s.[15] The British Library in London purchased a small but superb collection in the mid-1970s that had been assembled from sales by Sotheby's. These futurist books, which reside in the British Library Reference Division, formed the basis for

Susan Compton's important monograph, *The World Backwards: Russian Futurist Books, 1912–1916*, published in 1978. In an acquisition that significantly predated the British Library's, the New York Public Library amassed Russian books as early as 1923–24, when library representatives traveled to Russia and purchased sixty-two volumes of futurist poetry directly from the poet Alexei Kruchenykh, who obtained them from the writers and from bookstands.[16]

Also in New York, the Judith Rothschild Foundation appointed its trustee Harvey S. Shipley Miller, a longtime print collector, to build a collection of Russian avant-garde books for the Museum of Modern Art. In the preface to the catalog that accompanied its first exhibition at MoMA in 2002, Miller provides a vivid account of his discovery of Russian futurist books in this country:

> Although I had been a print collector for many years, I was unprepared for the radical originality and variability of the Russian books themselves: their rough, handmade quality; the break with the traditional book format.... Russian artists' books, with their anarchic color washes bursting through the text and into the margins, differed qualitatively from the more conservative, typographic approach initiated by the Italian Futurists. These small, sewn or stapled volumes, often issued in limited editions with great variations about individual copies and frequently bearing mounted lithographs as well as drawn images, were startling indeed. Some even demanded to be read aloud in the transrational language of the Russian Futurists called *zaum* with its syntactical innovations.[17]

Miller's comments articulate many of the unique qualities of futurist books, including their representation of sound. His reference to "such amusing and unfamiliar titles as *Piglets, Let's Grumble, Explodity,* and *Worldbackwards*" makes it clear that, before 2000, he had not encountered them.[18]

This pattern of increased collecting of Russian futurist books by Western institutions from the mid-1970s through the early twenty-first century finds corroboration in the growing number of auction sales during this period, as well as higher market values of individual titles. While neither collections nor auction sales confirm that scholars and the wider public knew about the futurist books, this data does indicate that they were circulating in Anglo-America with rising frequency, although still in very small numbers, and that they could have been seen and even studied. Looking at market activity for the book *Mirskontsa* (Worldbackwards), for example, shows only three major recorded sales in the last three decades, but each sale brought a dramatic price

increase, from $7,200 in 1985, to $14,242 in 2005, to $40,799 in 2007.[19] The futurist book *Vzorval'* has appeared at auction more frequently—indeed thirteen times between 1979 and 2012, and each sales price marks an increase over the previous. To cite some of these auctions, a copy sold for $1,430 in 1979 and another for $3,250 in 1993. Following a ten-year hiatus, copies of *Vzorval'* sold for $4,514 in 2003 and $12,051 in 2006; in 2011, the British bookseller Sims Reed acquired a privately held copy, which they sold for $14,464.[20] Certainly, the rarity of these futurist books, their small publication runs, and their fragile condition contributed to the scarcity of sales copies and the growing monetary value.

The significant lapse in time between the publication of Russian futurist books before and during World War I and their full rediscovery in the West in the twenty-first century prompts the following questions: How does one assess the afterlife of book art that went underground for nearly six decades? How could futurist book art be influential when it wasn't known? In addressing these questions, I start with Russia in the 1920s, when a direct influence was briefly possible. From there I identify an indirect influence of the Russian futurist verbivocovisual interplay on post–World War II poets and visual artists in the West who did not know the Russian avant-garde but had a few reference points. Contemporary artists' books might be expected to serve as logical, if indirect, heirs to the futurist books, yet differences—especially in the relation of word-image-sound and in the focus on the book as medium—outweigh the similarities.

Russia's "Last Avant-Gardes"

The Russian avant-gardist El Lissitzky made book art the locus of his radical invention and experimentation. Indeed, he often singled out the book as his preferred medium. In his first major essay, "The New Culture," published in Vitebsk in August 1919, Lissitzky comments about the book: "In contrast to the old monumental art, it itself goes to the people, and does not stand like a cathedral in one place, waiting for someone to approach.... Surely the book is now everything.... It expects the contemporary artist to make of it this 'monument of the future.'"[21] The principle of engaging the reader is important to keep in mind as I turn to Lissitzky's artist's book *Dlia golosa* (For the voice), published in 1923 and intended to be read aloud (see fig. 6, p. 162). *Dlia golosa* drew upon the futurist tradition of live reading, yet it differs otherwise, because the poems by Vladimir Mayakovsky are not *zaum,* and painter and poet worked by and large independently. Mayakovsky initiated the publication, meeting with Lissitzky in Berlin in late 1922 and asking him to provide the design for a collection of thirteen of Mayakovsky's most recited poems. Once they had made

their selection, Lissitzky assumed control of the project. Moreover, all thirteen poems had been published previously over a period of nearly ten years.[22] Hence, in lieu of the painter working concurrently with the poet to handwrite the verse and add lithographic imagery, as in futurist book art, Lissitzky worked separately, while following the book's guiding principle of live recitation.

Dlia golosa is ultimately best understood as a radical experiment in book architecture; Lissitzky replaced the usual table of contents with a tab index borrowed from the typology of the everyday address book. On each tab, he created both an abbreviated form of the poem title and a short version of the typographic design that illustrates the poem, as we see, for example, in "Tretii Internatsional" (Third international) (fig. 1).[23] The reader easily searches the tabs to find the contents. Although *Dlia golosa* did not follow the futurist model for collaboration, Lissitzky had in

mind a functional design that would assist Mayakovsky in declaiming his own verse at live performances. "Reading aloud" was appropriate, because Mayakovsky was known for his booming voice and declamatory style. According to Il'ia Ehrenburg, "An intimate Mayakovsky is pure nonsense. One must shout his poems, trumpet them, belch them forth in public squares."[24]

Pursuing utility as one goal, Lissitzky thus fabricated *Dlia golosa* as a small book about the same size as *Vzorval'* (Explodity). He intended it to be easy for Mayakovsky to hold and read from, just as he designed the tab index to enable the poet and all other reader-orators to easily locate the poems of choice. Intriguingly, Lissitzky's tab index also recasts the function of the conventional table of contents by facilitating readings that start anywhere in the book and follow no prescribed linear order. In this respect, if coincidentally, his design echoes the *mirskontsa* principle of the futurists. With regard to other aspects of the visual design, Lissitzky took responsibility for the two-color (black and red) typography and for the typographic designs illustrating each text. In the poem "Tretii Internatsional" (see fig. 1), for example, referring to a mostly left-wing Bolshevik group, the large letter *T* on the right stands for the initial letter of *Tretii*. Lissitzky juxtaposed it with the Soviet hammer and sickle (on the left), shown through invented typographic symbols that he printed over two large Roman numeral IIIs, one angled and black and one red. The verbivisual is thus prominent in *Dlia golosa,* while Lissitzky did not integrate the vocal into the design. "Reading aloud," in this context, forms part of his visual aesthetic of inviting the reader to engage and participate in the construction and the unfolding of the book.

The sound of poetry in futurist book art, by contrast, is integral to the very fabric of the book. It engages in dialogue with the visual imagery, tests the norms of Russian versification, and, as *zaum* poetry that lacks any definite meaning, recasts the word as a "vocable, a sequence of sounds and letters (phonemes), a composite of consonants and vowels, syllables and phonetic roots, indeed as an aural element of language rather than a signifying one."[25] What is so distinctive are the ways in which the futurists made sound as important as the visual and did so in an art form—the book—where one would not expect that.

If *Dlia golosa* is both foil and heir to the futurist book, the experiments of the OBERIU poets constitute a direct legacy. Generally considered "Russia's last avant-garde," the OBERIU literary group was also the first generation of Russian writers to come of age after World War I and the October Revolution.[26] The two principal founders, Alexander Vvedensky and Daniil Kharms, began their literary careers as students of Russian futurism. When they met in Leningrad in 1925, Vvedensky was working at Igor Terentiev's Phonological Section of the new State

Institute of Artistic Culture (or GINKhUK), while Kharms was studying with the sound poet Alexander Tufanov. Both teachers were masters of futurist *zaum,* which they understood to be sound poetry. Their abstract, nonobjective linguistic art, while seemingly meaningless, encouraged the two poet-researchers to study the relationship between sound and sense.[27] Yet even at this time, the OBERIU were not book artists; they were poets, fiction writers, and theorists to the core.

OBERIU's origins—which date back to a circle of friends who met regularly from 1922 onward for conversations, readings, and debates—point to early differences, as well as affinities, with futurism. The group first dubbed themselves Chinars, a cryptic neologism that came from the Russian words *chin* (rank or spiritual rank) and *chinit'* (to create or perform). Vvedensky assumed the title "Chinar, authority on nonsense," and Kharms called himself "Chinar-observer." While the use of a neologism was in the spirit of futurist *zaum,* the Chinars focused more on the "destruction of previously established connections between words and their meanings, things and their functions, and events and their causes" than they did on the invention of new words.[28] Theirs was an aesthetic that aimed to do away with protocols of semantic coherence and to get to the "real object" by using *bessmyslitza* (meaninglessness) and alogicality as tools of cognition, rather than ends in themselves.

By 1926, the Chinars had developed a new name for their group—the nonsense word OBERIU (Ob"edinenie real'nogo iskusstva), a "veiled and foreign-sounding acronym" that translates as Union of Real Art.[29] The futurist emphasis on form and on sound as substance had shifted to a deconstruction of the very concept of reality by employing modes of irony, parody, fragmentation, and disruption. The OBERIU critique of normative language destabilized it through rhyme—a means of introducing absurdity into content—and intuition, as well as through an attack on the very principle of ordering. In the words of Eugene Ostashevsky, "The role of intuition in OBERIU was all the greater because the usual linguistic mechanisms for constructing statements could no longer be trusted. In contrast to logical reasoning, which rests on order and continuity, intuition proceeds in leaps and bounds."[30]

November 1927 marked the beginning of rebukes and scoffs at OBERIU from Soviet newspapers. On 10 December 1931, the Stalinist regime incarcerated Kharms, Alexander Tufanov, Vvedensky, and several others and charged them with counterrevolutionary agitation in the form of *zaum* poetry. Sentenced to three years of internal exile, Kharms and Vvedensky suddenly received reduced terms and were allowed to return to Leningrad in winter 1933. Kharms was brought back in August 1941 on charges of agitating for defeat and was placed in a psychiatric

prison, where he died of starvation on 2 February 1942. Vvedensky died on 19 December 1941 on a prison train headed for Kazan.[31] The OBERIU-Chinar corpus did not begin to appear in Russia until after the onset of perestroika in 1985.[32]

Echoes of the Futurist Verbivocovisual in the West

While the Russian avant-garde and OBERIU were silenced, post–World War II poets and visual artists in the West began to produce inventive work distinguished by its hybrid nature on the borders of poetry, sound poetry, visual language, and the medium of the book. The Brazilian poet Augusto de Campos, the Scottish poet and visual artist Ian Hamilton Finlay, and the French sound poet Henri Chopin independently carried on aspects of the Russian futurist experiment, even though none had encountered Russian books or had much familiarity with Russian artists.

Brazilian Concrete Poets: The Noigandres Group

Augusto de Campos, his older brother, Haroldo, and fellow poet Décio Pignatari were among the founders of the international concrete poetry movement and were the leaders of concretism in Brazil. Rather than pursuing book art, they worked with typography on paper. Motivated by an opposition to a "poetry of expression, subjective and hedonistic," they wrote a manifesto, *Pilot Plan for Concrete Poetry* (São Paulo, 1958), in which they define "concrete poetry" as "tension of things-words in space-time" and "an object in and by itself, not an interpreter of exterior objects and/or more or less subjective feelings."[33] Their manifesto shows the influence of the Brazilian-born Swedish poet Öyvind Fahlström, who argues, in his earlier theoretical statement on concrete poetry, that "poetry can not only be analyzed but can also be created as structure. And not only as a structure with the emphasis on expression of ideas as contents but also as concrete structure."[34] The poet Rosmarie Waldrop summarizes this attention to materiality when she defines concrete poetry as making the "sound and shape of words its explicit field of investigation."[35] In futurist and formalist terms, the phonic dimension of transrational words becomes itself the signifier. The Brazilians may not have known the Russian work, but they belonged to that tradition.

The unity of form and content—which Antonio Sergio Bessa rephrased as "sound as subject"—and the multiple dimensions of "the word as such" carry forward the aesthetic of the Russian futurists. For the poets Khlebnikov and Kruchenykh, as we have seen, the transrational word cultivated the texture of the word itself, which was characterized by its distinctive speech-sound and "living coloration."[36] The crucial next step was to create affinities between and among words

that produced new verbal relationships based on sound, not semantics. Thus, Khlebnikov wrote to Kruchenykh about the "unmistakable geneological relationships" between *bes* (demon) and *belyi* (white), and between *chert* (devil) and *chernyi* (black)—pairs of words in which shared "content" or "subject" depends entirely upon sonority.[37] Recognizing these verbal and phonic relationships, and hence demonstrating the relevance of Russian futurism to Brazilian concrete poetry, Haroldo de Campos, in his article "Poetic Function and Ideogram: The Sinological Argument," quotes the following observation by Roman Jakobson: "In poetry, any phonological coincidence is felt to mean semantic kinship."[38] Haroldo calls this a process of "pseudoetymology or poetic etymology."

The program of the Brazilian concrete poets—who assumed the name Noigandres after Ezra Pound's *Canto XX*—also emphasized the "visuality of language."[39] Yet, while the poetry shows an increased sense of design and sometimes appears on the page like highly modernist architecture or suggests graphic riddles, Sergio Bessa maintains that "sound was submitted to as rigorous a program as the written text." For the Noigandres group, language was an "operation that makes ideas visible (and/or heard)."[40] Indeed, Bessa comes to argue—quoting from Augusto de Campos's preface to his second collection of poems, *Poetamenos* (1953; Minuspoet)—that the influence of *Klangfarbenmelodie* (melody of tone colors), as practiced by the Viennese twelve-tone composer Anton Webern, emerges in the conception of musical instruments articulating "phrase/word/syllable/letter(s)." Their timbres are "defined by a graphic-phonetic, or 'ideogramic,' theme" (fig. 2).[41] If tones (words) are distinguished principally by their timbres and tone colors, rather than by pitch (signification), then *Klangfarbenmelodie* is a synesthetic method of "painting" or "coloring" musical sounds. Applied to poetry, Augusto de Campos's preface explicitly calls for "oral reading," in which real voices act as timbres to the poem, in a fashion comparable to the tone colors of musical instruments in Webern's *Klangfarbenmelodie*.

This interest in synthesis—an equivalence of visual organization and musical harmony—also expresses itself in the Noigandres's portmanteau word *verbivocovisual* (borrowed from Book II, Episode 3 of James Joyce's *Finnegans Wake* [1939]).[42] As Augusto de Campos explains to Bessa: "Phonographic functions-relations and the substantive use of space as compositional element entertain a simultaneous dialectic of eye and breathing, that, allied to the ideogram-like synthesis of the signified, convey a sensible totality, 'verbivocovisual,' such as to juxtapose words and experience into a narrow phenomenological fold, until now unprecedented."[43]

The message the poet conveys here is that concrete poetry is not only visual poetry. The way a poem looks is also how it sounds. In the words of Haroldo de Campos: "THE CONCRETE

or aspiring to the hope of a
KLANGFARBENMELODIE
(tonecolormelody)
melody of timbres
with words
as in WEBERN:
a melody continuously switching from one ins-
trument to another, constantly changing its color:

instruments: phrase/word/syllable/letter(s), who-
se timbres are defined by a graphic-phonetic or "ideogrammic"
theme.

∴ the necessity of graphic representation in colors
(which even then are only approximately representative, capable
of losing functionality in ctn complex cases of thematic superim-
position or interpenetration), excluding monocolor representa-
tion which is for the poem as a photograph is to chromatic reality.

luminous letters, or filmletters, cd we but have
them!

reverberation: oral reading - real voices acting
(approximately) as timbres to the poem like the instruments in
WEBERN's klangfarbenmelodie.
(translated by jon m. tolman)

Fig. 2.

Preface to Augusto de Campos,
Poetamenos (Minuspoet).
(São Paulo, 1973).
Los Angeles, Getty Research Institute,
92-B22170.

POEM aspires to be: composition of basic elements of language, optical-acoustically organized in the graphic space by factors of proximity and similitude, like a kind of ideogram for a given emotion."[44] Moreover, the insistence in the Noigandres's "Pilot Plan" on "space-time structure," rather than "mere linear-temporistical development," and on "organic interpenetration of time and space" recalls both the futurist principle of *mirskontsa* and the hyperspace philosophy of P. D. Ouspensky, as expressed in their move against linear readings. In the words of Augusto de Campos, "The poetic nucleus is no longer placed in evidence by the successive and linear chaining

of verses, but by a system of relationships and equilibria between all parts of the poem, 'graphic-phonetic functions-relations.'"[45] The Brazilians may not have been familiar with futurist reversibility or with the noncausality of the fourth dimension, but their sensibility shared similar ideas as inspiration.

The fascination of Augusto de Campos with *Klangfarbenmelodie* had much to do with Webern's freeing music from "themes" and/or "motifs," expression and representation, and linearity, so as to focus on the relationship and ordering of intervals. The "Sator Square," a word square containing a Latin palindrome, was a great source of inspiration for Webern, and hence for Augusto de Campos, because it could be read horizontally or vertically from top to bottom, bottom to top, left to right, and right to left. It was indeed an ideogram, which modeled principles of mirror-form technique, inversion, multiple simultaneous readings, and concision.[46]

S A T O R
A R E P O
T E N E T
O P E R A
R O T A S

If we consider the operation of verbivocovisual in Augusto de Campos's *Poetamenos* (Minus-poet), we see that he color coded his elegant font in order to group words and syllables visually as part of one sentence or idea and to create a *Klangfarbenmelodie*. In the fifth poem, for example, de Campos arrayed his blue and red text symmetrically and colored the first six words running down the middle in red (fig. 3). They indeed comprise a sentence or "melody" of optical-acoustic words paired according to sound ("eis os sem senão os corpos"/here are the bare bodies). Yet they also form harmonies when superimposed over the two words printed on either side ("amantes, parentes"/lovers, kinless).[47] As the Brazilian poet, novelist, and musicologist Mário de Andrade explains in a discussion of what he calls "harmonic verse": "These words, by the very fact of not forming a coherent sequence, superpose over themselves and form, to our senses, not melodies, but harmonies.... Harmony, combination of simultaneous sounds."[48]

The visual arrangement of words on the page is spatial. Open space, suggesting silence and serving as a structural element, is as important to the poetic form as sound. While the neologisms, highlighted through color combinations of red and blue, recall the phonic

eis

os

amantes sem parentes

senão

os corpos

irmãum gemeoutrem

cimaeu baixela

ecoraçambos

d u p l a m p l i n f a n t u n o (s) e m p r e

semen(t)emventre

estêsse aquelêle

inhumenoutro

inventions of the Russian futurists (see *gemeoutrem* and *cimaeu*), the "dialectic between sound and silence"—a defining feature of Webern's music—marks an interesting departure and must be integrated into the performance.[49] Yet *Poetamenos* has shown itself to be as difficult to perform as any of Webern's pieces, perhaps because Augusto de Campos's voice cannot easily be distinguished from another voice in the poem: that of the woman who would later become his wife, Lygia Azeredo. A "shattering of the voice" takes place as the poet creates "private fictions" and "interior monologues and dialogues" that make it difficult to determine whose voice(s) speak(s). De Campos's annihilation of the "I," and hence of subjectivity, paved the way for concrete poetry.[50]

Ian Hamilton Finlay

The Russian futurist aesthetic of *mirskontsa* (worldbackwards) and hyperspace philosophy continues in the work of the Brazilian concrete poets. However, its presence is somewhat attenuated, and collaboration does not figure as the working method. The Scottish poet, sculptor, and landscape artist Ian Hamilton Finlay, like the Brazilians, explored verbivocovisual interplay, but he did not collaborate with visual artists as the futurist poets did. Finlay tended, rather, to invent and produce his own hybrid work as a poet and visual artist, with the aid of printers and craftsmen. He did, however, work extensively in book art, typically in the form of small booklet poems, and he took up concrete poetry in 1963, a decade after the publication of Fahlström's manifesto. Indeed, by 1962, Finlay had founded the monthly periodical *Poor. Old. Tired. Horse.* (*P.O.T.H.*), which borrowed its name from a poem by Robert Creeley and provided a "forum for the verbal and the visual, the traditional and the modernistic, the creative and the theoretical."[51]

The journal's founding coincided with Finlay's first acquaintance with both the Noigandres poets in Brazil and the Bolivian-born Swiss concrete poet Eugen Gomringer. While concrete poetry was never a dominant feature of *P.O.T.H.*, which reached twenty-five issues before ceasing publication in 1968, Finlay aimed to introduce the work of various foreign poets in translation to Scottish readers. He also embarked on the novel path of creating special numbers, each devoted to a specific poet, artist, or theme.[52] Issue no. 6 (1963), for instance, dedicates the last page of its four-sheet spread to Noigandres poetry, identified as *poesia concreta,* the term Augusto de Campos had applied to his *Poetamenos* in the second issue of the *Noigandres* journal (1955) (fig. 4).[53]

The eighth issue of *P.O.T.H.* (1963) distinguished itself as an homage to the Russian avant-garde. Finlay designed it "in honour of" five Russian futurists (David Burliuk, Natalia Goncharova,

Mikhail Larionov, Kazimir Malevich, and Olga Rozanova) and five constructivists (El Lissitzky, Liubov Popova, Alexander Rodchenko, Varvara Stepanova, and Vladimir Tatlin)—all visual artists. He listed their names in no particular order beneath the journal's masthead and substituted *s* for the conventional transliterated *z* in Kazimir, Lissitzky, and Rozanova (fig. 5). Finlay reserved the bulk of his issue for Russian poetry and included work by three Soviet poets;[54] two poems by Khlebnikov in translations by the Scottish poets Edwin Morgan and James Findlay Hendry; a page from the constructivist book *Dlia golosa,* featuring the poem "Prikaz po armii isskutsv" (Order for

POOR · OLD · TIRED · HORSE.

MONTHLY
number eight

9d per Issue
(plus 3d p & p)

THE WILD HAWTHORN PRESS
24 Fettes Row · Edinburgh · Scotland

Subscriptions : 12 Issues—12 shillings or $1.75 6 Issues—7 shillings or $1.00

In honour of

Natalia Goncharova (1881-1962) *Vladimir Tatlin* (1885-1953)
Mikhail Larionov (1881-) *Varvara Stepanova* (1894-1958)
El Lissitsky (1890-1941) *Olga Rosanova* (1886-1918)
Kasimir Malevich (1878-1935) *Liubov Popova* (1889-1924)
Alexander Rodchenko (1891-1956) *David Burliuk* (1882-)

lackblockblackb
lockblackblockb
lackblockblackb
lockblackblockb
lackblockblackb
lockblackblockb
lackblockblackb
lockblackblockb
lackblockblackb
lockblackblockb
lackblockblackb

Homage to Malevich

Ian Hamilton Finlay Peter Stitt

(Scotland)

Slow Song

The ship goes out to sea
The ship goes out to sea
The ship goes out to sea
Far out, far away . . .

And the sea goes out to the sky
And the sea goes out to the sky
And the sea goes out to the sky
High up, high above . . .

And the sky goes out to the stars
And the sky goes out to the stars
And the sky goes out to the stars
The green ones and the blue.

And the stars go out to eternity
And the stars go out to eternity
And the stars go out to eternity
Calmly and endlessly.

And eternity goes down to men
And eternity goes through to men
And eternity goes out to men
Both great and small.

And men go out to sea
And men go out to sea
And men go out to sea
And men go out . . .

Yury Pankratov (b. 1935)
(USSR)

trans. Edwin Morgan
(Scotland)

the army of the arts); a playful concrete poem by Jonathan Williams titled "The Inevitable Form of an Early Flying Machine"; and cartoonish line drawings by Mayakovsky (fig. 6).

Finlay devoted the back cover of the Russian issue to a concrete poem by the American poet and critic Mary Ellen Solt. Titled "White Rose," the poem serves as an "Homage to Goncharova," who died in 1962 (fig. 7). Doing away with syntax and with semantic and phonic relationships between words, Solt arranged her mostly nouns and verbs in a spiral shape that blossoms from the center. The reader's need to rotate the page or turn his or her head to decipher the words invokes futurist images by Nikolai Kulbin, Larionov, and Malevich that likewise require rotation in order to be read. The handwritten text—evocative of hand lithography in the futurist books—contrasts with the typographic settings that Finlay otherwise applied to poetry in the Russian issue. "White Rose" may allude to the Blue Rose group of symbolist artists, who exhibited in

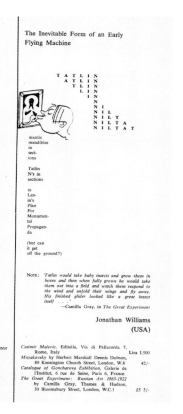

Poem

Now the rivers grow dark.
The bonfire coils in the air.
This morning—the field is bare—
No cattle have left the yard.
The frost is furred with grains.
Fresh, icy and delicious
The leaf of cabbage crunches.
Beyond the cry of the cranes
Gone like the mushrooms and nuts
Tractors for overhaul
Concluding harvest and fall
Break up the ice in the ruts.

Alexander Tvardovskii
(USSR)

trans. J. F. Hendry
(Scotland)

Poem

Once more, once more
I am your
Star.
No good comes to the seaman
Who takes a false angle of his ship
Or star: he
Will founder on the rocks,
On the unseen sandbanks.
No good will come to you either,
You have taken the heart's false angle on me:
You will founder on the rocks
And the rocks will mock
You
As you mocked
Me.

Velemir Khlebnikov
(USSR)

trans. Edwin Morgan
(Scotland)

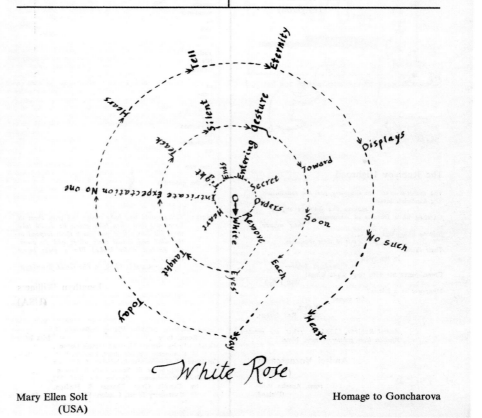

Mary Ellen Solt
(USA)

Homage to Goncharova

Fig. 6.
Ian Hamilton Finlay (Scottish, 1925–2006), editor.
Poor. Old. Tired. Horse., no. 8 (1963).
Los Angeles, Getty Research Institute, 1383-673.

Fig. 7.
Ian Hamilton Finlay (Scottish, 1925–2006), editor.
Back cover of *Poor. Old. Tired. Horse.*, no. 8 (1963), showing Mary Ellen Solt's "White Rose" ("Homage to Goncharova").
Los Angeles, Getty Research Institute, 1383-673.

Moscow in 1907 and believed in the spiritual and the mystical, rather than in concrete reality.[55] Because Goncharova and Larionov did not participate in this exhibition or espouse the group's principles of mystical symbolism, Solt may be intimating a contrast or taking an ironic stance.[56] Her choice of white, rather than blue, might suggest death. The list of artists under the masthead of this Russian issue of *P.O.T.H.* reminds us that two futurists, Larionov and Burliuk, were still alive at the time of publication (Larionov died in 1964, Burliuk in 1967).

Finlay's decision as early as 1963 to honor the Russian avant-garde is prescient.[57] His Scottish friend Edwin Morgan may have played an important role in making this introduction. Although not a fluent Russian speaker, Morgan studied Russian at Glasgow University and made what he called "direct" translations, often using local Scottish dialect, of Khlebnikov, Mayakovsky, Yuri Pankratov, Andrei Voznesensky, and other Soviet poets.[58] Moreover, as a concrete poet, Morgan felt the enormous influence of the Brazilian Noigandres group. He initiated contact by responding to a published letter in the *Times Literary Supplement* (May 1962) by the Portuguese concretist E. M. de Melo e Castro (Morgan's letter represented the first British reference in print to the international concrete movement). Shortly after Morgan's missive, Castro sent him the anthology *Poesia concreta* (1962), published in Lisbon through the Brazilian embassy there. At the same time, Augusto de Campos, who had seen Morgan's poetry in *P.O.T.H.*, sought his contact through Finlay. Morgan and de Campos corresponded, and Morgan sent his Brazilian friend English translations of his poetry, for example, "Ovonovelo," from *Poesia concreta.*

Morgan and the Brazilian concretists were drawn to one another through their sharing of texts written principally, but not exclusively, by the Russians—Khlebnikov, Mayakovsky, Voznesensky, and the contemporary Russian poet Gennady Aygi. Morgan's correspondence with many of the younger British concrete poets also involved exchanges of Russian books and discussions of his trips to Moscow to locate individual titles. It demonstrates how, according to James McGonigal in his article on Edwin Morgan, the "interest in Russian experimentalism overlapped with concrete, i.e., the 'zaumnyi iazyk' style of 'trans-sense language' of neologisms, odd sound combinations and morphological play that featured in the work of Russian Futurist poets such as Kruchenykh and Khlebnikov."[59]

Finlay included no date or copyright information on the pages of *P.O.T.H.* The Russian issue probably coincides with the publication of his first collection of concrete poetry, *Rapel: 10 Fauvist and Suprematist Poems,* in 1963. In addition to the works promised by the subtitle, *Rapel* contains the first appearance of Finlay's block of text, "Homage to Malevich," which also appears

on the front page of the eighth issue of *P.O.T.H.* (fig. 8). Here, Finlay alludes to Kazimir Malevich's suprematist painting *Black Square,* not only through the shape of a perfect square but also through the alternating words "black block" and "block black" that compose his square. The white of the page presumably acts as the white canvas of Malevich's painting. Finlay's alternation of the monosyllables creates alliteration, while his wrapping of the letter *b* around the end of each line uncovers two other equally readable, almost rhyming words, *lack* and *lock,* which mean opposite things: the first, "deficiency"; the second, "closure."[60] The black (figure) and block (ground) balance with lock (stability) and lack (instability).[61] Stephen Bann articulates further implications of this word alternation: "In 'Homage to Malevich,' the space of doubt is not simply the white page, but the dimension of meaning whose incompatible signs (lack/lock) are in contrast with the certainty of typographic structure."[62]

A subtle adjustment of sounds also permeates Finlay's collection *The Blue and the Brown Poems* (1968), which contains a different poem for each month of the year. The March poem, "Green waters," introduces proper names (all typeset in capital letters) that refer to fishing trawlers, as well as words chosen for their visual and sonic values and semantic potential (fig. 9). For instance, the same combination of phonemes—"ar-ra" or "at-ta"—recurs; *spray* rhymes with *gray* and *day;* and *drift,* comprising the final line, echoes the *it* sound of *starlit* and *moonlit*.[63] Finlay called concrete poetry "less a visual than a silent poetry," but, in many of his booklet poems from these years, as in the Brazilian concrete poetry, sounds pulsate and encourage live readings.

Finlay shared with the Russian futurists and the Noigandres group an interest in form as subject. For Finlay, this meant that discursivity, syntax, and the relations between successive words were replaced by the concrete poem as an object of language bearing its own internal structure. The content of this "play with letters" was "determined by the mechanism of construction," or, put differently, by the materiality of language as such.[64] In his "Letter to Pierre Garnier, September 17th, 1963," his most extensive theoretical statement on the new poetry, Finlay called concrete poetry a "model, of order, even if set in a space which is full of doubt."[65] The interplay between order or structure and doubt, referenced by Stephen Bann above, is distinctive to Finlay and can be followed in tantalizing ways in studies of his booklet poems. Molly Schwartzburg, for example, identifies a tension between permanence and ephemerality, between text and material context in Finlay's booklet *Two Poems* (1990), in which two tiny poems, one equating tombstone with sundial and the other marble with parachute, convey a "monumentality of language" that clashes with the ephemerality of their paper medium.[66]

```
lackblockblackb
lockblackblockb
lackblockblackb
lockblackblockb
lackblockblackb
lockblackblockb
lackblockblackb
lockblackblockb
lackblockblackb
lockblackblockb
lackblockblackb
lockblackblockb
lackblockblackb
```

homage to Malevich i h f

GREEN WATERS
BLUE SPRAY
GRAYFISH

ANNA T
KAREN B
NETTA CROAN

CONSTANT STAR
DAYSTAR
STARWOOD

STARLIT WATERS
MOONLIT WATERS
DRIFT

Henri Chopin

In an interview with Nicholas Zurbrugg in 1992, the French sound poet Henri Chopin describes how he came to abandon the written word and devote himself to "electronic" poetry.[67] By this, he means poetry that could only be made using electronic tape-recording technology—media that did not exist commercially before 1950. Chopin's interest in "vocal values in their own right" paralleled the interest of the Noigandres poets and of Finlay in language's materiality, and it can be traced, as he does, to ancient vocal traditions such as Russian improvisational singing and Vietnamese chanting. The *audio-poèmes,* which he developed in the mid-1950s out of these traditions, used microphones of high amplification to capture vocal sounds on the threshold of audition. They comprised a decomposition and recomposition of vowels and consonants, a slowing down and speeding up with multiple superimpositions.[68]

Chopin contrasted Kurt Schwitters's epic sound poem, the *Ursonate* (1922–32), which he deemed a "purely phonetic" work of the past, with his own electronic poetry.[69] He spoke of meeting Haroldo de Campos and learning about concrete poetry for the first time in Paris in 1958, and of Pierre Garnier's literary review *Les lettres,* published in 1963, in which Garnier "taught the general public about concrete poetry." Toward the end of his interview, Chopin praises not only the epoch of the 1960s, which brought the beginning of both sound poetry and visual poetry, but also the "three technological revolutions" of the twentieth century, namely, "video, electro-acoustic music, and *poésie sonore.*"[70] At the same time, he offers a surprising defense of typography: "Typography should not be forgotten. These days in Paris typesetting is mechanical, typefaces are ugly, and it's very difficult to locate a traditional typographer. As a result the manual and joyful aspects of typographic composition are becoming a thing of the past. In other words, one shouldn't forget the artisans of the past in one's enthusiasm for digital technology."[71]

A fine example of an artist's book by Chopin that is both *audio-poème* and visually inventive typography is his *Le dernier roman du monde: Histoire d'un chef occidental ou oriental* (1970; The last novel in the world: Story of a Western or an Oriental leader). The accompanying sound recording, a 45-inch LP titled *Pêche de nuit* (Night fishing), was published in 1958 under the title *La pêche.* According to the Canadian poet Steve McCaffery, this *audio-poème,* which represents Chopin's first foray into the genre, uses "a core verbal text made up of an onomatopoeic listing of fish names[.] Chopin destroys all verbal recognition by subjecting the verbal text to six speed changes and an additional forty-eight superimpositions of the initial reading of the text."[72] A playing of the recording reveals electronically altered and layered voices, shifts in speed, repeated consonants,

poppings of the cheek, and the occasional recognizable word, such as *pêche* and *tais-toi* (shut up), discernible amid sonic abstraction.

The printed book combines an actual narrative, lineated in straight prose, with typeset pages that experiment with repeated letters, syllables, and words and word combinations. In the poem "Vol voleauvent," Chopin develops one word and its sound out of another so that *vol* (flight) becomes *voleauvent* (flightwaterwind), *vol auvent* (puff pastry), *faire la vole* (win all the tricks), and *volatile* (winged creature). Chopin repeats these primarily portmanteau words and then modifies them by omitting individual letters (*fairelavole* becomes *faire avole* and later *fai ole*) or by adding new words, as in *pigeonvole* (fig. 10).

While Chopin creates visual formations with his typeset text, the shapes do not connote objects or ideas as they do in concrete poetry. One page, titled "Le poème phonétique impossible" (fig. 11), satirizes concrete poetry by alternating the word *cul* (ass) with its retrograde, *luc*, and substitutes the sound "lou" for *luc*. Chopin plays with and explores the difference between a written text and a live performance by repeating the vowels *u* and *ou*, which sound identical, but are written differently.[73] Moreover, the performer can read the phonetic poem either in vertical columns

```
le poème phonétique impossible

cul          luc
cul          luc
cul          luc
luc          cul
luc          cul
luc          cul
cul          luc
cul          luc
cul          luc
luc          cul
luc          cul
luc          cul
luc          cul
cul          luc
cul          luc
cul          luc
lou          per
cul          luc
lou          rde
cul          luc
cul          luc
cul          luc
cul          luc
luc          cul
luc          cul
luc          cul
luc          cul
lou          âge
lou          tes
lou          ise
l u c u      l l u s
```

Fig. 11.
Henri Chopin (French, 1922–2008).
"Le poème phonétique impossible."
From Henri Chopin, *Le dernier roman du monde: histoire d'un chef occidental ou oriental* (The last novel in the world: Story of a Western or an Oriental leader) (Wetteren, Belgium: n.p., 1970). Los Angeles: Getty Research Institute, 93-B2246.

or horizontally. A horizontal reading across the columns results occasionally in actual words (*louper, lourde, louâge*), but Chopin focuses primarily on pure sound without semantic evocation. Patterns of repetition ("cul luc, cul luc, cul luc"/ "luc cul, luc cul, luc cul"), read horizontally, insert a rhythmic component, which helps give this poem its sonic character. With the live recitations of sound poetry, which we find in futurist books, Chopin incorporates the possibility of multiple readings (horizontal and vertical), which result in variable, nonsemantic verbal and sonic patterns.

The Contemporary Artist's Book: A Postwar Futurism?

In their pursuit of verbal, visual, and sonic magic, midcentury poets such as Augusto de Campos, Ian Hamilton Finlay, and Henri Chopin followed a path first charted by the Russian futurists. Although they had no direct contact with the Russians, they developed a verbal language that was phonic, and they explored visual means consisting of colored fonts, unusual graphic designs, and typesetting that highlighted sound.[74] While it is true that they did not work principally as book artists or as collaborators, they produced pamphlets and graphic art closer in spirit to futurist intermedia and the verbivocovisual than did contemporary book artists, to whom I now turn.[75]

It may come as a surprise that Russian futurism has not found its legacy in the contemporary artist's book. The futurists' self-consciousness about their medium—format, paper type, sequencing of pages, variant copies, lithography, rubber-stamping—does not quite carry over into the contemporary artist's book. Moreover, the artist's book is defined broadly as spanning from the postwar period to today and comprising a visual/verbal work of art on its own, conceived specifically for the book form and often self-published by the artist; it is not a hybrid form developed through collaboration between poets and painters.[76] Rather, it tends to be conceptual or designed. The diminishing role of imagery in contemporary artists' books can be attributed in some cases to a scaling back of ambitions, as artists' books have become an industry, selling cheaply and no longer truly integrating text with sound and image or exploiting sonic play.

As an example of changing ambitions and shifting goals, let's take a look at two books that were published by the Brooklyn-based Ugly Duckling Presse. The press's mission statement, while not directly acknowledging its neo-futurist bent, emphasizes the handmade and reads as follows: "Ugly Duckling Presse is a nonprofit publisher for poetry, translation, experimental nonfiction, performance texts, and books by artists....UDP favors emerging, international, and 'forgotten' writers, and its books, chapbooks, artist's books, broadsides, and periodicals often contain handmade elements, calling attention to the labor and history of bookmaking."[77]

Fig. 12.
Cover of *6 x 6*, no. 2 (New York, 2008),
showing "*Ecliptophiles* from Burlingame
Proclaim the Universe Works."
Private collection.

Fig. 13.
Tone Škrjanec (Slovenian, b. 1953).
Cover of Tone Škrjanec, *Sun on a Knee*
(New York, 2008).
Private collection.

The second issue of a journal called *6 x 6* and published by Ugly Duckling Presse in 2002 carries the cryptic title "*Ecliptophiles* from Burlingame Proclaim the Universe Works." The issue engages the work of six poets and models its pentagonal shape, floral covers, and different fonts and Cyrillic typefaces on the Russian futurist book *Tango s korovami* (1914; Tango with cows) by Vasily Kamensky and David and Vladimir Burliuk (fig. 12). Kamensky invented the pentagonal shape of his book and printed the poetry and imagery on the reverse side of brightly colored floral wallpaper.

"*Ecliptophiles*" does not use the highly visual "ferro-concrete" poetry of Kamensky, in which the poet omits syntax and inserts words and word fragments that share semantic associations within diagonal grids. However, "*Ecliptophiles*" varies the material and the hue of each page to imitate the futurists' alternation of different paper weaves in their handmade books. In addition, its

spine is strengthened with rubber band, thus emulating the futurist paradigm of the unique artist's book. Some of the poems follow a language of nonsensicality and nonsequiturs that alludes to *zaum*. And the book highlights the six poets by silkscreening "6" on the cover and on various frontispieces.

On a number of levels, "*Ecliptophiles*" therefore follows a neo-futurist model. Yet it lacks visual imagery and typographic experimentation and contains surprisingly little phonic dimension—true even of the poems called "Planesong" and "Carsong"—that would reveal itself through reading aloud. Ultimately, this book does not quite meet the expectations raised by the use of the pentagonal shape of Kamensky's famous book. However, precisely because of its difference,

it offers a provocative reflection back on Russian futurism and forward to a new scaled-back practice of artists' books. Published in an edition of six hundred, "*Ecliptophiles*" sells for $3.00.

A second example from Ugly Duckling Presse is *Sun on a Knee,* written by the Slovenian poet Tone Škrjanec and translated by Joshua Beckman and the author in 2008 as part of the press's Eastern European Poets Series (fig. 13).[78] The book's pocket size and handmade appearance, especially the lovely hand-colored boards that serve as covers and the sewn binding, are again neo-futurist, recalling *Starinnaia liubov'* (Old-fashioned love) and *Sadok sudei* (A trap for judges). The poems, one per page and each three lines long in the manner of a haiku, display a spare, uniform typeface that recalls Ian Hamilton Finlay's booklet poems. Yet, unlike Finlay—who structured individual poems around a common theme (fishing vessels, sailing gear), shared phonemes, language play, or references to Malevich—Škrjanec did not identify the poems thematically or sonically, nor did he place them in a particular sequence. In addition, the absence of visual imagery (for instance, taking further the tree images on the front and back covers) and sound poetry results in a book of poems that differs in purpose from those of the Russian futurists.

What, then, makes "*Ecliptophiles*" and *Sun on a Knee* artists' books? Given the absence of verbal/visual or verbal/sonic interplay, perhaps it is more accurate to classify these texts as "designed" books, in which abstract but suggestive poetry provides the centerpiece for a book with a decorative jacket, but with little connection otherwise to the visual or to the vocal. Augusto de Campos, Ian Hamilton Finlay, and Henri Chopin continued their intermedia experiments well past the early work of the 1950s and '60s and, in the case of de Campos, right up to the present day via dazzling digital art forms.[79] Artists' books from the late 1960s on, by contrast, pursued either a design or a conceptual-art model.

For instance, Susan King's artist's book *Women and Cars,* published in 1983, treats the book primarily as a design object. Structure, rather than content, makes this book distinctive. Placed flat and closed, *Women and Cars* resembles a traditional book with heavy cardboard front and back covers. A black-and-white photograph of a Model-T Ford on the front reinforces this customary look. However, when the reader begins to open the covers, the "spine" reveals itself to be five closely folded edges of pink cardboard, which form an accordion. The accordion reverses the direction of the divided printed pages, where texts and graphics alternate on three strips of paper per page.

Turning the pages, one discovers two sets of text: on the left, quotations from Gertrude Stein ("She could not back the car very successfully. She goes forward admirably, she does not go backwards successfully."), Nancy Drew, Eloise Klein Healy, and Susan King; and on the right, King's short confessional anecdotes about her move to Los Angeles and about cars, which she sometimes personifies with feminine attributes. The design in this format is utterly conventional. In the opinion of Renée Riese Hubert and Judd Hubert, the continual emergence of anecdotes, coupled with the indistinct photographs, "drastically reduces any expectancy we might have entertained of directly comparing text with image."[80] When the two covers are opened completely, the book transforms into a pure accordion with no visible text. In this form, it stands erect, like a pop-up book (fig. 14).

King's design for *Women and Cars* is both clever and ingenious. She made her book so malleable that it assumes multiple forms instead of one. But how did she integrate these formats with her text? Do we find any aspect of her design that contributes to the quotations and narratives in the way that collage serves as technique and metaphor in *Mirskontsa*? King sought to reach a broad audience by creating her book as a reflection of the artist's lived experience. We can as easily read her stories independently of the pop-up design as with it. Moreover, when it comes to assessing the verbivocovisual relationship in *Women and Cars,* I would agree with

Fig. 14.
Susan E. King (American, b. 1947). Pop-up view of Susan E. King, *Women and Cars* (Rosendale, NY, 1983). Los Angeles, Getty Research Institute, 91-B29038.

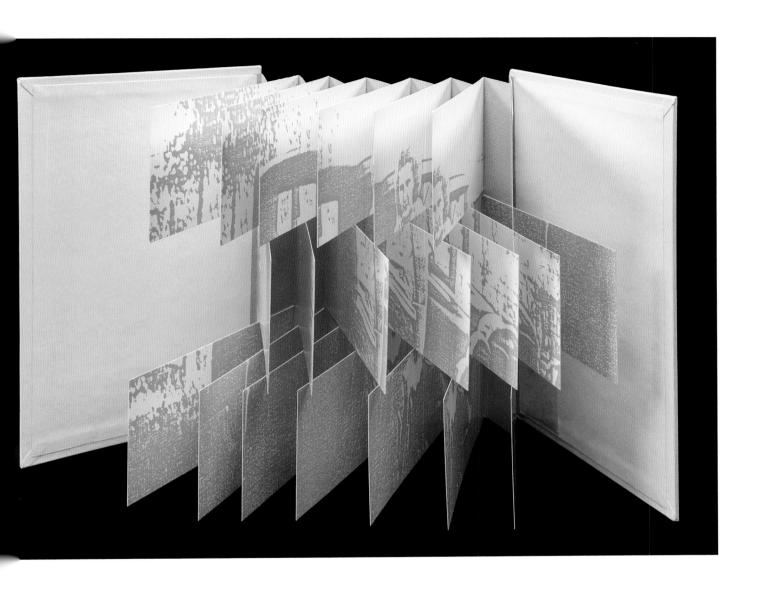

the Huberts that "neither the fuzzy photos nor the vivid anecdotes can quite compete with the impressive structuring of the volume. Bookwork definitely upstages content, noticeably when expansion obliterates the text and jumbles the graphics."[81] Is it an artist's book? Absolutely, but King did not aim to bring together design and image, never mind sound and image, to illuminate the meaning of the text.

In conceptual art, the displacement of the image by the idea coincided with the use of language in painting as a matter of course. From Joseph Kosuth to John Baldessari, "language art," also called "conceptual art," became one of the prominent forms that "ushered art into the nonspace of the text."[82] Let's begin by reviewing conceptual art as it was practiced in media outside the book, then turn to the contemporary artist's book as a genre that relied more heavily on the conceptual than on the verbivocovisual, thus departing from the model of futurist book art.

The conceptual art movement began in roughly the year of Marcel Duchamp's death—1968. It took its point of departure from Duchamp's rejection of the "retinal" aspect of art; art as idea became as legitimate as art as product or object.[83] In the words of Sol Lewitt, who published his "Paragraphs on Conceptual Art" in *Artforum* in 1967:

> In conceptual art the idea or concept is the most important aspect of the work. When an artist uses a conceptual form of art, it means that all of the planning and decisions are made beforehand and the execution is a perfunctory affair.... What the work of art looks like isn't too important.... No matter what form it may finally have it must begin with an idea. It is the process of conception and realization with which the artist is concerned.[84]

While each conceptual artist develops a distinctive style, all employ the conceptual style of "scripting"—that is, the use of brief, prosaic, verbal propositions for mental or physical activities to be completed by the artist or audience.[85] From 1965 to 1968, for example, the American conceptual artist Joseph Kosuth used photostats of dictionary definitions in his work. He selected the images from dictionaries, rather than creating them himself, in a process of appropriating rather than generating information. In order to further dissociate himself from the act of fabricating objects, he commissioned a craftsperson to make the photostats. His mixed-media work *One and Three Tables* consists of a photograph of a table, a photostat of a dictionary definition of the word *table,* and the actual object (fig. 15). In Kosuth's words: "It was the feeling I had about [eliminating] the gap between materials and ideas that led me to present a series of

Photostats....I didn't consider the photostat a work of art; only the idea was art. The words in the definition supplied the *art information;* just as the shape and color of a work could be considered its art information."[86]

By representing the table as a physical object, a photograph, and a photostat, Kosuth presented an abstraction of a table. His goal was to remove experience from the work of art and to create a sense of redundancy through the sequence of object, image, and word, each equivalent to each.[87] The new art depended upon ideas and hence upon language.[88]

Fig. 15.
Joseph Kosuth (American, b. 1945).
One and Three Tables, 1965,
gelatin silver photograph, wooden
table, and photostat mounted on foam-
core, installation dimensions variable.
Sydney, Art Gallery of New South
Wales, 102.1999.a-c.

EVERYTHING IS PURGED FROM THIS PAINTING
BUT ART, NO IDEAS HAVE ENTERED THIS WORK.

In the late 1960s, John Baldessari took a different approach to language art by producing text and phototext canvases on which a sign painter transcribed sentences conceived by Baldessari. The artist preserved the canvas as "the only remaining link to art."[89] However, in both their break with and their affirmation of traditional easel painting, the text and phototext canvases defy easy categorization. Statements such as "Everything is purged from this painting but art, no ideas have entered this work" are ironic because ideas, in the form of words, represent the only art for the conceptualist (fig. 16). And if this one sentence is purged, then an empty stretched canvas remains. Is that the "art" to which Baldessari is referring?

Given the absorption of language into visual art—whether on a canvas, in a photostat, on a gallery wall, or in neon or other signage—what is the impact on the artist's book? In one sense, artists' books have proliferated even more.[90] But abundance does not always mean significance. The contemporary artist's book is typically either a design object or a conceptual work, a tracing of one idea, often in narrative form. Let's consider some examples of the latter.

An acclaimed and unique bookwork demonstrating the conceptual turn is Buzz Spector's *A Passage*, published by Granary Books in 1994. According to the colophon, this book was "written, designed and torn by Buzz Spector" and published in an edition of forty-eight, with thirty-five numbered and for sale. Spector gave his book a traditional case binding so that, standing on a shelf or seen from the spine side, the work appears to be a regular book. But the reader who opens the book discovers that its pages have been altered, with each page slightly longer than the next, resulting in a book that slants at an oblique angle. Spector has altered and hand torn a "passage" by the well-known Egyptian francophone poet Edmond Jabès, in which he writes about Jewish and Biblical thought.[91] Spector repeated the same page over and over again but made each permutation of the page different, so that with each guise, new words or letters flicker in and out of visibility (fig. 17).

Of Spector's torn-pages bookwork, Granary Books writes: "Since 1981, Buzz Spector has created unique and editioned volumes and installation pieces confronting the cultural significance and history of the book. As a writer, editor, and book designer, he employs the materials of his trade: books and found texts, which he alters through tearing, cutting, painting, and other processes. Spector's intention is not to destroy, but to transform, books and language."[92]

Spector considers himself as much a writer (poet and critic) as a visual artist and therefore speaks of being drawn to the "interrelatedness of language and image and object. The emphasis placed on ideas and meanings by the conceptual artists of the 1960s and '70s was manifested in

works of art consisting largely (or entirely) of language, and I was interested in this kind of art making long before I began using words and texts in my own art."[93]

Spector's altered bookwork has what he calls a "conceptual purity," because it engages completely with the book as a book. His alteration, moreover, transforms the book into a "topological narration." We focus on tactility, topology, and on the idea of narrative, which Spector invoked through his appropriation of the author, Jabès. At the same time, *A Passage* is intended to be not only conceptual but also quite visual, as Spector himself explains: "My careful peeling away of each printed page in succession takes almost as long to complete as it would take to read the book, and the torn edges I create are visibly affected in a much different way than would be the case by simply tearing up a sheet of paper. If you think about my 'fields' of torn edges in relation to drawing rather than tearing, it becomes clear that my altered books are graphic exercises."[94]

As conceptual work, *A Passage* does not engage in the intricate verbal and sonic play of the Russian artists' books or, for that matter, the Noigandres poets. Rather, Spector generates his unusual treatment of the page and of bookwork from a concept—namely, that of physical alteration and its transformation of the book into an object that is studied graphically and topologically but no longer read. Instead of cover collage and verbal-visual-vocal collaboration, as in *Mirskontsa*, we have a text appropriated and modified by the artist-writer. But as a compelling conceptual work, *A Passage* also creates an intriguing dynamic between the senses of sight and touch. Narrative is now realized through relief and tactility, rather than through the printed word (fig. 18).

My preceding discussion of postwar and contemporary artists' books leads to the surprising conclusion that the verbivocovisual play and the *mirskontsa* principle of the Russian futurist book do not reemerge in later book art, which is more designed and conceptual than multimedia. Moreover, many contemporary collaborative "artists' books" are sometimes best understood as books of poetry. When, for example, collaboration plays a role in Susan Howe and James Welling's book *Frolic Architecture* (2010), surely the driving force is Howe's extraordinary poetry, which can and has been viewed or read aloud independently of Welling's photographs.[95] One might call this publication a book of poems paired with photographic images. Yet the strongest visual component lies in Howe's own rendition of her work as "type-collages"—that is, multi-typeface poems forged from fragments of broken off and overlapping text that require facsimile reproduction to be reprinted (fig. 19). Howe's facsimile technique becomes the basis for a conceptual, technological, and aesthetic framework in which to read her type-collages.

vas
to sum
t to her
although
rath

he Di p s- e ṽ c c e c o c o

ursuit of a snow-drift, which the west-wind was
and thither! At length, after a vast deal of
voices stranger into a corner, where
and enjoy herself in
the snow-birds took to flight.
fled backward, shaking her hea
touch me!'—and roguishly, as i.
through the deepest of the snow.
stumbled, and floundered down upo.
gathering himself

Fig. 19.
Susan Howe (American, b. 1937).
Type-collage.
From Susan Howe and James Welling,
Frolic Architecture (New York, 2010), n.p.
Los Angeles, Getty Research Institute,
2881-665.

Drawing on the artistic potential of the facsimile, she imagines a "print-based form of poetry that is equally linguistic and visual."[96]

In Howe and David Grubbs's haunting audio rendition of *Frolic Architecture* (2011), which mixes Howe's live reading with previously recorded and manipulated sounds, including recordings of her voice, the chief component remains the poetry. With its highly textured phonemes, spliced words, and audible phrases, Howe's poetry benefits from live reading. This verbivocal dimension represents the audio project's lasting impact.

Epilogue

In a letter written between 12 February and 7 March 1913 to Mikhail Matiushin and the Russian painter and theater artist Iosif Shkolnik, Malevich responds to an appeal from Khlebnikov and Kruchenykh to create "word novelties." He opens his letter with a series of playful *zaumnyi* neologisms: "I haven't received a single 'word-letter' from you yet, and thought that maybe you'd got held up in some 'warm'n cozy' refreshment establishment on your way to St. Petersburg…and that is why your word-creating mouths are silent. You, Mikhail Vasilievich, are a 'live-resonating person.'"[97]

Malevich addresses *zaum* explicitly and links it to abstract paintings in a letter to Matiushin dated 3 July 1913:

> We have reached the point of rejecting the sense and logic of the old reason, but we must try to perceive the sense and logic of the already newly emerged reason, the "transsense" (*zaumnyi*) reason, you might say, by comparison we've arrived at *zaum*. I don't know whether you'll agree with me or not, but I am beginning to learn that a strict law also exists in this *zaum*, which will give paintings a right to exist. And not a single line must be drawn without an awareness of this principle, for only then are we alive.[98]

Malevich wrote this letter while completing the cover and four drawings for the futurist almanac *Troe* (The three), which he dedicated to the memory of Matiushin's wife, the poet Elena Guro. The "three" were Khlebnikov, Kruchenykh, and Guro, the latter contributing poetry and prose before she died of leukemia at age thirty-six. Published on 15 August 1913, the book features a preface by Matiushin, poetry and prose by Khlebnikov and Kruchenykh, and Kruchenykh's important manifesto on *zaum*, *Novye puti slova* (New ways of the word).

The cover of *Troe,* Malevich's first published book cover, is one of his most remarkable contributions to futurist book art (see "Introduction," fig. 6). Moving between abstraction and figuration, Malevich anticipated Kruchenykh's manifesto—with its call for combining words according to their inner laws—by drawing an oversize, inverted comma, which speaks to the new, alogical language of *zaum.* Isolated and transformed in this way, the comma loses all semantic, grammatical, and syntactic implications and becomes what we might call a nonobjective "sign as such." It also serves to prop up a large robotic peasant figure—neither overtly male nor female—positioned precisely in the center of the cover and built of steely cones and a triangular head. The tension between Russia's past, which the peasant embodies, and its future, expressed through mechanized form, continues in the four vibrant Cyrillic letters of the book's title, which employ a stylized Old Church Slavonic calligraphy while also breaking down into loosely drawn triangles and straight-line slabs.[99] Abstraction pushes against representation: the letter *T* suggests a human form, while the *E* becomes a flag.

Troe was conceived during a June 1913 retreat at Matiushin's country house in Uusikirkko, a Finnish township north of Saint Petersburg. During the retreat, Malevich, Matiushin, and Kruchenykh also conceived of the idea of *Pobeda nad solntsem* (*Victory over the Sun*), the first futurist opera. In the fall, Kruchenykh wrote to Matiushin, "It would be good if the characters recalled the figure on the cover of *The Three* and spoke crudely and downward."[100] "Crudely and downward," as applied to Malevich's robotic peasant, is only one part of the equation, the other being the mechanized, just as his cover explores the past and the present. Such polarities recall his painting *Morning in the Village after a Snowstorm* (1912) (see "Introduction," fig. 1), which likewise shifts between these oppositions and between abstraction and the figurative.

In closing, I shall return to P. D. Ouspensky's image of looking down on a landscape from the vantage of the fourth dimension, so that the beginning, middle, and end of time appear together all at once. Time becomes simultaneous in all directions. In Ouspensky's words, "Within the limits of its moment such a receptivity will not be in a position to discriminate between *before, now, after;* all this will be for it *now.*"[101] This vision is an apt encapsulation of Malevich's book cover for *Troe,* and for his and his collaborators' entire oeuvre of Russian futurist book art. In that brief period between 1910 and 1915, we see both the beginning and the culmination of an avant-garde moment for the artist's book—verbivocovisual, reversible, handmade, and laid bare—that has never been repeated.

Notes

1. Note that three of the five catalog essays address Russian futurist books. See note 17.

2. For examples of earlier scholarship, see Susan Compton, *The World Backwards: Russian Futurist Books, 1912–16* (London: British Library Board, 1978); Gerald Janecek, *The Look of Russian Literature: Avant-Garde Visual Experiments, 1900–1930* (Princeton, NJ: Princeton University Press, 1984); and Vladimir Markov, *Russian Futurism: A History* (Washington, D.C.: New Academia, 2006).

3. Stephanie Barron and Maurice Tuchman, eds., *The Avant-Garde in Russia, 1910–1930: New Perspectives* (Los Angeles: Los Angeles County Museum of Art, 1980), 12, 17.

4. John E. Bowlt, ed., *Russian Art of the Avant-Garde: Theory and Criticism, 1902–1934* (New York: Thames & Hudson, 1977), 293. This is an excerpt from Andrei Zhdanov's speech at the First All-Union Congress of Soviet Writers in 1934.

5. For this quote, see Michael Kimmelman, "Russia's Fling with the Future," *New York Times*, 25 September 1992, http://www.nytimes.com/1992/09/25/arts/review-art-russia-s-fling-with-the-future.html. For the information on dispatching Russian avant-garde works to provincial centers and the subsequent information on early exhibitions of the Russian avant-garde, see John E. Bowlt, "Utopia Revisited," *Art in America* 81, no. 5 (1993): 100.

6. Barr illustrated suprematist paintings by Malevich and constructivist reliefs and sculptures by Alexander Rodchenko and Vladimir Tatlin. Please note that the work of Malevich was an exception to the rule of late reception. The Stedelijk Museum in Amsterdam acquired a rich Malevich collection (thirty-six paintings and fifteen drawings) in 1958 and displayed much of it in the exhibition *Kasimir Malevich, 1878–1935*, at the Whitechapel Art Gallery, London, October–November 1959. See Yve-Alain Bois, "The Availability of Malevich," in *Malevich and the American Legacy* (New York: Gagosian Gallery, 2011), 21, 31n1.

7. I use "first survey" to distinguish the Grosvenor show from earlier exhibitions of Russian art, especially those organized by commercial galleries in western Europe, that tended to be "indiscriminately inclusive" by showing a range of artistic pursuits, émigré or otherwise. See Éva Forgács, "How the New Left Invented East-European Art," in *Blindheit und Hellsichtigkeit: Künstlerkritik an Politik und Gesellschaft der Gegenwart*, ed. Cornelia Klinger (Berlin: De Gruyter, 2014), 64.

8. Quoted in Barron and Tuchman, *The Avant-Garde in Russia*, 12.

9. Barron and Tuchman, *The Avant-Garde in Russia*, 12–13.

10. Barron and Tuchman, *The Avant-Garde in Russia*, 6, 102. It is significant that at the time of that publication, so little was known about the Russian avant-garde that Barron and Tuchman included a glossary of terms ("Inkhuk," "Lef," "Proun," "Unovis") followed by artist biographies/catalog entries written by graduate students. These occupy over half of the entire volume and often represent the first publication in English on these artists.

11. Marjorie Perloff, *The Futurist Moment: Avant-Garde, Avant-Guerre, and the Language of Rupture* (Chicago: University of Chicago Press, 1986).

12. The medium of the propaganda board was probably oil and sand. See Lissitzky's comparable painting *Town* (1919–20), oil and sand on plywood. T. J. Clark, *Farewell to an Idea: Episodes from a History of Modernism* (New Haven, CT: Yale University Press, 1999).

13. Jean-Louis Cohen, "Introduction," in *Russian Modernism: The Collections of the Getty Research Institute for the History of Art and the Humanities*, compiled and annotated by David Woodruff and Ljiljana Grubisic (Santa Monica, CA: Getty Research Institute for the History of Art and the Humanities, 1997), 5.

14. See "Center Description: The Whitney Gift," Amherst Center for Russian Culture, Amherst College, https://www.amherst.edu/academiclife/departments/russian/acrc/description, for newsletters by Stanley J. Rabinowitz, Director of the Amherst Center, and press clippings. Whitney was an alumnus and former diplomat best known for translating the work of the dissident writer Alexander Solzhenitsyn. He built his collection in the mid-1960s and acquired material at auction or through private purchases in France and the United States.

15. See Woodruff and Grubisic, *Russian Modernism*, which is an annotated bibliography of this collection at the Getty Research Institute.

16. Compton, *The World Backwards*, 7; and Edward Kasinec and Robert Davis, "Russian Book Arts on the Eve of World War One: The New York Public Library Collections," *The Journal of Decorative and Propaganda Arts* 14 (1989): 94n2, 105n12. Kasinec and Davis quote a December 1923 letter from the library's chief reference librarian, Harry Miller Lydenberg (1874–1960), to the then-director of the NYPL, Edwin H. Anderson (director, 1913–34), describing "a bill for $12.50, representing 62 volumes of futuristic Russian poetry we got from a poet named Kruchonykh [*sic*] to go out and buy for us from the writers themselves and from the stand. Much of this…cannot be got through regular channels." Letter quoted in Robert A. Karlowich, "Stranger in a Far Land: Report of a Bookbuying Trip by Harry Miller Lydenberg in Eastern Europe and Russia in 1923–24," *Bulletin of Research in the Humanities* 87, nod. 2–3 (1986/87): 182–224. The NYPL continued to augment its futurist collections during the course of the twentieth century.

17. Miller was assisted by Jared Ash, the Judith Rothschild Foundation curator. See Deborah Wye and Margit Rowell, eds., *The Russian Avant-Garde Book, 1910–1934* (New York: Museum of Modern Art, 2002), 7.

18. Wye and Rowell, *The Russian Avant-Garde Book*, 7.

19. Price information gleaned from Sotheby's and Christies sales cited in *American Book Prices Current* online, under "Mirskontsa." Certainly, there may have been early sales not documented on databases. The year 2007 marked the last recorded sale. The 1985 sale is a hammer price; the 2005 sale includes the buyer's premium; the 2007 sale also includes premium.

20. In all but two of the thirteen auction sales, the sale involved the first edition, rather than the second. The sales in 1993, 2003, and 2006 included the buyer's premium. The British vendor Sims Reed reports dealing with two privately held copies of the first edition. According to Sims Reed's records of sales of other futurist books between 2003 and 2013, only *Igra v adu* (A game in hell) in its second edition appeared on the market every year. Appearances of *Pomada* (Pomade) and *Zaumnaia gniga* (Transrational boog) were limited to two or three copies during this period, and *Te li le* is so rare (published in a small edition) that it has no auction records. Correspondence with Tim Byers of Sims Reed, 24 May 2013. Sales data culled from *American Book Prices Current* online.

21. Lissitzky published his essay "Novaia kul'tura" (1919; The new culture) in the final issue of *Shkola i revoliutsiia*" (School and revolution), in Vitebsk. See translation in Peter Nisbet, *El Lissitzky in the Proun Years: A Study of His Work and Thought, 1919–1927* (Ann Arbor, MI: University Microfilms, 1995), 49.

22. Eight of the thirteen poems were published between mid-1917 and late 1920; two were published before the revolution; the remaining three appeared earlier in 1922. For information on the collaboration and the publication history of the poems, see Patricia Railing, ed., *Voices of the Revolution: Collected Essays*, 3 vols. (London: British Library, 2000), 1:35–38.

23. Maria Gough, "Contains Graphic Material: El Lissitzky and the Topography of G," in *G: An Avant-Garde Journal of Art, Architecture, Design, and Film, 1923–1926*, ed. Detlef Mertins and Michael W. Jennings (Los Angeles: Getty Research Institute, 2010), 29.

24. Nisbet, *El Lissitzky*, 203.

25. Mladen Ovadija, *Dramaturgy of Sound in the Avant-Garde and Postdramatic Theatre* (London: McGill-Queen's University Press, 2013), 86.

26. Eugene Ostashevsky, ed., *OBERIU: An Anthology of Russian Absurdism* (Evanston, IL: Northwestern University Press, 2006), xiii.

27. In their 1925 application to the Leningrad Writers' Union, Kharms and Vvedensky clearly stated their literary orientation as "futurist." This futurist lineage is traced in Evgeny Pavlov, "OBERIU: Daniil Kharms and Aleksandr Vvedensky on/in Time and History," in *The Russian Avant-Garde and Radical Modernism*, ed. Dennis G. Ioffe and Frederick H. White (Brighton, MA: Academic Studies, 2012), 299–300; and in Ostashevsky, *OBERIU*, xiv–v.

28. Matvei Yankelevich, ed. and trans., *Today I Wrote Nothing: The Selected Writings of Daniil Kharms* (New York: Overlook Duckworth, 2007), 14.

29. Yankelevich, *Today I Wrote Nothing*, 21; and Ostashevsky, *OBERIU*, xvi.

30. Ostashevsky, *OBERIU*, xxiii.

31. Ostashevsky, *OBERIU*, xix–xx. Matvei Yankelevich explains that even income from Kharms's writing and translations for children became scarce "as his editors got deeper into trouble with Soviet censors. Kharms's notebooks from the years 1936–1941 detail his impoverishment, and the effect of hunger on his relationship with his wife and on his writing." Yankelevich, *Today I Wrote Nothing*, 27.

32. Apart from Kharms's late prose, very little of the group's work was available in English until the publication of Eugene Ostashevsky's anthology in 2006.

33. Mary Ellen Solt, ed., *Concrete Poetry: A World View* (Bloomington: Indiana University Press, 1971), 72.

34. Fahlström's manifesto "Hipy Papy Bthuthdth Thuthda Bthuthdy: Manifesto for Concrete Poetry" [1953], in Antonio Sergio Bessa, *Öyvind Fahlström: The Art of Writing* (Evanston, IL: Northwestern University Press, 2008), 136.

35. Quoted in Marjorie Perloff, *Unoriginal Genius: Poetry by Other Means in the New Century* (Chicago: University of Chicago Press, 2010), 59.

36. Alexei Kruchenykh, *New Ways of the Word*, in Anna Lawton, ed., *Russian Futurism through Its Manifestos, 1912–1928* (Ithaca, NY: Cornell University Press, 1988), 71.

37. Letter from Velimir Khlebnikov to Alexei Kruchenykh, 16 October 1913, in Velimir Khlebnikov, *Collected Works of Velimir Khlebnikov*, vol. 1, *Letters and Theoretical Writings*, ed. Charlotte Douglas, trans. Paul Schmidt (Cambridge, MA: Harvard University Press, 1987), 84.

38. From Haroldo de Campos, "Poetic Function and Ideogram: The Sinological Argument," trans. Kevin Mundy and Mark Nelson, in Haroldo de Campos, *Novas: Selected Writings of Haroldo de Campos*, ed. Antonio Sergio Bessa and Odile Cisneros (Evanston, IL: Northwestern University Press, 2007), cited in Perloff, *Unoriginal Genius*, 180n43.

39. For a fascinating explication of the (intentionally) complex etymology of the name Noigandres, see Perloff, *Unoriginal Genius*, 65–66.

40. Marjorie Perloff and Craig Dworkin, eds., *The Sound of Poetry/The Poetry of Sound* (Chicago: University of Chicago Press, 2009); and Antonio Sergio Bessa, "Sound as Subject: Augusto de Campos's *Poetamenos*," in Perloff and Dworkin, *The Sound of Poetry*, 219, 221.

41. Augusto de Campos's preface to *Poetamenos* (1953), translated in Bessa, "Sound as Subject," 222–23.

42. Irene Small, "Verbivocovisual: Brazilian Concrete Poetry," paper presented at "POEM/ART: 50 Years of Brazilian Concrete Poetry in the São Paulo Modern Art Museum 1956–2006," an international conference organized by K. David Jackson at Yale University, 3–4 November 2006. A "portmanteau word" is a combination of two or more words and their definitions.

43. Augusto de Campos, "Poesia concreta," in Augusto de Campos, Décio Pignatari, and Haroldo de Campos, *Teoria da poesia concreta— Textos criticos e manifestos, 1950–1960*, 2nd ed. (São Paolo: Livraria Duas Cidades, 1975), 45; translated and quoted in Antonio Sergio Bessa, "Word as Object: Concrete Poetry in Brazil, circa 1953," in Anne Thurmann-Jajes, ed., *Poesie–Konkret / Poetry–Concrete, 7 Schriftenreihe für Kunstlerpublikationen* (Bremen, Germany: Salon, 2012), 84.

44. From "Olho por olho a olho nu" (Eye for an eye in daylight), 1956, quoted in Bessa, "Sound as Subject," 220.

45. Augusto de Campos, "Concrete Poetry: A Manifesto" [1956], quoted in Peter Frank, "Geometric Literature: From Concrete Poetry to Artists' Books," in *Beyond Geometry: Experiments in Form, 1940s–70s*, ed. Lynn Zelevansky (Cambridge, MA: MIT Press, 2004), 156, 158.

46. Sergio Bessa discusses the "Sator Arepo" palindrome in "Sound as Subject," 223–24.

47. Translation by Augusto de Campos, Marco Guimarães, and Mary Ellen Solt. See Solt, *Concrete Poetry*, frontispiece.

48. Quoted by Décio Pignatari in "Poesia concreta: Organização," in de Campos, Pignatari, and de Campos, *Teoria da poesia concreta*, 220.

49. Augusto de Campos's comment on the dialectic is quoted by Bessa in "Sound as Subject," 225.

50. See Bessa quoting an analysis by the Brazilian poet Eduardo Sterzi of de Campos's early poetry, in Bessa, "Sound as Subject," 226–28.

51. Yves Abrioux, "Biographical Notes," in *Ian Hamilton Finlay: A Visual Primer*, introductory notes and commentaries by Stephen Bann (Edinburgh: Reaktion, 1985), 9. For inclusive dates of *P.O.T.H.*, which has no copyright information on the individual issues, see "Poor. Old. Tired. Horse.," UbuWeb: Visual Poetry, http://ubu.com/vp/Poor.Old.Tired.Horse.html.

52. Alec Finlay, ed., *Wood Notes Wild: Essays on the Poetry and Art of Ian Hamilton Finlay* (Edinburgh: Polygon, 1995). See Edwin Morgan, "Poor. Old. Tired. Horse.," in Finlay, *Wood Notes Wild*, 26–27.

53. Edwin Morgan dates issue 6 of *P.O.T.H.* to March 1963, but he does not attribute any other dates. See Edwin Morgan, "Early Finlay," in Finlay, *Wood Notes Wild*, 21.

54. The most famous of the three, Andrei Voznesensky, would devote a section of his book *Ten' zvuka* (1970; The shadow of a sound) to concrete poetry, calling it "experiments in figurative poetry." See Edwin Morgan, "Into the Constellation: Some Thoughts on the Origin and Nature of Concrete Poetry," in *Essays*, idem (Cheadle, UK: Carcanet, 1974), 29.

55. Bowlt, *Russian Art*, xxiv–xxv, 6. The Blue Rose artists were based in Moscow and led by Pavel Kuznetsov.

56. Camilla Gray writes about Goncharova's contributions to the *Golden Fleece* exhibitions, which featured Blue Rose artists.

57. Stephen Bann and I exchanged e-mail correspondence about Finlay's relationship to the Russians on 18 May 2013. With regard to his 1967 anthology of international concrete poetry, Bann mentioned that Finlay offered him two possibilities: the "Homage to Malevich" from *Rapel* (1963) and a composition more analogous to a Malevich work with two or more squares. By way of a note to the second composition, Finlay wrote to Bann, "As Malevich's works are not hard-edge abstracts as we know them, it is possible to imagine this poem with hand-drawn type, or with machine-type." The reference to the "hand-drawn" acknowledges both Malevich's painterly approach and the handmade aesthetic of the Russian futurists.

58. For Edwin Morgan's translation of Khlebnikov's poem "Zakliatie smekhom" (1910; Incantation by laughter), see Edwin Morgan, "Flying with Tatlin, Clouds in Trousers: A Look at Russian Avant-Gardes," in *Beyond Scotland: New Contexts for Twentieth-Century Scottish Literature*, ed. Gerard Carruthers, David Goldie, and Alastair Renfrew (Amsterdam: Rodopi, 2004), 102.

59. For this information on Edwin Morgan, see James McGonigal, "Keeping It Concrete: Edwin Morgan in the Sixties," *PN Review* 40, no. 2 (2013): n.p.

60. Caitlin Murray and Tim Johnson, eds., *The Present Order: Writings on the Work of Ian Hamilton Finlay*, trans. Jessica Moore (Marfa, TX: Marfa, 2010); and Anne Moeglin-Delcroix, "Poet or Artist?," in Murray and Johnson, *The Present Order*, 36–37.

61. See analysis by the poet Susan Howe, quoted by Marjorie Perloff, "From 'Suprematism' to Language Game: The *Blue and Brown Poems* of Ian Hamilton Finlay," in Murray and Johnson, *The Present Order*, 91–92.

62. Stephen Bann, "Ian Hamilton Finlay: An Imaginary Portrait," in Finlay, *Wood Notes Wild*, 60.

63. Perloff, "From 'Suprematism' to Language Game," 96–98.

64. Moeglin-Delcroix, "Poet or Artist?" 34.

65. Ian Hamilton Finlay, "Letter to Pierre Garnier, September 17th, 1963," in Solt, *Concrete Poetry*, 84.

66. Molly Schwartzburg, "Reading Finlay's Booklet Poems," in Murray and Johnson, *The Present Order*, 115.

67. "Henri Chopin," interviewed by Nicholas Zurbrugg, Paris, 12 January 1992, from Nicholas Zurbrugg and Marlene Hall, eds., *Henri Chopin* (Morningside, Aus.: Queensland College of Art Gallery, 1992), 40, 43, 51.

68. Steve McCaffery, "From Phonic to Sonic: The Emergence of the Audio-Poem," in *Sound States: Innovative Poetics and Acoustical Technologies*, ed. Adelaide Morris (Chapel Hill: University of North Carolina Press, 1997), 158.

69. Zurbrugg and Hall, *Henri Chopin*, 40, 43.

70. Zurbrugg and Hall, *Henri Chopin*, 49.

71. Zurbrugg and Hall, *Henri Chopin*, 51.

72. McCaffery, "From Phonic to Sonic," 158.

73. See Brian M. Reed on this phenomenon in "Visual Experiment and Oral Performance," in Perloff and Dworkin, *The Sound of Poetry*, 278.

74. De Campos's Brazilian colleague, the poet Andre Vallias, created a digital version of Khlebnikov's "Zakliatie smekhom" (1910; Incantation by laughter), based on the translation into Portuguese by Haroldo de Campos.

75. Ian Hamilton Finlay created ephemeral pieces (small-scale objects typeset on paper) that took the form of booklets, pamphlets, posters, and cards. See Molly Schwartzburg, "Reading Finlay's Booklet Poems," in Murray and Johnson, *The Present Order*, 109–53. The term *intermedia* refers here to the verbivocovisual and not to Dick Higgins's *intermedia*, which emphasizes art forms like Happenings and event pieces existing between the genres.

76. Joan Lyons, ed., *Artists' Books: A Critical Anthology and Sourcebook* (Rochester, NY: Visual Studies Workshop, 1985). For this definition of the artist's book, see Lucy Lippard, "The Artist's Book Goes Public," in Lyons, *Artists' Books*, 85.

77. For the mission statement, see "Mission," Ugly Duckling Presse, http://www.uglyducklingpresse.org/about/.

78. The book appeared in two editions, the first in December 2004 in an edition of 150 copies, the second (discussed here) in 2008.

79. For de Campos's digital poetry based on the sounds of phonemes, see "Clip poemas do livro 'Não'" [2003], Augusto de Campos, http://www2.uol.com.br/augustodecampos/clippoemas.htm.

80. Renée Riese Hubert and Judd Hubert, *The Cutting Edge of Reading: Artists' Books* (New York: Granary, 1999), 109.

81. Hubert and Hubert, *The Cutting Edge of Reading*, 109.

82. Quoted by Jessica Prinz in Carter Ratcliff, "Robert Morris: Prisoner of Modernism," *Art in America* 67 (1979): 107. See Jessica Prinz, *Art Discourse/Discourse in Art* (New Brunswick, NJ: Rutgers University Press, 1991), 3.

83. For a clear explanation of conceptual art, see Prinz, *Art Discourse*, 11–13, 45–47.

84. Excerpted from http://sfaq.us/2011/11/sol-lewitt-on-conceptual-art-1967/.

85. Prinz, *Art Discourse*, 45.

86. Gregory Battcock, *Idea Art: A Critical Anthology* (New York: E. P. Dutton, 1973), 145.

87. Prinz, *Art Discourse*, 47.

88. Henry Flynt defines "concept art" as "first of all an art of which the material is 'concepts,' as the material of for ex. music is sound. Since concepts are closely bound up with language, concept art is a kind of art of which the material is language." See Henry Flynt, "Concept Art," in *An Anthology of Chance Operations…*, ed. La Monte Young (New York: L. Young & J. Mac Low, 1963).

89. For the discussion of Baldessari, including this quote, see Coosje van Bruggen, *John Baldessari* (New York: Rizzoli International, 1990), 41.

90. Critics such as Renée and Judd Hubert and Johanna Drucker identify a multitude of categories, including different media (pamphlets, kinetic flip-books, pop-up books, palimpsests), narratives (emotional works, performances), and "zones of activity" (fine printing, independent publishing, the craft tradition of book arts). See Hubert and Hubert, *The Cutting Edge*, 7–10; Shelley Rice, "Words and Images: Artists' Books as Visual Literature," in Lyons, *Artists' Books*, 62–72; and Johanna Drucker, *The Century of Artists' Books* (New York: Granary, 1995), 2.

91. Hubert and Hubert, *The Cutting Edge*, 87.

92. Xiaohang Zeng, "Buzz Spector: The Dual Identity of Artist and Professor," in Sally Alatalo, ed., *Buzzwords: Interviews with Buzz Spector* (Chicago: Sara Ranchouse, 2012), n.p.

93. Zeng, "Buzz Spector," n.p.

94. Zeng, "Buzz Spector," n.p.

95. Susan Howe's *Frolic Architecture* was first published as the second of three sections in the New Directions book of poetry *That This*, with six black-and-white photograms by James Welling. Susan Howe, *That This* (New York: New Directions, 2010).

96. Chelsea Jennings, "Susan Howe's Facsimile Aesthetic," *Contemporary Literature* 56 (December 2015), 670.

97. Irina A. Vakar and Tatiana N. Mikhienko, eds., *Kazimir Malevich: Letters, Documents, Memoirs, Criticism*, trans. Antonina W. Bouis (London: Tate Publishing, 2015) 1:47.

98. Vakar and Mikhienko, *Kazimir Malevich*, 1:52.

99. Donald Karshan discusses Malevich's reference to Old Church Slavonic calligraphy in *Malevich: The Graphic Work, 1913–1930; A Print Catalogue Raisonné* (Jerusalem: Israel Museum, 1975), 42.

100. Letter from Alexei Kruchenykh to Mikhail Matiushin, 5–13 October 1913, translated and quoted by Eugene Ostashevsky in Eugene Ostashevsky, ed., *Victory over the Sun: The First Futurist Opera by Aleksei Kruchenykh*, trans. Larissa Shmailo (W. Somerville, MA: Červaná Barva, 2014), n.p.

101. P. D. Ouspensky, *Tertium Organum*, trans. Claude Bragdon (New York: Cosimo, 2005), 48–49.

Acknowledgments

I am grateful to the following friends, colleagues, editors, curators, and lecture conveners, who offered useful advice at various points in the writing of this book and whose scholarship proved especially valuable to me: Elena Basner, Timothy O. Benson, Sergio Bessa, Rosalind P. Blakesley, Christian Bök, John E. Bowlt, Clare Cavanagh, Craig Dworkin, Éva Forgács, Maria Gough, Nina Gurianova, Louise Hardiman, Gerald Janecek, Olga Kagan, Nicola Kozicharow, Galina Mardilovich, John Milner, Oleg Minin, Nicoletta Misler, Eugene Ostashevsky, Vladimir Paperny, Jann Pasler, Vanessa Place, Sarah Pratt, Allison Pultz, Brian M. Reed, Sophia Rochmes, Kristin Romberg, Kristina Rosenberg, Rainer Rumold, Wendy Salmond, Stephanie Sandler, Jane Sharp, Ronald Vroon, Glenn Watkins, Roland John Wiley, and Matvei Yankelevich.

Among my colleagues in Russia, I give heartfelt thanks to Dmitrii Karpov, curator of rare books at the State Mayakovsky Museum in Moscow, who graciously showed me copies of every futurist book that interested me and provided image files; Valerii Leonov, director of the Library of the Russian Academy of Sciences in Saint Petersburg, who made his library's collection of Russian avant-garde books available to me; and Vladimir Poliakov, with whom I met and corresponded about his most recent book on Russian cubo-futurism. In addition, I am deeply grateful to the following scholars who welcomed me at their institutions: Evgeniia Iliukhina, curator of drawings, State Tretiakov Gallery, Moscow; Irina Lynden, deputy director general for international activities, National Library of Russia, Saint Petersburg; Larisa Ostrovskaya, curator, Russian State Archive of Literature and Art, Moscow; Elena Ponomareva, curator, State Pushkin Museum, Moscow; Elena Rymshina, curator, Pushkin State Museum of Fine Arts, Moscow; and Alexander Samarin, director, State Russian Library, Moscow. In addition, Larisa Karkafi was an invaluable Russian tutor, and Antanina Sergieff, graduate student at the University of California, Los Angeles, produced excellent translations of *zaum* poetry and of significant passages in Russian monographs.

I have been fortunate to benefit from the remarkable scholarly expertise of my colleagues at the Getty. I wish to thank Christina Aube for her expert organization of the abundant illustrations; Michele Ciaccio for her close guidance on all details of development; Lauren Edson for her careful editing; and Catherine Bell and Alicia Houtrouw for their imaginative design of the online resource. Greg Albers, Liz McDermott, Merritt Price, and Robert Checchi also made valuable contributions. Designer Kurt Hauser and production coordinator Michelle Woo Deemer brought this elegant book to life. Gail Feigenbaum, associate director of research and publications, provided enormous help and encouragement, as did Marcia Reed, an exemplary chief curator, and Andrew Perchuk, deputy director. I am especially grateful to Thomas W. Gaehtgens, our esteemed director, who provided me with the resources to carry out this study, and to president and CEO James Cuno, who shared with me his fascination with Russian modernism, including the writing of his MA thesis on Vladimir Tatlin.

Lastly, a great debt goes to my family: my sister Carey Perloff, who offered many fascinating insights about my futurist exhibition; my in-laws, Susan and Arthur Lempert, who were patient and interested throughout; my son, Benjamin Lempert, who tolerated the process with good humor and even wrote a high-school paper on *Tango with Cows*. And finally, my husband, Robert Lempert, a scientist and policy analyst, read the book chapters closely and helped refine the logic and clarity of my arguments. His love and patience and his genuine excitement about the book sustained my enthusiasm at challenging moments. Without my mother, Marjorie Perloff, a literary critic whose astute perspective I treasure, the book might never have happened. She read drafts of every chapter, offering both praise and pointed critique. The book is lovingly dedicated to her and to the memory of my wonderful father, Joseph Perloff, who was the first person to teach me how to look at works of art, but, unfortunately, did not live to see the publication of this book.

—*Nancy Perloff*

Illustration Credits

Photographs of items in the holdings of the Research Library at the Getty Research Institute are courtesy the Research Library. The following sources have granted additional permission to reproduce illustrations in this book:

Introduction

Fig. 1. Photo: The Solomon R. Guggenheim Foundation / Art Resource, NY.

Fig. 2. Photo: Erich Lessing / Art Resource, NY.

Fig. 3. Photo: Herve Lewandowski, © RMN-Grand Palais / Art Resource, NY.

Fig. 4. Photo: HIP / Art Resource, NY. Art © 2016 Estate of Pablo Picasso / Artists Rights Society (ARS), New York.

Fig. 7. Photo: Art Resource, NY.

Fig. 8. Art © 2016 Artists Rights Society (ARS), New York / SIAE, Rome.

Fig. 10. Photo: MIT Libraries, Institute Archives and Special Collections, Cambridge, Massachusetts, Roman Jakobson, Roman Jakobson Papers. All rights reserved. Used by permission of the Roman Jakobson Trust, Linda R. Waugh, Executive Director.

From the Provinces

Fig. 2. Photo: HIP / Art Resource, NY.

Fig. 3. © 2016 J. Paul Getty Trust.

Figs. 4, 6. Courtesy Bengt Jangfeldt Archive, Stockholm.

Fig. 10. Photo: Snark / Art Resource, NY.

Mirskontsa

Figs. 2, 3. Gift of The Judith Rothschild Foundation. Digital Image © The Museum of Modern Art / Licensed by SCALA / Art Resource, NY.

Figs. 4, 14. Photo: State Mayakovsky Museum, Moscow.

Fig. 11. Photo: Gianni Dagli Orti / The Art Archive at Art Resource, NY. Art © 2016 Artists Rights Society (ARS), New York / ADAGP, Paris.

The Afterlife of Russian Futurist Book Art

Figs. 4, 5, 6, 7, 8, 9. By courtesy of the Estate of Ian Hamilton Finlay.

Fig. 12. © Ugly Duckling Presse.

Fig. 13. © Ugly Duckling Presse.

Fig. 14. Courtesy of Susan E. King.

Fig. 15. Photo: Art Gallery of New South Wales, Mervyn Horton Bequest Fund 1999. AGNSW © Joseph Kosuth, 1965/ARS 102.1999.a-c. Art © 2016 Joseph Kosuth / Artists Rights Society (ARS), New York.

Fig. 16. Courtesy of the artist and Marian Goodman Gallery.

Fig. 19. Used by permission of Susan Howe.

Index

Page numbers in italics refer to images; those followed by *n* refer to notes, with note number. Poems marked with ◀)) are available as audio recordings at www.getty.edu/ZaumPoetry.

Explodity: Sound, Image, and Word in Russian Futurist Book Art

Nancy Perloff is curator of modern and contemporary collections at the Getty Research Institute (GRI). Trained as a musicologist and an art historian, she pursues scholarship on the Russian avant-garde, European modernism, and the relationship between music and the visual arts. Her exhibitions at the GRI include *Monuments of the Future: Designs by El Lissitzky* (1998–99); *Sea Tails: A Video Collaboration* (2004); and *Tango with Cows: Book Art of the Russian Avant-Garde, 1910–1917* (2008–9); and she led the curatorial team for *World War I: War of Images, Images of War* (2014). Perloff is the author of *Art and the Everyday: Popular Entertainment and the Circle of Erik Satie* (Oxford, 1991) and coeditor, with Brian M. Reed, of *Situating El Lissitzky: Vitebsk, Berlin, Moscow* (Getty, 2003). She has written and lectured widely on avant-garde composers such as John Cage and David Tudor.

The Getty Research Institute Publications Program
Thomas W. Gaehtgens, *Director, Getty Research Institute*
Gail Feigenbaum, *Associate Director*

© 2016 J. Paul Getty Trust
Published by the Getty Research Institute, Los Angeles
Getty Publications
1200 Getty Center Drive, Suite 500
Los Angeles, California 90049-1682
www.getty.edu/publications

Lauren Edson, *Manuscript Editor*
Kurt Hauser, *Designer*
Michelle Woo Deemer, *Production Coordinator*
Diane Franco, *Typesetter*

Type composed in Kievit

Distributed in the United States and Canada by the University of Chicago Press
Distributed outside the United States and Canada by Yale University Press, London

Printed in China

Front cover: Olga Rozanova (Russian, 1886–1918), Exploding sun (detail), from Alexei Kruchenykh, *Vzorval'* (Explodity), 2nd ed. (Saint Petersburg, 1913). See p. 138, fig. 15.

Back cover: Natalia Goncharova (Russian, 1881–1962), Cover of Velimir Khlebnikov and Alexei Kruchenykh, *Mirskontsa* (Worldbackwards) (Moscow, 1912). See p. 87, fig. 1.

Frontispiece: Nikolai Kulbin (Russian, 1868–1917), Detail of cover of Alexei Kruchenykh, *Vzorval'* (Explodity), 1st ed. (Saint Petersburg, 1913). See p. 119, fig. 4.

Page viii: Kazimir Malevich, *Prayer (Molitva)*, from Alexei Kruchenykh, *Vzorval'* (Explodity), 2nd ed. (Saint Petersburg, 1913). Los Angeles, Getty Research Institute, 85-B4913.

Page 189: Olga Rozanova (Russian, 1886–1918), Rearing horse (detail), from Alexei Kruchenykh, *Vzorval'* (Explodity), 2nd ed. (Saint Petersburg, 1913). See p. 139, fig. 16.

Every effort has been made to contact the owners and photographers of objects reproduced here whose names do not appear in the captions or in the illustration credits listed at the back of this book. Anyone having further information concerning copyright holders is asked to contact Getty Publications so this information can be included in future printings.

Library of Congress Cataloging-in-Publication Data
Names: Perloff, Nancy, author. | Getty Research Institute, issuing body.
Title: Explodity : sound, image, and word in Russian futurist book art /
 Nancy Perloff.
Description: Los Angeles : Getty Research Institute, [2016] | Includes bibliographical
 references and index. | "The artists' books made in Russia between 1910 and 1915 are
 like no others. Unique in their fusion of the verbal, visual, and sonic, these books are
 meant to be read, looked at, and listened to. Painters and poets—including Natalia
 Goncharova, Velimir Khlebnikov, Mikhail Larionov, Kazimir Malevich, and Vladimir
 Mayakovsky—collaborated to fabricate hand-lithographed books, for which they
 invented a new language called zaum (a neologism meaning "beyond the mind") that
 was distinctive in its emphasis on "sound as such" and its rejection of definite logical
 meaning. At the heart of this volume are close analyses of two of the most significant
 and experimental futurist books: Mirskontsa (Worldbackwards) and Vzorval' (Explod-
 ity). In addition, Nancy Perloff examines the profound difference between the Russian
 avant-garde and Western art movements, including futurism, and she uncovers a
 wide-ranging legacy in the midcentury global movement of sound and concrete poetry
 (the Brazilian Noigandres group, Ian Hamilton Finlay, and Henri Chopin), contempo-
 rary Western conceptual art, and the artist's book."—ECIP data view.
Identifiers: LCCN 2016013972 | ISBN 9781606065082
Subjects: LCSH: Futurism (Literary movement)—Russia. | Futurism (Art),Russia. |
 Literature, Experimental—Russia—20th century—History and criticism. | Artists'
 books—Russia—History—20th century. | Avant-garde (Aesthetics)—History—
 20th century.
Classification: LCC PG3065.F8 P47 2016 | DDC 709.04/082—dc23
LC record available at https://lccn.loc.gov/2016013972